Pilgrimage

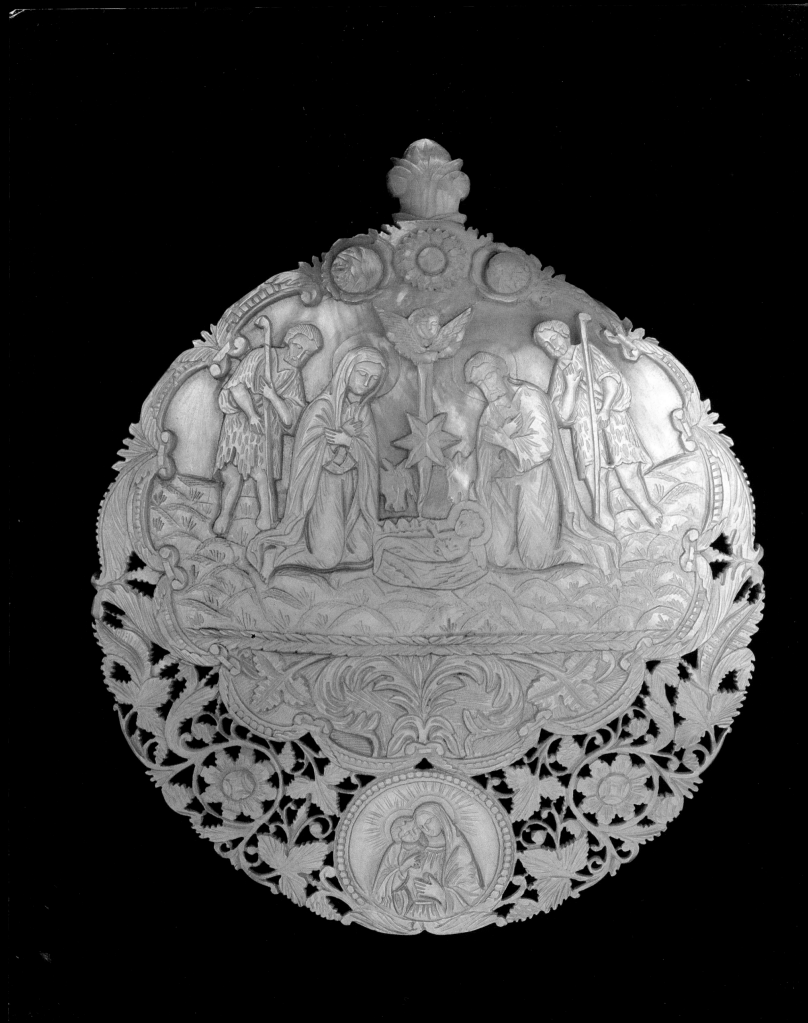

Pilgrimage

THE SACRED JOURNEY

RUTH BARNES AND CRISPIN BRANFOOT
EDITORS

WITH CONTRIBUTIONS BY
JAMES W. ALLAN, FRANCIS DAVEY AND CAROLINE FRIEND

ASHMOLEAN MUSEUM, OXFORD
2006

Pilgrimage

THE SACRED JOURNEY

THE ASHMOLEAN MUSEUM, OXFORD

British Library Cataloguing in Publication Data

A catalogue record for this book is available from the British Library

ISBN: 1 85444 215 5

Catalogue designed by Rhian Lonergan-White

Typeset in Carolina and Garamond

Printed and bound in the United Kingdom by Alden Group Ltd

Front cover: **Monasteries of Meteora, Edward Lear**
 c. 1849, The Ashmolean
Previous page: **Pilgrims' souvenir showing the Nativity**
 Shell. Palestine, 18th century. Ashmolean Museum AN 1915.126.
Next page: **Pilgrims bathing in the river Ganges at Varanasi, north India**
 (Photo: Crispin Branfoot 1996)

Contents

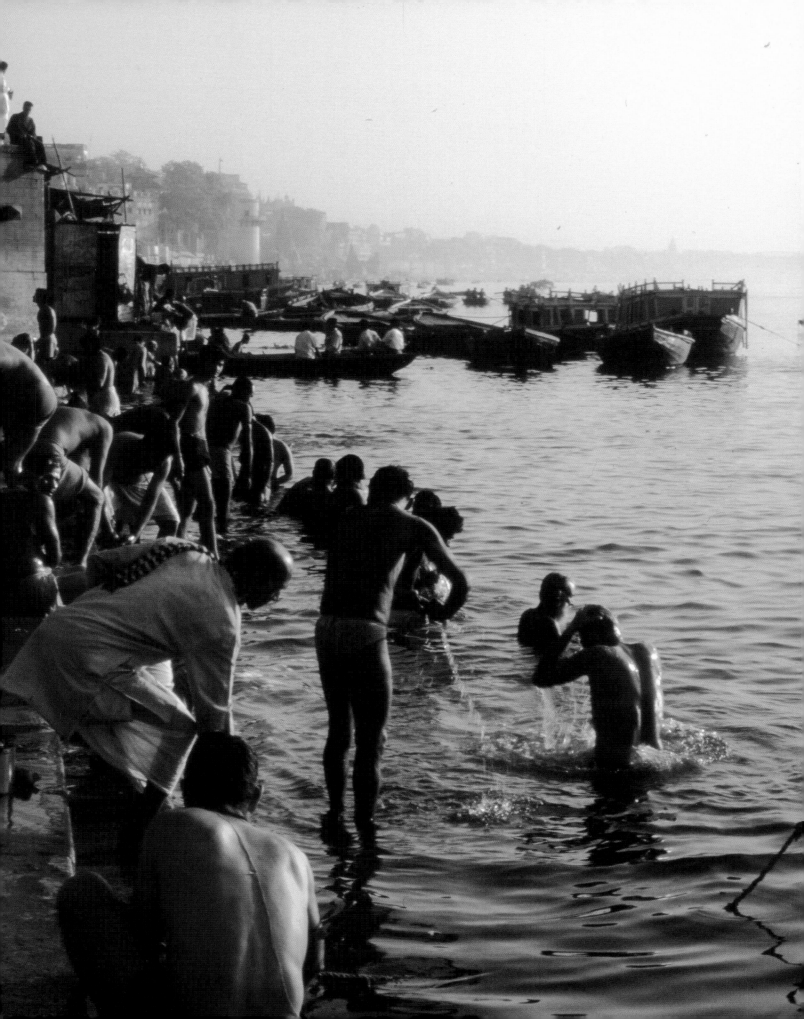

Foreword

This is the first in a series of exhibitions to be organised by the Ashmolean Inter-Faith Exhibition Service (AIFES). As with all exhibitions, its primary purpose is to display works of art. However, AIFES has a particular role, for it was created by the Museum in order to devise exhibitions whose subjects are common to the great religions of the world. Through such exhibitions we want to help and encourage adherents of those religions to understand one another's actions and beliefs, and thus to promote understanding between different religious and ethnic communities. Our first task is to do this in Oxford and Oxfordshire, but we also plan to take the exhibitions to other cities in the country, where they will create similar opportunities. The service is the brainchild of my remarkable colleague, Professor James Allan, who until recently was the head of the Eastern Art Department. James is an Islamicist of great distinction and a devout Christian. As he explains in his Preface to this publication, the fundamental aim of the Service is to draw together people from different backgrounds and religious beliefs, so that they can enjoy and share each other's cultural heritage and appreciate the artistic creativity which has found expression in those different contexts. This is of paramount importance in Britain's 21st-century multicultural society. If we do not grow together, we will wither separately. The Ashmolean is taking a lead in showing that we can grow together – and that art can be a means to this end.

The first exhibition is devoted to the theme of pilgrimage. We are enormously grateful to Ian Laing, High Sheriff of Oxfordshire, and to his wife Caroline, for supporting this enterprise. The creation of a successful multicultural society in Oxfordshire has been a central theme of his period of office.

DR CHRISTOPHER BROWN
Director of the Ashmolean Museum

Preface

JAMES W. ALLAN

Director of the Ashmolean Inter-Faith Exhibition Service

As a result of its history, Oxford University has become a treasure house of works of art. Many of these, which now reside in the Bodleian Library, the Ashmolean Museum, the Pitt Rivers Museum and the Museum of the History of Science, are little known, and it is the aim of the present exhibition to bring into the public arena many fine objects and manuscripts which deserve to be enjoyed and appreciated. However, the purpose of this exhibition, and of this accompanying volume, is wider than that. In the first place, we wish to share with the public treasures of the University that specifically represent different religions from around the world. In this a major step forward has already been made by the digitisation of the Bodleian Library's *Shikshapatri* manuscript, written by Shri Swaminarayan; it is now available on the web, where it can be read worldwide by adherents of this Hindu sect. But many such religious treasures are all too little appreciated, or their existence is not widely known, and much more needs to be done to bring them before the public.

The most important aim of the exhibition and of this book, however, is to offer these works of art as a mechanism for drawing together members of different faiths. Words seem to divide humanity. Works of art, however, appeal to us at a very different level. Of course we may reflect on their message, but we can also enjoy their use of colour, their sense of design or pattern, their form and style. Such features thereby offer us a different avenue by which to approach belief, for they take us away from our differences, and open up to us important areas of common humanity and common creativity: the extraordinary ability of human beings to make objects which are not simply practical tools for everyday survival, but objects of artistry and beauty, creations which touch our senses, which can sometimes move us to an emotional response. It is our hope that all those who come to the exhibition or read this book, will appreciate the beauty of the objects created by members of other faiths, and come to a deeper understanding and enjoyment of our common humanity.

Religions may appear very different from each other, and from a theological perspective they are indeed distinct. But, intriguingly, they share particular concerns, and although their interpretations of these may vary in detail, they nevertheless hold them in common. For example, even though the details may vary, pilgrimage is an element in virtually every world religion. In the Protestant Christian tradition it is valued comparatively little, though earlier this year

my wife and I took the opportunity of joining the pilgrimage of St. Birinus in Oxfordshire. Commemorating the arrival of Christianity in this part of Wessex, the pilgrims walk some twelve miles, from near Blewbury on the Downs, to Dorchester on the Thames. Such pilgrimages are of purely local significance. The *Hajj*, the Muslim pilgrimage to Mecca, on the other hand, is perhaps the greatest unifying force in the Islamic faith, while pilgrimage in many parts of India might be likened to the waves of the sea, for there is a continual movement of people between sites of worship. Pilgrimage may receive different emphasis in different religious traditions, but it always carries both physical and spiritual connotations: the journey to and from the site, and the encounter with the divine, which is the objective of the pilgrimage itself.

Pilgrimage lends itself to exhibitions, for it includes not only the beautiful, the works of art which perhaps represent the object of the pilgrimage and can be appreciated for their own sake; it also includes everyday objects which speak of the pilgrim's journey to the site and return home, and of his or her daily needs during the time away. In other words it has a strong anthropological element to it, which appeals to the viewer because of its everyday dimension. 13th century pilgrims' badges from Canterbury have served in their time a similar purpose to present-day badges from Lourdes in France or Kerbala in Iraq.

The artistic success of the exhibition will be magnified as visitors take it back into their communities, and there share it with friends, neighbours and those around them of other faith traditions. It is my hope and prayer that both the exhibition and the book will be used in this way, and that new, harmonious relationships will result.

The formation of the Ashmolean Inter-Faith Exhibition Service, together with this exhibition and publication, would not have been possible without the generosity of Ian Laing, High Sheriff of Oxfordshire, and his wife, Caroline. I would like to express my deep gratitude to them for catching the vision and for providing the means. I would also like to express my thanks to the Heritage Lottery Fund for generously financing the Education Outreach Officer, who has the skills to make the most of this opportunity both on behalf of the Museum and on behalf of the local religious communities.

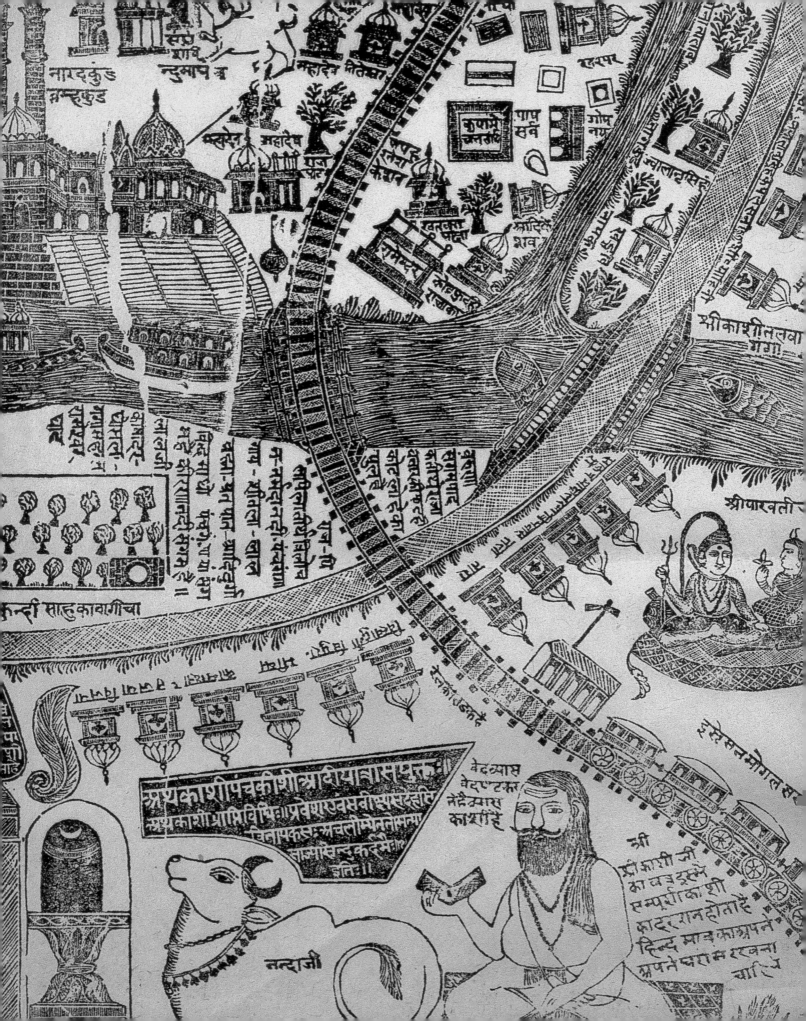

Acknowledgements

Our foremost thanks must go to Ian Laing, High Sheriff of Oxfordshire, and his wife Caroline Laing, who responded with such whole-hearted enthusiasm to the project when it was still in a nascent stage and gave it their generous financial support. Without their help the Ashmolean Inter-Faith Exhibition Service and our first exhibition on Pilgrimage would have remained a pipedream. They were interested in the progress throughout, and were always happy to listen to ideas and progress reports; they made valuable suggestions for contacts and approaches, but gave us complete freedom in how we reached our goal.

Our sister institutions in the University, the Bodleian Library, Pitt Rivers Museum, and the Museum for the History of Science have been generous with their loans to the exhibition. Our thanks go to Dr Bruce Barker-Benfield, Leslie Forbes, Dr Gillian Evison, Colin Wakefield, and Dana Josephson at the Bodleian, to Julia Nicholson and Zena McGreevy at the Pitt Rivers, and to Dr James Bennett at the Museum of the History of Science. Cambridge University Library allowed the loan of one of its finest Oriental manuscripts, thanks to the support of Craig Jamieson, curator of the Oriental Collections.

Professor James Allan has been the mentor of the entire project, and we are indebted to his formidable knowledge as a scholar of Islamic art. We thank our curatorial colleagues in the Ashmolean Museum, in particular Dr Arthur MacGregor, Dr Andrew Topsfield, Dr Catherine Whistler, and Timothy Wilson for advice and suggestions. Dr Kate Heard in the Western Art Print Room was always most helpful. Dr Marlia Mango, St. John's College, Oxford, contributed to the interpretation of Eastern Christian objects. Moira Hook generously gave of her expertise and time. The Museum's Photographic Department must be credited with saintly patience, as they produced wonderful work even when under great pressure. The preparations for the exhibition were accomplished by the Conservation department, in particular by Daniel Bone, Alexandra Greathead, Veronika Vlkova, and Susan Stanton. The exhibition and publication were prepared at a time when the Ashmolean Museum was packing up most of its collections for a major rebuilding project, and it was essential to work closely with the decant team, so that the objects to be displayed were not packed away: special thanks to Flora Nuttgens, who kept a close eye on our needs and requests. The loans were efficiently dealt with by Geraldine Glynn. Thanks also go to Alan Kitchen and the Museum's workshop team, and to Graeme Campbell in the Design Office. Rhian Lonergan-White is responsible for the design of the publication, Keith Bennett the maps, and Declan McCarthy and Sarah Parkin saw the manuscript through to publication.

Detail of Fig. 66 on p. 67

Introduction

RUTH BARNES AND CRISPIN BRANFOOT

This book was developed to coincide with the exhibition 'Pilgrimage - The Sacred Journey' at the Ashmolean Museum, Oxford (January to April 2006). It does not, however, represent a catalogue of the display, but is intended to be read quite independently. It is hoped, therefore, that it will have a life of its own. It may even be used as a companion to similar exhibitions elsewhere, when the Ashmolean Inter-Faith Exhibition Service (AIFES) achieves its goal of helping to set up travelling exhibitions following a similar theme.

The original exhibition and this publication explore the role of pilgrimage in Christianity, Islam, Judaism, and the religions that developed in India. The exhibition's structure is thematic, with five sections titled, respectively, Departure, The Journey, Sacred Space, The Central Shrine, and finally Return. To view the exhibition, the visitor is invited to follow this sequence. This book takes a complementary approach. The editors present an outline of attitudes to pilgrimage in the different religions, first in a chapter devoted to Judaism, Islam, and Christianity, and then in a second chapter that considers the religions practised in South Asia.

The life and times of the English 15th century pilgrim William Wey, who undertook three pilgrimages and whose account of them is now in the Bodleian Library, Oxford (and available for the Ashmolean Museum's exhibition), gives a remarkable glimpse of the physical conditions of pilgrimage in the 15th century and the spiritual concerns of one man in his travels to the Holy Land. Francis Davey focuses on Wey's manuscript and gives a lucid account of the information it contains. Although there are parts where Wey probably copied pilgrims' guide books or the local 'travel guides' of his time, much of it is original to Wey's observations. These are always interesting to read about and are often quite amusing. To expand on the theme of pilgrims' accounts in the other religions covered in this book, James Allan and Crispin Branfoot have chosen excerpts from travellers' descriptions of, and experiences at, sacred locations. The book's final chapter is a very personal account, by Caroline Friend, of walking the French section of the path to Compostela as recently as the summer of 2004.

Certain themes emerge in these five essays about pilgrimage, regardless of religious affiliation. These connect directly with the five stages presented in the exhibition. The departure from daily life is the first motif. The pilgrim leaves behind his or her social status to engage in the common

goal of reaching the final destination. This may be emphasised by adopting a uniform dress that identifies the person as a pilgrim. People joined in this endeavour often establish a special bond; evidence for it reach across time, from the *Canterbury Tales* to the account of 21st century pilgrimage.

Visiting lesser shrines and being unusually engaged in sacred spaces and landscapes is another experience that apparently is often part of the pilgrimage experience. This is especially strong where pilgrims move through space on foot or at least can experience the landscape, rather than being transported in aeroplanes, as is now most common for the *hajj* to Mecca. The concentration on the central shrine, the final goal of the journey, always culminates in an intense spiritual experience at the moment of physical proximity to the venerated shrine. Physical contact gives at least a fleeting moment of direct contact with Divinity, even if it is through the intercession of saints.

To hold on to this moment and make it possible to transfer its power back into everyday life, is the object of reliquaries and souvenirs brought back from the journey. By returning home with blessed objects, the pilgrim hopes to have the continued aura of the encounter with the sacred at the pilgrimage's destination. Amulets, reliquaries, or mementoes are taken home to help protect him or her for a lifetime, but also to be shared with relatives and friends who have not been able to partake of the journey.

One cannot look at pilgrimage, though, without considering the strong opposition to it, elements of which are found in most of the religions represented here. Although there is a firm injunction to visit the most important sacred monuments in at least two of these, in Judaism and in Islam, there nevertheless is often a concern that pilgrimage may be a distraction from the 'real' experience of communion with the Divine, which should be found within oneself. Pilgrimage may be seen as an externalised religious experience, too dependent on the material world and as a distraction from the pursuit of truly spiritual contact with Divinity. But despite its critics, be they ascetic renouncers of worldly ways or puritan interpreters of texts, pilgrimage survives as an important, even as a defining, aspect of religious awareness and identification.

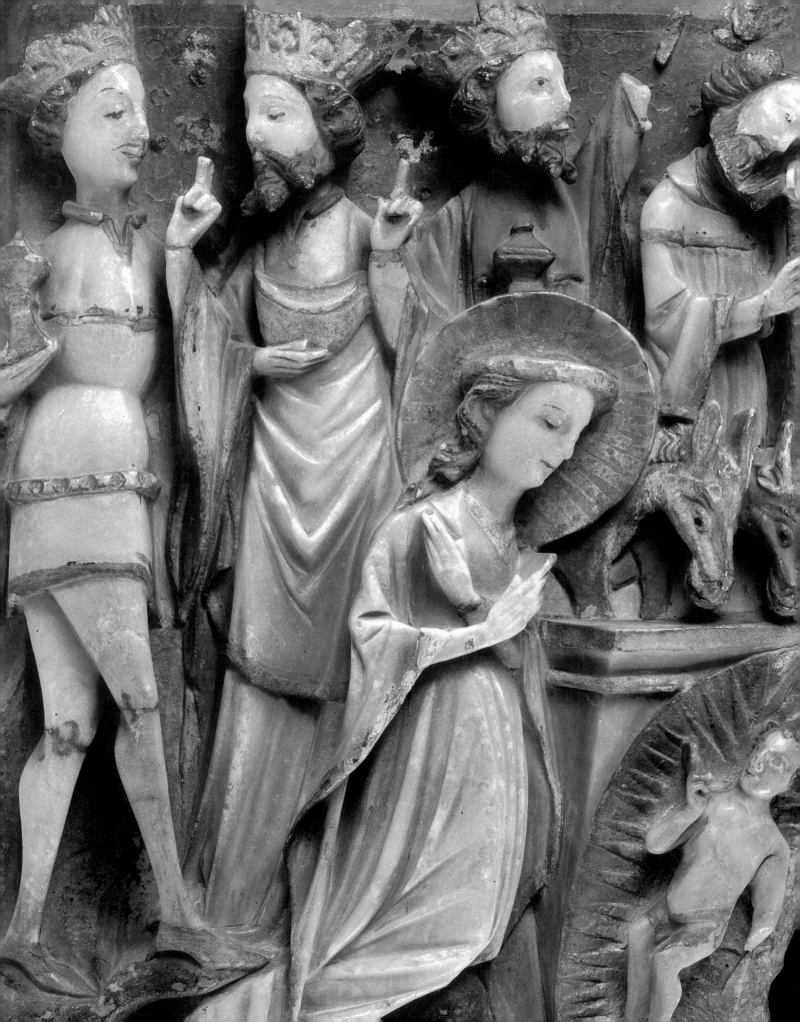

Relatives in Faith

PILGRIMAGE IN JUDAISM, ISLAM AND CHRISTIANITY

Ruth Barnes

The three major religions that developed in the Near East and are still with us today – Judaism, Christianity, and Islam – share many fundamental aspects. These are characterised by the belief in a single God, a belief in the same account of creation as told in Genesis, and a foundation of their faith on revelations that were set into texts. All three recognise Abraham as a prophet and spiritual ancestor and the Hebrew Bible as a fundamental religious scripture, where the nature and commandments of God are revealed through the writings of Moses and the later prophets. This is despite the fact that religious disagreement divides all three faiths, and each clearly defines itself in contrast to the others. For Jews and Muslims God is seen strictly in monotheistic terms, while Christians believe in the Divine tripartite nature of Father, Son, and Holy Spirit, as set out in the New Testament which focuses on the life of Jesus Christ as the Son of God and the saviour of humanity. (Fig. 1) Muslims believe that the Jewish God is the same as Allah and that Jesus is a divinely inspired prophet, but not a divinity. Thus, in Islam both the Torah and New Testament are accepted as valid in principle, but are believed to have been corrupted, while the Qur'an is seen as the final uncorrupted word of God revealed through the last prophet, Muhammad. Despite differences that may seem fundamental, Islam, Christianity, and Judaism share a common ancestry. This chapter therefore brings together all three and looks at the role of pilgrimage in each. As Judaism is historically and theologically the foundation of the three Abrahamic religions, its attitude to pilgrimage serves as the starting point.

Jewish Pilgrimage

> Thrice in the year shall all your menchildren appear before the Lord God, the God of Israel (*Exodus* 34: 23)

This order was given to Moses on Mount Sinai, where God had called him to receive the Ten Commandments written in stone. Not only did the encounter confirm God as the One and Only and set out the ethical behaviour expected of His 'chosen people', but it also established appropriate ritual actions in everyday life and on special ceremonial occasions. God required his people to appear before Him in his temple three times a year: at the time of the feast of the unleavened bread (Passover), the feast of weeks (Shavu'ot), and the feast of the tabernacle (Sukkot). His injunctions passed on to Moses also included detailed descriptions of the construction of the tabernacle, the portable tent shrine which was to be the central place of worship. It was to be built of shittim wood (acacia) with blue, purple and scarlet textile hangings of fine twined linen. God instructed Moses that the stone tablets were to be kept inside the tabernacle in the Ark of the Covenant, also of shittim wood, and He gave detailed measurements, as well as instructions for the external decoration with staves and carrying rings. (Fig. 2) The ritual implements to be kept with the shrine were also clearly prescribed, among them the menorah, the seven-branched candlestick (*Exodus* 26: 31–37). (Fig. 3)

The Jews received the tablets during their wanderings in the desert, and until they settled finally in Canaan, their shrine was portable and moved with the community. Once they gave up their nomadic wanderings the Ark first came to rest in a central sanctuary at Shiloh, which is probably the modern Seihu, approximately eight miles north of Bethel, where it remained until it was moved to Jerusalem by David and was housed in the Temple built by Solomon, David's son. Already at Shiloh the Ark would have been the object of pilgrimage on the three occasions required annually, but in Jewish history it is in particular Jerusalem and its temple that became the focus of ritual attention, attracting the believers to visit from all parts of Palestine. As the home of the Ark of the Covenant, it provided a direct link to God Himself, as the stone tablets kept in the Ark

Image on previous page
Fig. 1
Relief of the Three Magi
England, ?15th century.
Alabaster and paint.
Ashmolean Museum, Oxford,
B. Pomeroy Loan.

The panel combines the
Nativity with the Adoration
of the Magi, who came to
Bethlehem to worship the
Christ Child; this may
be considered the first
pilgrimage in Christianity.

were His manifestation passed on to Moses and the Jews:

> And the tables *were* the work of God, and the writing *was* the writing of God, graven upon the tables (*Exodus* 33: 16).

The presence of God in His writing made the Ark the foremost sacred object in Judaism, and the temple in which it was housed the most venerated sacred space. The importance of the divine written word is of course similarly familiar from Islam; it is by no means universal to religious beliefs and practices, but is a particular strength of these two religions. Access to the Divine is granted not only through altars, offerings, and ceremonies, but directly through the written word, as found in the stone tablets, and later

in Islam in the writing of the Qur'an. It is a sharp departure from the pagan religions of Mediterranean antiquity. (see map, p.43)

Pilgrimage to the place where God's written word was preserved was demanded of the Jews in order to enter the presence of God, as He was embodied in the text written on Mount Sinai. It was believed that the faithful entered the proximity of the Divine in the temple, and Jerusalem, the royal city of David and Solomon, was at the heart of Jewish religious culture. The location of the temple itself gained an extraordinary symbolic meaning: in Jewish mythology it was supposed to have been the exact place where the waters of the Deep were blocked off on the first day of creation, and the site where God collected the dust of the earth to form Adam. It was

Figs. 2 & 3
Hebrew Bible
Spain, 1476 AD. Vellum.
Bodleian Library, Oxford,
MS. Kennicott 1, fol. 120v-
121r

The Kennicott Bible is one of the most magnificent Hebrew manuscript ever produced. It was written by the scribe Moses ibn Zabara and illuminated by Joseph ibn Hayyim. Both worked at Corunna in north-west Spain. The bible was made for Isaac de Braga. It is written on very fine vellum and is bound in a contemporary leather binding. The text is decorated throughout with marginal tracery and designs, including some figural illustrations. The two pages on view show the Menorah, the seven-armed cande-labrum, and the Vessels of the Sanctuary, a reference to the Temple in Jerusalem.

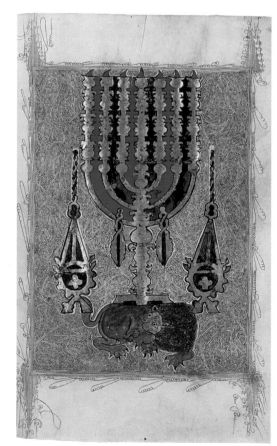

where Adam made his first sacrifice, where his grave was, and where Cain and Abel made their offerings. The disaster of the Flood came about when the temple's foundation stone was lifted and the waters of the Deep were once again released; when it ceased Noah made his first sacrifice here. The site of the temple had become a location where crucial events in Jewish religious history were believed to have taken place.[1]

The destruction of Solomon's temple by Nebuchadnezzar in 586 BC and the forced resettlement of the Jews in exile in Babylon therefore brought a dilemma that was to be repeated in the community's history: if God must be approached by visiting his temple and the Ark, how could the faithful be near to him in exile? The motifs of exile and lamentation, the loss of the cosmic centre, found an early articulation in Jewish writing. In the Biblical accounts a theological solution was found in the role given to prophets who foresaw that God had not forsaken his People, and that a time would come when the Jews could return to their sacred centre, and find reconstitution in moral and spiritual terms.

On return from Babylon the temple in Jerusalem was rebuilt, although it is likely that the Ark of the Covenant had already been lost during Nebuchadnezzar's sacking of Jerusalem. The third temple was the major reconstruction undertaken during Herod the Great's reign. It was again destroyed by Titus in 70 AD; this is the date usually given as the beginning of Jewish Diaspora from Palestine. After a further rebellion against Roman occupation in the mid-second century AD, Hadrian destroyed the remains of Jerusalem in 135 AD and built a pagan shrine on the site of Solomon's temple, and Jews were not allowed to enter Roman Jerusalem again until after Constantine's conversion to Christianity in 312 AD. When Palestine was under Byzantine and

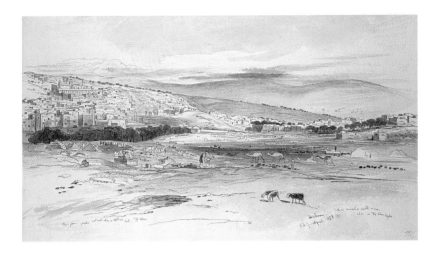

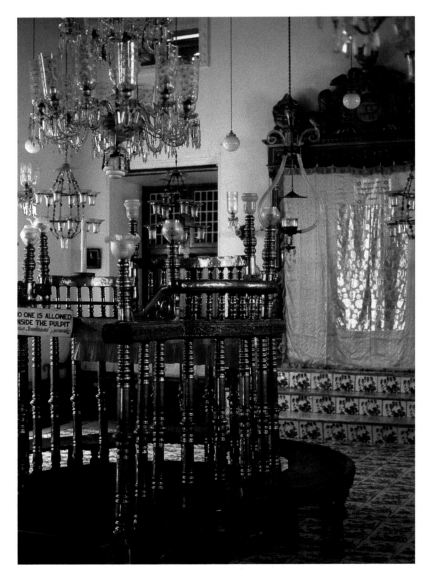

Fig. 4
**Edward Lear, View of
Hebron, Palestine, 1858.**
Watercolour, pen and ink on
paper. Ashmolean Museum,
Oxford, WA 1942.168.

Fig. 5
Synagogue interior
Cochin, Kerala,
India, 18th century.
(Photo: Ruth Barnes 1999.)

The floor of the synagogue
is covered with Chinese
blue-and-white tiles made
in Canton.

later Islamic rule Jewish communities did prosper in Palestine, although as a minority religion they were often subject to social and economic restrictions and special tax regulations. (Fig. 4)

During the later medieval period Jewish pilgrimage to Jerusalem or other sites of religious significance in Palestine continued, but new sites also developed in Iraq and Iran, as well as Morocco. Quite often these were dedicated to rabbi revered for their spiritual power and wisdom. One traveller in the 1160s, the Rabbi Benjamin of Tudela in Spain, left a written account of visiting Jewish sacred sites in Rome and Palestine, although the main reason for his journey was to visit different Jewish communities in the Near East.[2] At the time there was much social and economic contact between these settlements around the Mediterranean littoral.[3] Other communities in southern Arabia and in India, in particular in the Yemen and at Cochin in Kerala, even linked the Jews of the Mediterranean to the wider world of the Indian Ocean via their mercantile connections. (Fig.5) While in the Diaspora, Jerusalem and the Promised Land became a significant evocation of religious ritual, in particular during the Passover service; in reality, though, the focus of each community was primarily found in the synagogue, where a scroll copy of the Torah (the Law, the first five books of the Bible which provide the basis for Judaism) was kept. The Torah echoes, in that sense, the stone tablets held in the Ark itself.

It was only with the development of Zionism in the late 19th century that the return to Palestine again became a mission for those Jews who followed it. The temple in Jerusalem was not rebuilt, but its western wall, the so-called Wailing Wall and the only part of the temple left standing after the final destruction, remains a focus of pilgrimage for many Jews. (Fig. 6)

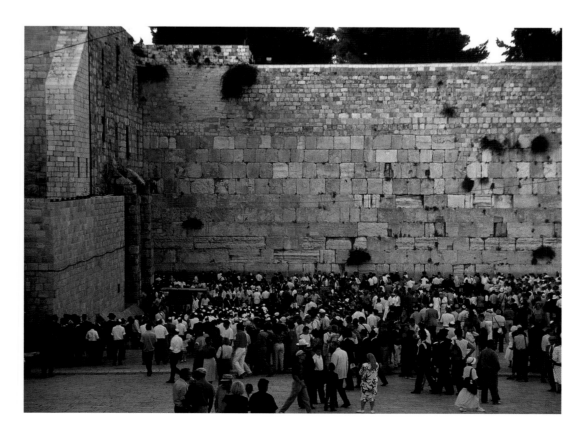

Fig. 6
**Jerusalem, remains of the
Jewish Temple ('Wailing
Wall')**
(Photo: Crispin Branfoot 1989)

Pilgrimage in Islam

As in Judaism, there is a firm injunction for pilgrimage in the Qur'an. Every Muslim should go on pilgrimage and visit Mecca once in a lifetime, provided the means are available:

> Pilgrimage to the House is a duty laid upon people which they owe to Allah, those of them that can afford the journey thither (Qur'an 3:98)

The centre of pilgrimage to Mecca is the Ka'ba, the 'House of God' believed by Muslims to have been built by Abraham and his son Ishmael. As an important shrine it goes back to pre-Islamic times and was venerated by various Arab peoples, including Muhammad's clan, the Quraysh, who actually were guardians of the Ka'ba.

The Prophet Muhammad was born in Mecca around 570 AD. He was a merchant by profession and did not start preaching until he was in his early 40s. He had his first revelation in 611 AD, when the Angel Gabriel revealed himself to him and commanded him to memorize and recite the verses later collected as the Qur'an; (Fig. 7) Muhammad's claim of a journey to heaven (the *miraj*) took place ten years later. He opposed polytheism and the worship of images; his religious fervour was objected to by many in Mecca, and he and his followers were forced to flee to Medina in 622 AD, the year from which the Muslim era is dated (named *hijra*, 'flight'). He found support in Medina and eventually could exert pressure on Mecca to accept his demands of purifying the Ka'ba. His requests for the destruction of 'idols' and the renovation of the Ka'ba were finally agreed to in 630 AD. He returned to Mecca on pilgrimage to the Ka'ba shortly before his death in 632 AD: this established the city as the holiest in Islam, and the Ka'ba as its sacred centre. By worshipping at the House built by Abraham he emphasised the connection of Islam to the Old Testament tradition. His pilgrimage became the precedent for all Muslims to emulate. Prayer in Islam is directed towards the Ka'ba, from anywhere in the world. (Fig.8)

Fig. 8 (right)
Portable atlas
North Africa, 1571 AD. Drawing on paper. Bodleian Library, Oxford, MS. Marsh 294, fol. 5.

The atlas was drawn by Safakusi (Ali b. Ahmad) al-Maliki from Tunisia. Folio 5 shows the compass with the representation of the Ka'ba in the centre.

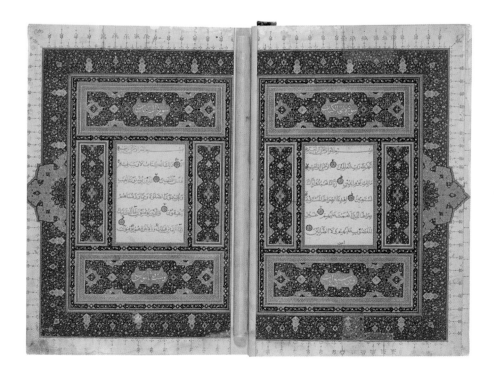

Fig. 7
Qur'an
Iran or India, mid-16th century. Bodleian Library, Oxford, MS. Ouseley Add. 178, fol. 2v–3r.

The opening of the Qur'an shows a very fine illumination, with floral scrolls on blue and gold writing.

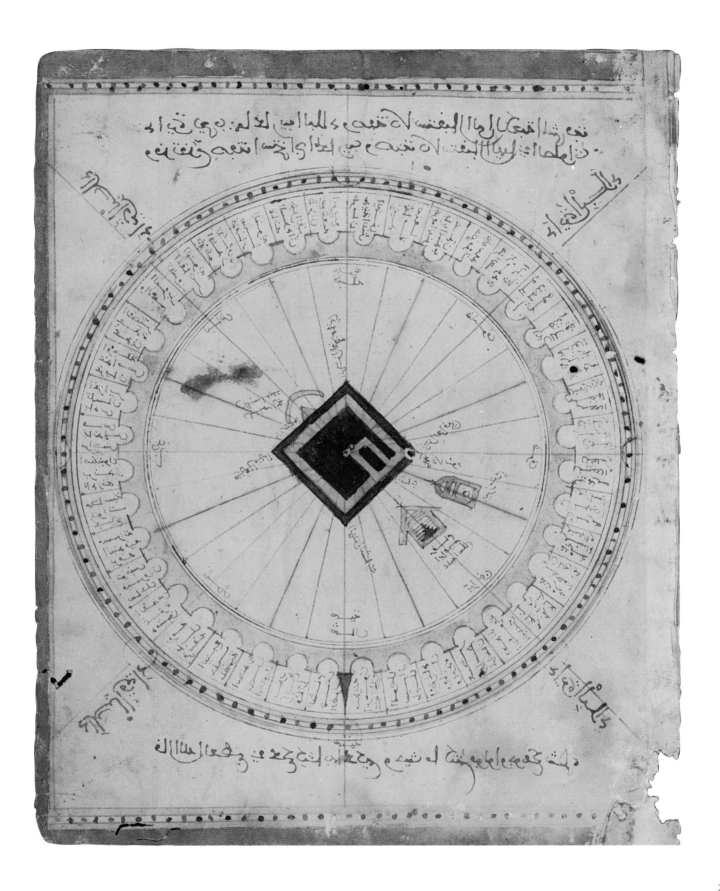

The so-called Five Pillars of Islam, the foundation of Muslim behaviour, are as follows:

- Allah is to be proclaimed God, and Muhammad is his Prophet
- Fasting is to be observed during the holy month of Ramadan
- Alms are to be given
- Prayers are to be said five times a day
- The faithful is to go to Mecca once in a lifetime

The fifth pillar (pilgrimage) is a key experience for all Muslims. For a world-wide religious community that by the 14th century had spread from its Near Eastern home to Central Asia and Indonesia, to India and parts of Africa, it transcends many ethnic and national boundaries and brings together pilgrims from hugely different backgrounds and languages. Regardless of origin or social status, all Muslims who join on pilgrimage in Mecca are as one before God on this occasion. They dress uniformly and momentarily discard all external marks of identity. There are two versions of pilgrimage, the *hajj* being the greater, *umra* the lesser. The *hajj* (translated as 'effort', but also 'procession')[4] is carried out between the 8th and the 13th day of the twelfth month (*Dhul Hijjah*) in the Muslim year, the month that brings the year to a close. It unites the largest collection of believers in one place, at a specific time, and it requires them to carry out together a set of prescribed rituals. A journey to Mecca at another time of year is referred to as the 'lesser' pilgrimage *umra* ('visitation'). The English word 'pilgrimage', which stresses the *journey* to a sacred space, is not really adequate to describe the Muslim's *hajj* or *umra*. The pilgrims will usually have travelled far to reach the Hijaz, the desert stretch along the eastern coast of the Red Sea where Mecca and Medina are situated, and in former times they had to endure hardships along the way. But strictly speaking, the journey itself is not part of the *hajj*: it is only the sequence of rituals undertaken once one has arrived in the

Holy City. The *hajj* follows clearly defined stages.

It begins with rites of purification before entering the sacred space, which involve ritual washing, hair-cutting and shaving. Men and women put on plain robes, and all personal adornment is left behind. Traditionally this preparation for the *hajj* is undertaken just prior to entering Mecca; nowadays as many pilgrims travel by air, it may precede the journey. On entry into Mecca, the Muslim identity of the pilgrim is established, by identity cards and special passports. The sacred space of Mecca is strictly reserved for the Islamic faith community, the *umma*, and no non-Muslim is allowed to enter. As the pilgrims pass the boundary stones that mark the holy space of Mecca, they vow to abstain from any worldly activity, whether economic, political, or sexual. They are received by guides who will make sure that the rituals are carried out correctly.

The Ka'ba is the sacred centre, set into the huge courtyard of the mosque which measures 164 m x 110 m. (Fig. 9) The central building goes back to the 7th century and contains fragments of the structure that was visited by Muhammad, but it has been restored numerous times. It is a large construction, almost cubic with a height of 13 m and 11 m square, and is covered with a black cloth embroidered in gold, the *kiswah*. The Ka'ba contains the black stone that was once kissed by the Prophet; it is a meteorite which was venerated already in pre-Islamic times, when it may have been moved about in procession. Everything that comes into contact with the Ka'ba – the cloth cover, the water and brooms used to clean the vicinity – absorb its sanctity. (Fig. 10) Once the pilgrim arrives in the courtyard he or she is actually engaging in the *hajj*, by walking seven times around the Ka'ba, in imitation 'of the angels who circle the throne of Allah'. The *hajji* (pilgrim) tries to get close to the black stone and kiss it; if it cannot be reached because of the crowds in the yard, he or she will call out and greet it from afar.

Fig. 9
Pilgrims at the Ka'ba, Mecca
Source: M. Amin, *Pilgrimage to Mecca*, London: Macdonald and Jane's (1978): 94.

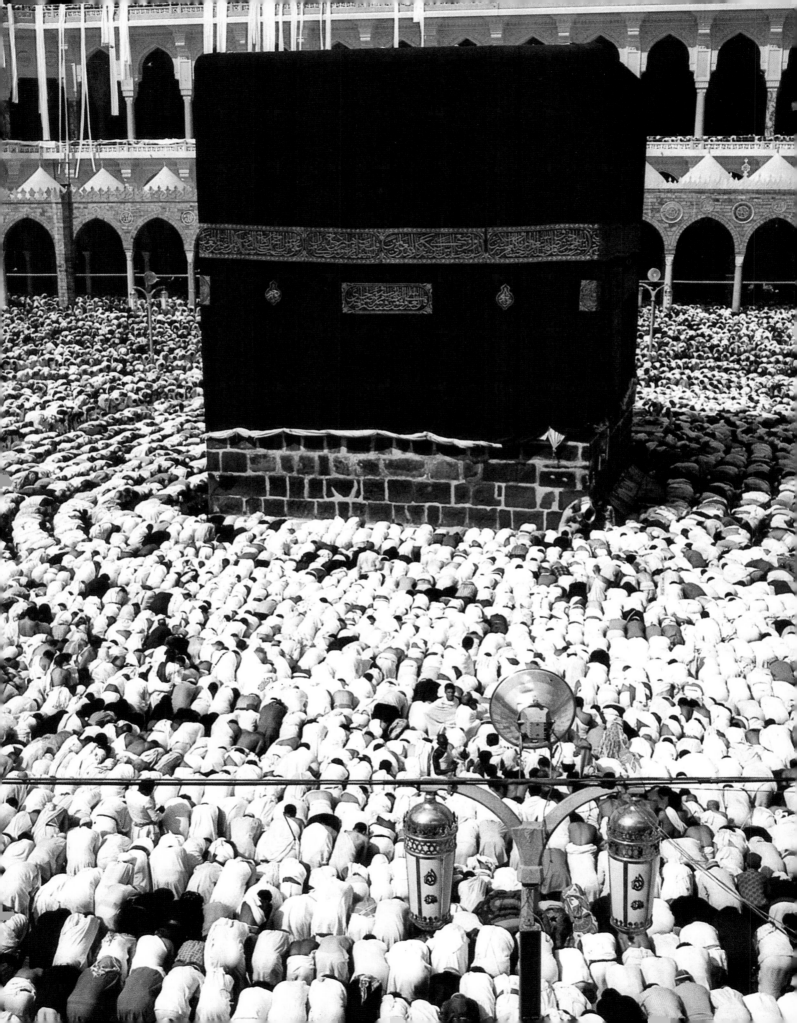

At the next stage the pilgrim runs between two hills, in memory of Hagar, Abraham's first wife and mother of Ishmael. She was searching here for water for her son. This area is called the garden of Zam Zam, after the well located in it which is believed to have been miraculously created. The bitter water may be collected in bottles to take home as souvenirs, and drinking from it and receiving a sprinkling of the waters of Zam Zam are supposed to purify the pilgrim from sin. (Fig. 11)

Then comes one of the most important moments of the *hajj*, when the pilgrims travel to the Mount of Mercy at Arafat, a site approximately 12 miles to the East of Mecca, where Muhammad addressed his followers for the last time before his death. This day is dedicated to sermons and prayers, with the pilgrims dressed in a white unhemmed cloth draped over the body, called an *ihram*, and a pair of sandals.

At sunset the mood of contemplation is abandoned and shifts to great activity, as the pilgrims begin to move quickly and gather stones for the next day: when the 'stoning of the pillars' takes place at a location called Mina. This frequently turns into a combative contest which in the past frequently became violent. Each pilgrim hurls a total of 41 stones at three pillars, over a period of three days. The stoning of the pillars is not referred to in the Qur'an, but it is said to reenact the time when Abraham was tempted by Satan to disobey God's command to sacrifice his son, and in response hurled stones at him.

On the following day Abraham's sacrifice is commemorated, when an animal is ritually slaughtered. This is the feast of Eid ul-Adha, the culmination of the *hajj* and one of the key ceremonies in the Muslim calendar. The small village of Mina then becomes the world-wide centre for the celebrations of Eid ul-Adha. The village plays host to scores of butchers who arrange for the *halaal* slaughter of the sacrificial animals on the pilgrims' behalf. The recent increase of people attending the *hajj* has led

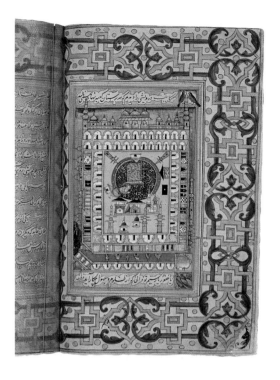

to a huge number of animals being slaughtered. This time of sacrifice is not only celebrated by the *hajji*, but by the entire Islamic faith community, as simultaneously the same offerings are made by Muslims worldwide.

Eid ul-Adha brings the pilgrimage to an end. The pilgrims have their hair cut, cleanse themselves, and return to Mecca and possibly continue on to Medina, to visit the Prophet's mosque and tomb.

Fig. 11

Glass bottle with embroidered cover

Egypt, 14th–15th century. Glass, linen, drawn thread stitching. Ashmolean Museum, Oxford, EA 1994.113.

Small bottles like this one were used to store sacred water from pilgrimage to Mecca.

Alternative Muslim Pilgrimage

Islam is closely focused on the text, in the revelation of the Qur'an to the Prophet, and in the writings that record Muhammad's religious practices (the *sunnah*) and his comments and sayings (the *hadith*). It mistrusts all worship that detracts from the centrality of the Qur'an, which defines the relationship of man to God. In Islam God is remote from human nature, and no person can be closer to God than any other person. Mecca and Medina are sacred places not because of their association with the life of Muhammad, but because the original revelation took place there. But other sacred places have emerged, many of them at an early stage in Islam. Jerusalem was considered holy by Muhammad, and he is said to have ascended to heaven (the *miraj*) from the sacred rock in the Dome of the Rock. (Fig. 12) In the early years of his prophecy, Muhammad faced Jerusalem when praying; the direction only changed to Mecca after he had a quarrel with the Jews of Medina. (Fig. 13) In addition to sites sanctified by the Prophet's revelations, cults for the veneration of intermediaries developed, for saints and holy men who could transfer their blessing (*baraka*) and might help the faithful in spiritual guidance.

A secondary type of pilgrimage is the *ziyara*, which is a visit to a holy place, tomb, or shrine. It can be to sites associated with wise men who acquired a saintly reputation, as such the *marabouts* of Morocco. They were spiritual leaders who also had a reputation as scholars of the Qur'an. They lived from alms and often were supported by ties to a particular family. Nowadays *marabouts* are rare in the Maghreb, but are still common in West Africa. At the eastern end of the Islamic world in Indonesia, where people became Muslims by the 14th century, the tombs of the founders of Islam became sacred spots and places of pilgrimage. One of the most venerated sites it the tomb of Maulana Malik Ibrahim in Gresik, east Java, dated to 1419 AD.

Fig. 12

Jerusalem. View of the Dome of the Rock from the Mount of Olives

(Photo: Crispin Branfoot 1989)

Fig. 13

David Wilkie, Pilgrims to Mecca and Jerusalem, Egypt, dated 1 July 1841

Pen drawing. Ashmolean Museum, Oxford, WA 1942.122.

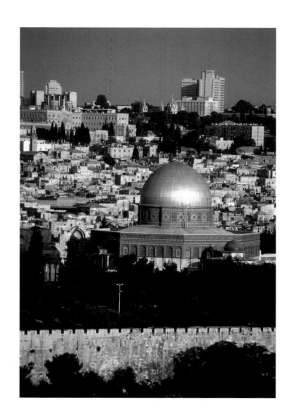

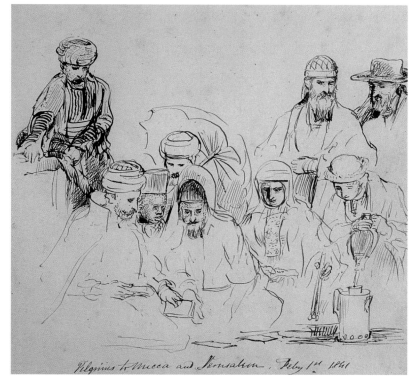

Pilgrims to Mecca and Jerusalem, Feby 1st 1841

No doubt the most important alternative sacred sites in Islam are affiliated with Shi'ism, a movement that is associated with the early formative years. Shi'ites reject the authority of the first three caliphs recognised by Sunni Muslims; instead they believe that religious authority passed through Ali ibn Abi Talib, husband of the Prophet's daughter Fatima. Secret knowledge is supposed to have been passed to the male line of his descendants, with a number of Imams chosen by God. The total number of Imams varies, depending on the interpretations in different Shi'ite traditions. All Imams are revered as martyrs, and their graves became places of annual pilgrimage; Najaf, Kerbala, and Samarra in Iraq and Mashad in Iran are among the most important. Najaf is the site of the tomb of Ali ibn Abi Talib (also known as Imam Ali), who the Shi'a consider to be their founder and first Imam. His shrine therefore is one of the holiest places for Shi'ite Muslims. At the centre of the old city of Kerbala is the tomb of Husayn ibn Ali, the grandson of the Prophet Muhammad by his daughter Fatima and Ali ibn Abi Talib. Husayn's tomb is a place of pilgrimage for many Shi'a Muslims, especially on the anniversary of the battle in 680 AD at which he was killed. (Figs. 14 & 15) Elderly pilgrims travel there to await death, as they believe the tomb to be one of the gates to paradise. Another focal point of the Shi'a pilgrimage to Kerbala is al-Makhayam, traditionally believed to be the location of Husayn's camp, where his martyrdom and that of his followers is publicly commemorated. From earliest Islamic times pilgrimage guides were compiled to inform would-be pilgrims. (Fig. 16)

The *ziyara* (lesser pilgrimage) is also of importance in Sufism, another form of worship found in both Sunni and Shi'a Islam. It emphasises a mystic religious experience; great Sufi leaders often become saints after their death, and their tombs are venerated. One Sufi order of importance in India and Pakistan is the Chishti Order, founded in the 10th century AD by the Syrian Khwaja Abu

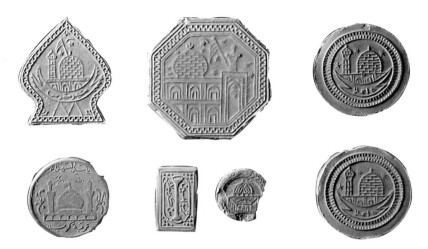

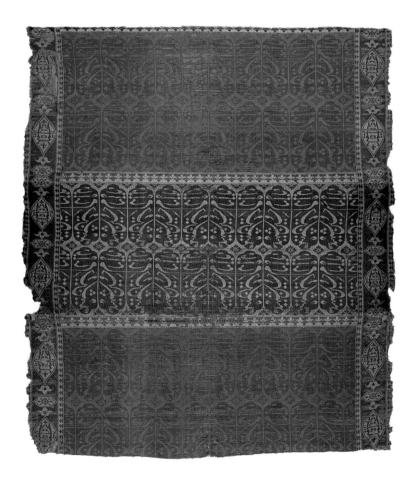

Fig. 14 (Left above)
Six pilgrim's tokens
Iraq, 20th century. Clay from
the shrine at Kerbala.
Ashmolean Museum, Oxford,
EA 2002.25–30.

Fig. 15 (Left below)
Cenotaph cover
Iran, 1710–11 AD. Silk lam-
pas weave. Ashmolean
Museum, Oxford, EA 2004.4.

The cover comes from the
tomb of a Shi'ite martyr;
the woven inscription
reads "Oh Imam Husayn,
the Martyr!", a reference
to Husayn ibn Ali, the
grandson of Prophet
Muhammad, who was
killed at the battle of
Kerbala in 680 AD.

Fig. 16
**Pilgrim's manual
of holy places**
India, 18th century.
Watercolour on paper.
Bodleian Library, Oxford,
MS Pers. d. 29, fol. 8v.

This page shows the
Garden of Zam Zam at
Mecca, with the foot
imprint of Ismael, the son
of Abraham. The manual
has illustrations of impor-
tant Shi'ite shrines, such
as the tombs of Hasan
and Husayn, the tomb
of Fatima at Medina,
and the coffin of Ali.

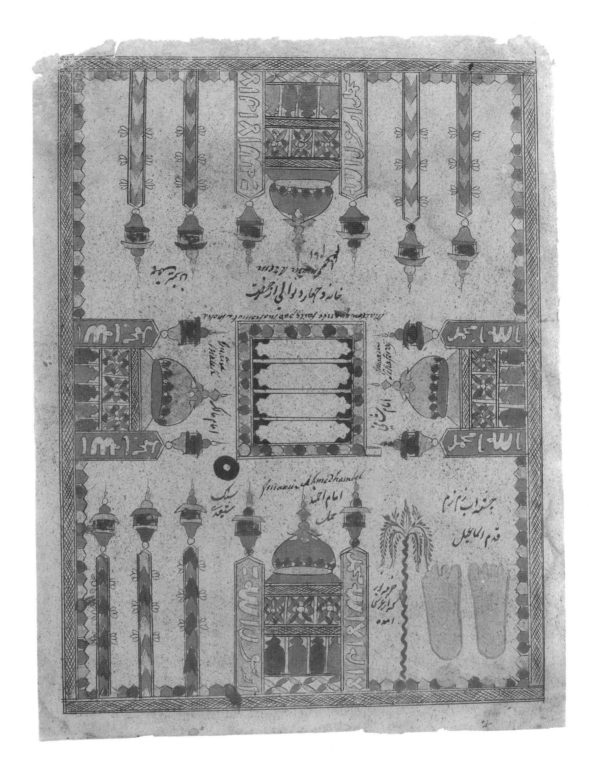

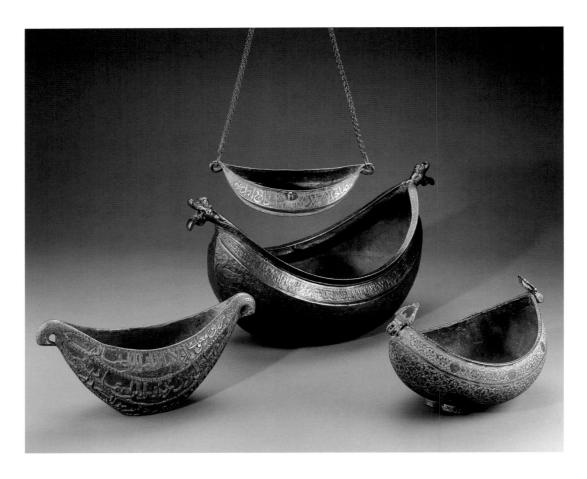

Fig. 17
Four begging bowls (*kashgul*)
(from top clockwise) (a) Iran, 17th–18th century, (b) Iran, 15th century, (c) India or Iran, 18th–19th century, all tinned copper; (d) ?Southern Arabia, early 19th century. Wood. Ashmolean Museum, Oxford, EA 1959.10, 1959.12, EA 1992.31, EA 1978.153.

Kashgul are associated with wandering Sufis who depend on the generosity of others for their living. They may be boat-shaped, as these four examples, but often also take the form of double coconuts.

Ishaq Shami. He brought Sufism to the town of Chisht, east of Herat in present-day Afghanistan, and subsequently the so-called Chishtiyya flourished as a regional mystical order, specialising in ritual music and Islamic prayer combined with sacred dancing. It is the source of Qawwali devotional music, popular in India and particularly in Pakistan. The most famous of the Chishti saints is Mu'in al-Din Chishti whose shrine is in Ajmer, Rajasthan (India). (Fig. 56, p. 60)

Sufism is not always condoned by the legalistic establishment of conventional Islam, and Sufi beliefs may set them outside the accepted norm of Islam. They are ascetics who try to come closer to God through spiritual contemplation, rather than through set rules of religious behaviour. They may even object to the pilgrimage to Mecca, as a detraction from the true revelation of God through an 'inner pilgrimage'. (Figs. 17 & 18)

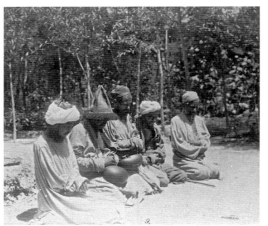

Fig. 18
A group of Sufi dervishes
late 19th century, Central Asia. Photographer unknown. Rau Collection, London.

This particular concern, of how appropriate it actually is to seek the presence of God in sacred spaces, rather than in oneself, finds resonance in attitude to pilgrimage in the third religion to be considered, in Christianity.

Christian Pilgrimage:

The Holy Land and Beyond

Unlike in Judaism and Islam, pilgrimage is not, and never was, an injunction in Christianity, and throughout its history there were influential people in the Church who opposed the practice. In the first three centuries after Christ's death it was in fact difficult to undertake pilgrimage to any site associated with the formation of Christianity, at least in an overt manner, as the religion remained suppressed and its adherents were persecuted. It was only with the Edict of Milan in 313 AD, proclaimed jointly by Emperors Constantine and Licinius, that the Christian religion became legalised and church property was reinstated in the Roman Empire. But although this made it possible for Christians to worship openly, it still was not a state-condoned religion, but remained one among several, including Judaism and the pagan beliefs of Greece and Rome. Its rise to the major Mediterranean religion (prior to Islam) began after 324 AD, when Constantine, Emperor over the western half of the Roman Empire, defeated his brother-in-law Licinius, who until then had ruled the eastern part. His victory put into power a Christian ruler over the entire Roman Empire. To create unity and theological clarity in a church riddled with doctrinal disputes, he summoned the Council of Nicaea in 325 AD.

The council was to resolve disagreements in the church of Alexandria over the nature of Divinity, and in particular whether the second aspect of the Trinity (the Son) was like or unlike the first (the Father). The council agreed to adopt the former definition. Another result of the council was an agreement by all the Churches to celebrate Easter on the same day. As by far the most important feast in the annual calendar, it was thought important for all to celebrate the Resurrection together, on a day that no longer followed the Jewish Year. The council

aimed to unify the Church and provide a clear guideline over disputed matters on what it meant to be a practising Christian. Constantine's convoking and presiding over it also signalled a degree of imperial control over the church.

Some matters discussed, such as the use of images in worship and the role of pilgrimage, remained disputed issues for centuries to come. Regardless of divided doctrinal positions, though, pilgrimage to Palestine – the Holy Land – became an important preoccupation almost immediately. It received Imperial support from the beginning. Constantine's mother, the Empress Helena, travelled to Jerusalem and other sites in the Holy Land in 326–7 AD, and several 4th and 5th century sources claimed that she found the site and remains of the True Cross, as well as the nails used in the crucifixion. The nails were sent back to Constantinople, but the True Cross became one of the relics venerated in the Basilica of the Holy Sepulchre, the building of which was inaugurated by Helena along with a basilica at the site of the Nativity in Bethlehem.[5] Both churches were built with imperial funds. (Fig. 19)

During the 4th century Palestine became the Christian Holy Land, with the sacred topography imprinted in the pilgrims' minds over the landscape as it then was. This brought about apocryphal stories and occasionally the fictional merging of sites: Mount Sion, for example, the site of the Pentecost, by the 5th century had also become the location where the Last Supper and, therefore, the first celebration of the Eucharist occurred. The historical landscape was reinterpreted in terms of the convenient or – to the pilgrims' guides – logical special relationships of events. We also hear of a merging of Old and New Testament events, in order to link them by a shared geography. The Holy Sepulchre with the tomb of Christ thus became identified as the site of the creation of Adam, as well as the location of Abraham's sacrifice of Isaac. Both had previously been associated in Judaism with Solomon's temple.

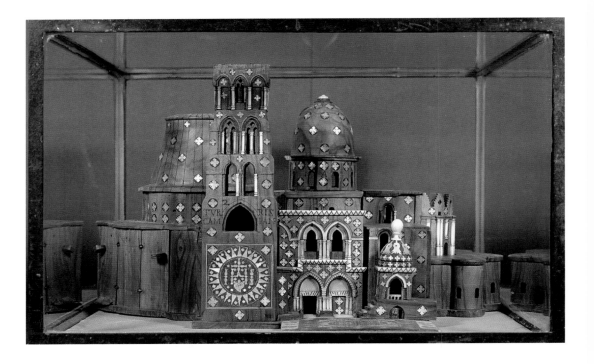

Fig. 19
**Model of the Church
of the Holy Sepulchre**
Palestine, 17th century.
Olive wood, ivory and
mother-of-pearl inlay.
Bodleian Library, Oxford,
Library Object 605.

The spectacular model of the Holy Sepulchre at Jerusalem was brought back from Palestine by a pilgrim. The model gives quite an accurate view of the church, and different parts of it are numbered to help identify the various altars and shrines in the building. It comes apart for easier transport. Many pilgrims' models of churches in the Holy Land survive, but usually these are much smaller.

Visiting the locations affiliated with scenes from the Old and New Testament was one reason to travel to the Holy Land. Another was increasingly to meet Christian holy men who had made it their home, as priests serving the sites and their houses of worship, or as hermits who might eventually be canonised. One of these was St. Simeon Stylites (c. 388–459), who lived for many years on a small platform atop a pillar. (Fig. 20) He received visitors who could climb a ladder to his platform, and he did not shy away from contact. He wrote letters, some of which survive, counselled Emperor Theodosius and the Empress Eudocia, and instructed disciples. He also delivered addresses to those assembled beneath, who included pilgrims from as far away as Gaul and Arabia. After spending 36 years on his pillar, Simeon died on 2 September 459. He inspired many imitators, and for the next century ascetics living on pillars were a common sight throughout the Byzantine Levant. After his death one of the largest churches built in the eastern Mediterranean prior to the 6th century was erected on the site of his pillar and became a major pilgrimage destination.

Many of those who engaged in pilgrimage wrote an account of their travels. The earliest to suvive was written in 333 AD and is known as the *Journal of the Bordeaux Pilgrim.*[6] This man spent one year on the journey, with three months devoted to Palestine. It shows that to go on a pilgrimage required courage and the ability to put up with hardship; it certainly was a dangerous undertaking, and along the way the pilgrims were always dependent on the benevolence of their fellow men and on the hospitality of monasteries and hostels. Another courageous pilgrim was a nun from Spain or France, Egeria, who wrote about her experiences in the Holy Land in the 380s.[7] She put down her observations in a book called *Itinerarium Egeriae*, in which she described many holy places and geographical points in her travels and included details of the liturgical practices of the church at Jerusalem.

Fig. 20
**St Simeon Stylites
(the Younger)**
Syria 10th–11th century.
Lead. Ashmolean Museum,
Oxford, AN 1980.46.

The medallion replicates earlier pilgrim's tokens from the shrine of the first Simeon Stylites, although it is 500 years later. The saint is flanked by angels above, St Konon and St Martha below. The Greek inscription says 'Blessings of our saint and holy father Symeon of the Wondrous Mountain.'

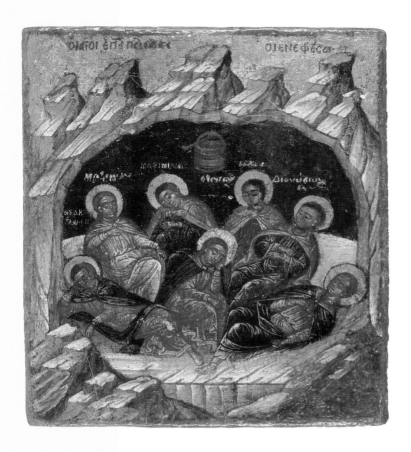

Fig. 21
**The Seven Sleepers
of Ephesus**
Crete, 15th century.
Oil on wood panel.
Ashmolean Museum,
Oxford, AN1988.23.

The subject refers to a
legend of seven Christian
youths seeking refuge in
a cave from the persecu-
tion of the Emperor
Decius in c. 200, where
they fell asleep and were
miraculously awakened
over two hundred years
later at the time of the
Council of Ephesus (431).

Pilgrims' accounts could become an aid to contemplation for those who were not able to make the journey; the writer facilitated others to share in the experience of pilgrimage. Egeria's description became an evocation of the Holy Land for others who never reached it; she was pronounced a Saint by the 7th century. Others, such as the English pilgrim William Wey, who more than a millennium later than Egeria travelled twice to the Holy Land and once to Santiago de Compostela, did not just give a pious description of the sites, but also included practical hints for the pilgrim.

In 638 AD the Caliph Umar ibn al-Khattab conquered Jerusalem; eighty years later the Arab empire stretched from Iran and Pakistan in the East to North Africa and Spain in the West. It dominated the entire southern littoral of the Mediterranean. For the Christians of Europe and Byzantium, the world of the Late Roman Empire had changed for good. As a result, after the 7th century pilgrimage to the Holy Land became the exception. However, local Christian communities continued to exist under Islamic rule, and although they were subject to special taxes and restrictions similar to the Jewish communities, there was no interference with their worship practices. Monasteries and churches could continue to function, and while Eastern Christianity in Constantinople was torn apart by the iconoclast controversy for most of the 8th and 9th century, the communities under Arab rule were not affected. The few icons that survived iconoclasm had been kept safely in monasteries in Islamic Palestine.

The desire to travel to a sacred location for spiritual reasons, but also to seek redemption from sin, did not lose its appeal to Christians in East and West. As the pilgrimage sites in the Holy Land became less accessible, different solutions were found to achieve this goal. Local shrines developed, often at sites that had already been sacred in pre-Christian times. Reliquaries that had been transferred from the Holy Land at an earlier time, as well as the tombs of saints became destinations of pilgrimage. In the Eastern Christian church Constantinople had received relics and icons from visitors to the Holy Land, and once the iconoclast conflict had been solved by the end of the 9th century, the Church accepted images as a means of gaining access to the Divine. (Fig. 21) Thereafter the relics and icons and the great churches of the city became the new focus for pilgrimage in the Eastern Church. One of the most powerful icons was the Virgin Hodegetria, which was believed to have been painted by St Luke; on certain occasions the image was carried in procession around the city and could apparently perform miracles, protect the vulnerable, and heal the sick. (Fig. 22)

In 1204 Constantinople was sacked by the knights of the Fourth Crusade, and many of the sacred relics were pilfered to be sent to

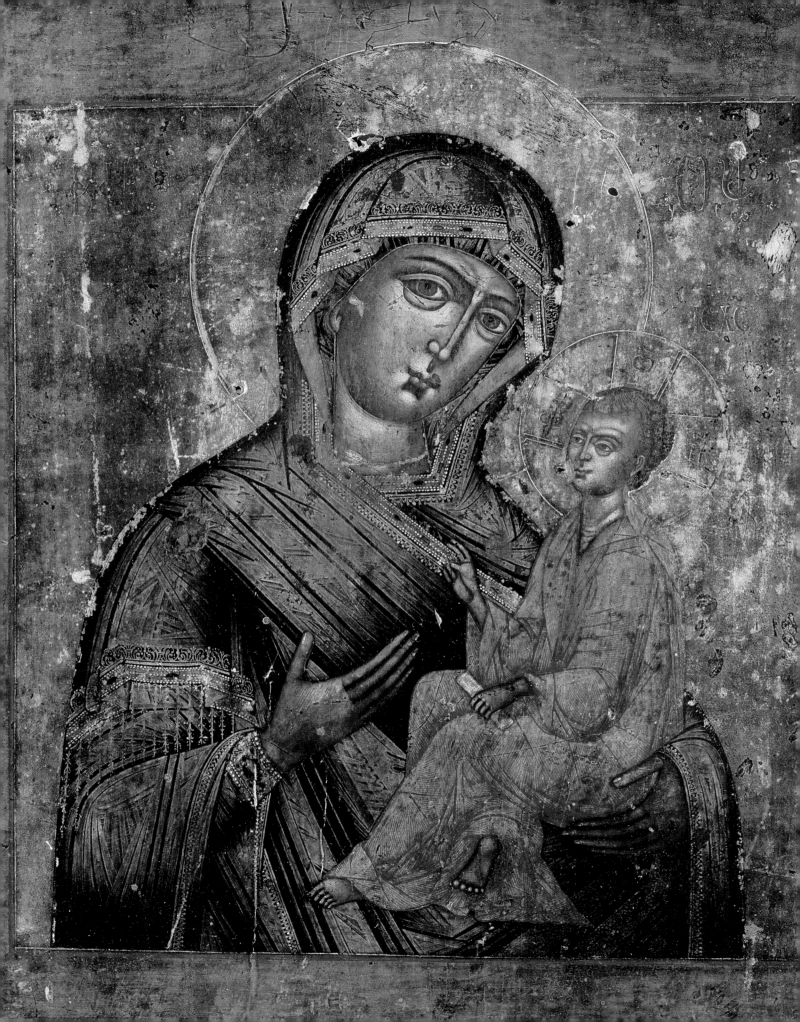

Fig. 22 (Left)
The Virgin Hodegetria, Russia

?19th century. Oil on wood panel. Ashmolean Museum, Oxford, AN1915.190.

This is a copy of one of the most famous icons, supposedly painted by St Luke and brought from the Holy Land to Constantinople by the Empress Eudocia in the 5th century.

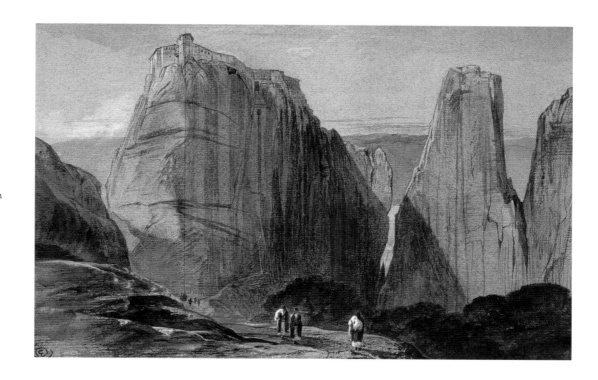

Fig. 23 (Above right)
Monasteries of Meteora, Greece

Edward Lear. ?1849. Watercolour. Ashmolean Museum, Oxford, WA 1916.51.

Fig. 24 (Right)
The Monastry of Zagrafu, Mount Athos, Greece

Edward Lear. ?1849. Watercolour. Ashmolean Museum, Oxford, WA 1916.63

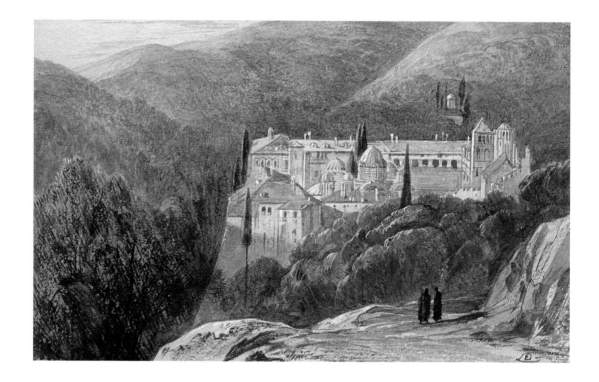

western Europe. The final fall of Christianity's greatest city came in 1453 with the Ottoman conquest. Hagia Sophia, the church built by Justinian in the 6th century and for centuries the focus of Eastern Christian pilgrimage, became a place of Islamic worship. The Orthodox church could only turn to the tombs of saints in remote Greek settlements, such as Mount Athos or Meteora, and to local shrines in Serbia and Russia to accommodate the needs for pilgrimage. (Figs. 23 & 24)

Rome was a pre-eminent goal for pilgrims in the western Mediterranean, as it had the tombs of both St Peter and St Paul, fragments of the True Cross, and was the seat of the Pope, head of the Catholic Church, the successor of Peter. Another principle site for pilgrimage was Santiago de Compostela, located in a remote and fairly inaccessible location in north-western Spain. Its sanctity is based on the belief that the remains of St James, one of the apostles and a relative of Christ, had been found in Spain in the 9th century. According to a tradition that can only be traced as far back as the 12th century, the relics were said to have been discovered in 835 by Theodomir, bishop of Iria Flavia in the north-west of the principality of Asturias. There was apparently a belief as early as 400 AD that St James had travelled to the Iberian Peninsula and had preached there. (See map, p.42)

It is uncertain why this particular shrine became such a magnet for European pilgrims. Whatever the true origins of the remains were, a church was built, and the bones were placed behind the reliquary statue, to be kissed by the pilgrim when he or she had come to the end of the journey. The earliest pilgrims from beyond the Pyrenees were recorded to have visited the shrine in the middle of the 10th century (Fig. 25). By the 11th century pilgrims from abroad were regularly journeying to Santiago in large numbers, including the first recorded pilgrims from England between 1092 and 1105. By the early 12th century the pilgrimage had become a highly organized affair.

Four established pilgrimage routes from starting points in France converged in the Basque country of the western Pyrenees. From there a single combined track crossed northern Spain, linking Burgos, Carrión, Sahagún, León, Astorga and Lugo. The needs of the pilgrim trade were met by a series of hospices along the way, by the evolution of a new style of ecclesiastical architecture, the Romanesque building, which could cope

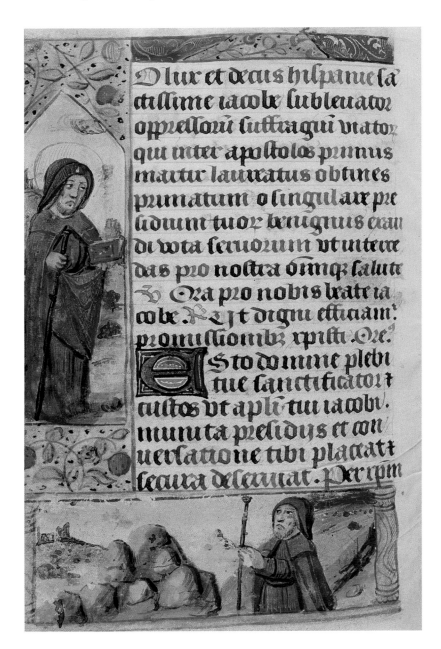

The prayer on this page is to St. James, who was martyred in 44 AD in Jerusalem, but whose body was believed to be miraculously transferred to Spain. His shrine at Compostela was a major pilgrims' destination in the Middle Ages, and it is still visited today. Here we see him as a pilgrim himself in the left margin, with a staff and wearing a cloak and traveller's hat, possibly with a shell badge attached. The shell was originally associated with St. James, but became a general sign of pilgrimage. A small figure of a pilgrim walking through a rocky landscape is at the bottom of the page; he stretches out his hands to the Saint. The prayer opens with an appeal to St James, "Light and splendour of Spain, buttress of the prayers of pilgrims".

The two pages open the prayers to the Virgin. On the left is a miniature of the Annunciation; a pilgrim's badge from the shrine to the Virgin at Hal, in Flanders, is sewn to the top corner of the right page. It was not uncommon to fix badges from shrines visited to prayer books, to be cherished as secondary relics and reminders of past pilgrimage.

with large devout crowds, and by the familiar paraphernalia of tourism, selling badges and souvenirs, and even a guide-book put together by about 1140. The pilgrimage route to Santiago de Compostela became an international road, and many of the places along the way became destinations in their own right, albeit of a lesser significance. (Fig. 26)

Two major shrines were founded in England. The older one was at Walsingham in Norfolk, where Richeldis, a Saxon noblewoman, in 1061 had a vision of the Virgin who instructed her to build a local replica of the house of the Holy Family in Nazareth, where the Annunciation had occurred. Walsingham, known as the 'English Nazareth', became one of Northern Europe's great places of medieval pilgrimage. (Fig. 27) An Augustinian priory was established on the site in 1153. Several English kings visited the shrine, including Henry III, Edward I, Edward II and Edward III. The last to do so was Henry VIII, who was later

responsible for its destruction in 1538 during the Dissolution of the Monasteries. Since 1900 Anglican, Roman Catholic and Orthodox shrines to the Virgin have been re-established in Walsingham, and pilgrimages are held through the summer months.

The second shrine was the one to St Thomas Becket, a powerful political and ecclesiastical figure at the court of Henry II, who made him Archbishop of Canterbury in 1162. A bitter conflict over the judicial independence of the clergy and their direct responsibility to Rome arose between Henry and the archbishop, and as a result Becket was murdered on 29 December 1170 near the Lady Chapel in Canterbury Cathedral. His death was almost immediately seen as martyrdom for the Church, and he was canonised three years later. (Figs. 28 & 29) Henry eventually had to bow to the affirmation of spiritual power over temporal might, and went on a pilgrimage to Canterbury, approaching the shrine barefoot as a sign of humility.

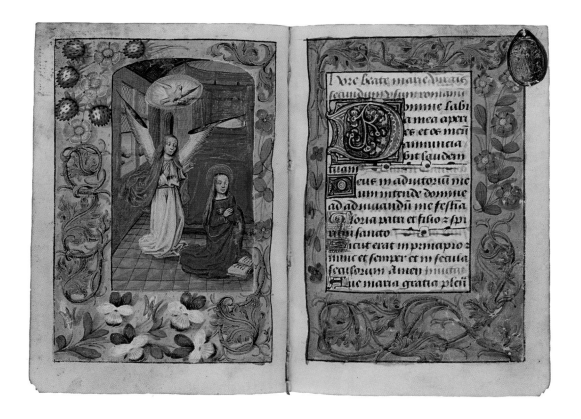

Fig. 27 (Far left)
Pilgrim's badges
England, possibly
Walsingham, 13th–14th
century. Lead alloy. Ashmolean
Museum, Oxford,
AN 1927.6409.

Fig. 28 (Left)
Two pilgrim's badges
Canterbury, 13th–14th century.
Lead alloy. Ashmolean
Museum, Oxford, AN 1986.2,
1988.397

The badges are both from
the tomb of St Thomas
Becket at Canterbury. One
shows the head of the saint
himself, the other is a
small replica of his tomb,
which was destroyed
during the Reformation.

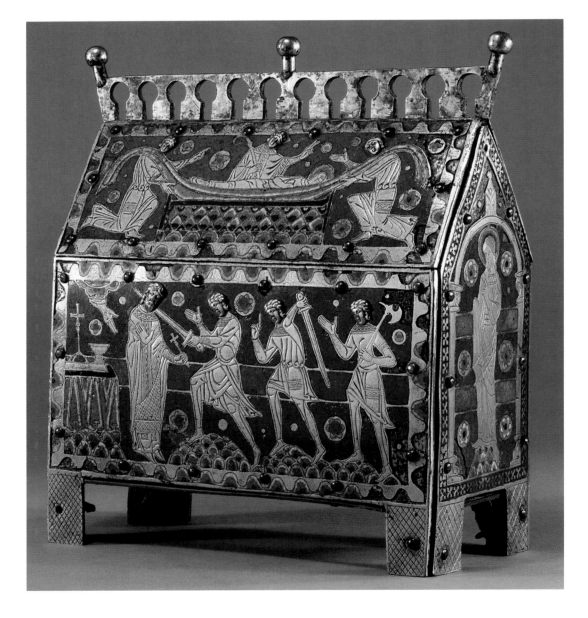

Fig. 29
**Reliquary casket of St
Thomas Becket**
Limoges, France, c. 1200.
Enamelled metal.
Ashmolean Museum, Oxford,
WA 1947.191.255

Fig. 30
Tale of Melibeus from Chaucer's *Canterbury Tales*
English manuscript, c. 1450–60. Vellum, illuminated. Bodleian Library, MS. Rawl. Poet 223, fol 183r.

The page shown has the Prologue to and the Tale of Melibeus, the latter told by the character of the poet (Chaucer) among the pilgrims. The standing figure in the illumination therefore may be an image of the poet, but probably is intended as a generic rather than specific and personal representation.

The Tale of Melibeus is one of the less well-known stories in the *Canterbury Tales*. It is a translation of the French story of *Livre de Melibé et de Dame Prudence*, a didactic allegory of the need for conciliation and forgiveness among enemies.

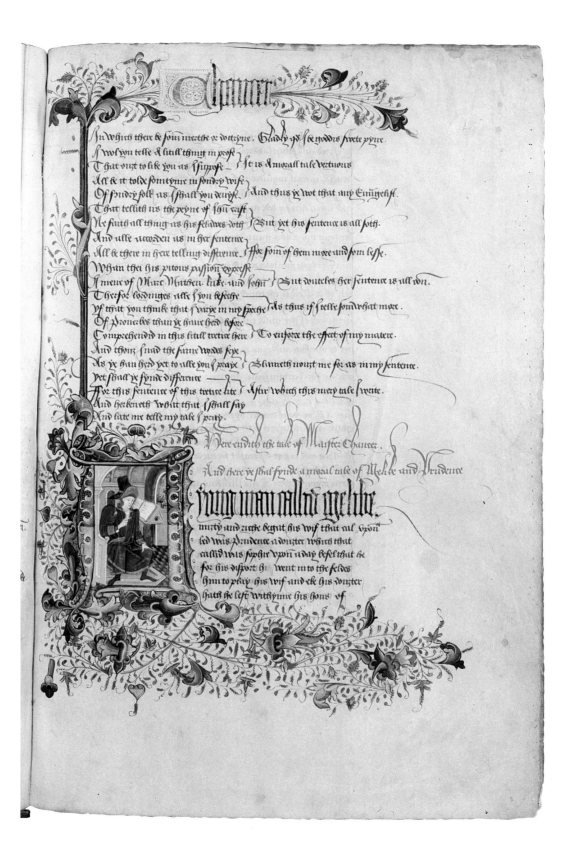

The annual pilgrims' journey to the shrine was immortalised in Chaucer's *Canterbury Tales*. (Fig. 30) The shrine at the tomb of St Thomas was also destroyed by Henry VIII.

There were many reasons for the popularity of pilgrimage in the Christian medieval world, several of them common to all pilgrimage traditions across faiths. Some were deep-felt religious ones, of course. To travel to places associated with sacred people or events meant that one established an emotional link that could transcend time, and bring one close to the venerated. The purifying aspect of pilgrimage was another reason: the notion of mankind as basically sinful and corrupt was prominent, and by engaging in acts of penance one could hope to find redemption from a real or perceived sin committed. The journey also was undertaken to bring well-being to the sick: by making a vow of pilgrimage to the shrine of a saint or the Virgin, one might hope, for example, to regain sight, movement, or mental health. (Figs. 31 & 32) If the cure was accomplished, the pilgrim often left behind *ex-votos*, wax or tin models of the body part healed. At the shrine itself, it is important to see and touch the objects of veneration, to release their power and transfer some of it to the faithful. An opening in the tomb or the reliquary box may be used to drop in a small piece of cloth to make contact with the remains, or the dust swept from the shrine may be drunk mixed in water. The spiritual power one participated in at the shrine could even be bottled and taken home, as water or oil, or one might buy a dish made from the sacred soil at the location. (Fig. 33) Back home it would continue to hold its power, and those who had not been able to take part in the journey could benefit from it. Relics might be worn to protect against illness and in battle. (Figs. 34 & 35)

Unlike in Islam, where the act of pilgrimage is focussed firmly on Mecca and other, lesser shrines and the journey is just a necessary step to get to the goal, in Christianity the journey became an important part of the undertaking. While this can be understood in spiritual terms, the opportunity to travel and see the world was certainly an important aspect. This enjoyable side of the undertaking, which was not without its frivolity, was already noticed and criticised at an early time. Gregory of Nyssa, an important early Christian 4th century writer on mystical and ascetic themes, strongly attacked the practice of pilgrimage to Palestine. He claimed it inflicted moral mischief, with the journey's many temptations; in his opinion a change of place did not bring one closer to God. What mattered was the heart, not the place the worshipper visited: God could not be confined to Palestine. St Augustine had a similar view when he announced that God did not only dwell in one place, but was everywhere. Throughout Christian tradition, this criticism came up again and again. It was a major concern of the iconoclast controversy in the Eastern church, and it was voiced strongly during the time of the Reformation in Western Europe.

Fig. 31
Pilgrim badges associated with John Schorne
Buckinghamshire, England, 15th century. Lead alloy. Ashmolean Museum, Oxford, AN 1997.3, .6, .11, .13–15.

Fig. 32
Clay mould for producing pilgrim badges at the shrine of John Schorne
North Marston, Buckinghamshire, England, 15th century.
Ashmolean Museum, Oxford, AN 1997.20.

John Schorne was revered throughout England between the 14th and 16th century, although he was never canonized. Little is known of his origin, but he may have come from the village of Shorn near Rochester, Kent. He is documented as rector of St. Mary the Virgin at North Marston in Buckinghamshire between 1290 and 1314, the year of his death. He performed his first miracle when he struck the ground near his church during a devastating drought, and a spring came forth. A well was built at the site which was attributed with healing properties: it was believed to cure ague (malaria), toothache, blindness, melancholy, and especially gout. The well was restored in 1970 and flows to this day.

His image shows him holding a long boot, which refers to an event when Schorne was said to have summoned the Devil and conjured him into a boot: hence a small winged demon usually peeps out of the boot top. It was believed that John Schorne could 'subjugate the evil powers that plagued the bodies of the sick', and to control ultimate evil.

After his death in 1314 North Marston became one of England's principle centres for pilgrimage, along with Canterbury and Walsingham. In 1478 Henry VI petitioned Pope Sixtus V to have Schorne's remains moved to a new chapel at Windsor; this was dismantled a century later.

The removal of Schorne's body marked the end of North Marston's importance as a pilgrimage shrine, and the community lost considerable income (at least £500 annually).[8]

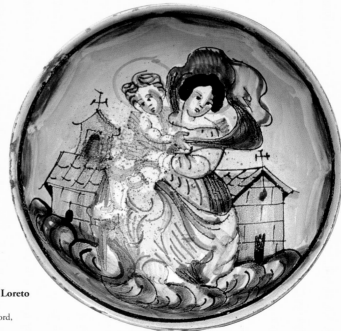

Fig. 33
Devotional bowl with the Madonna of Loreto
Italy, probably Loreto, 18th century.
Glazed earthenware. Ashmolean Museum, Oxford,
WA 1888.CDEF.C464.

At the time certain excesses had become prominent in the Catholic church, the most reviled being the sale of 'indulgences', paper slips that guaranteed the pilgrim forgiveness of his sins, salvation in the afterlife and a 'fast lane to heaven', in return for a money payment. Professional indulgence dealers misused the purpose of pilgrimage and outraged critics and reformers of the church. The hypocrisy of indulgences and the perceived idolatry involved in worshipping images caused a Protestant revulsion against the practice which found their expression in the violent destruction of the shrines at Canterbury and Walsingham.

But while the abolition of pilgrimage fostered by the European Reformation had a profound effect, it did not bring an end to the practice. Catholics continued to visit shrines in Italy, France, Germany, and Spain, and with the expansion of European power to Asia and the New World new destinations for Christian pilgrimage were created. Nowadays, the shrine to the Virgin of Guadalupe in Mexico and the tomb of St Francis Xavier in Goa are centres for local and national religious attention. (Fig. 57, p.61) One of the most popular contemporary Christian pilgrimages is to Lourdes in southern France, where the Virgin appeared to a 14-year old girl in 1858 and revealed to her a spring with healing powers.

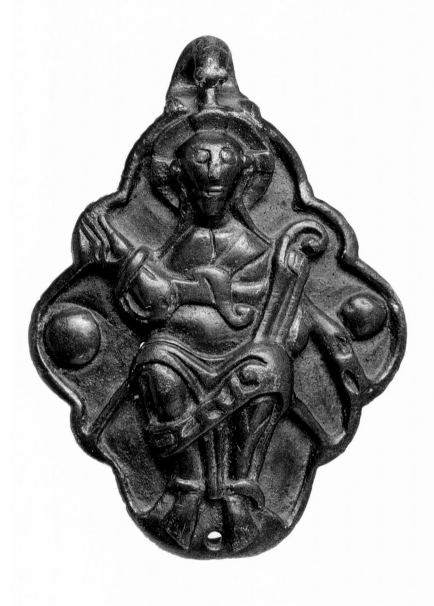

Fig. 34
The Sandford Reliquary
England, late 11th century. Gilded copper alloy. Ashmolean Museum, Oxford, AN 1891.10

The reliquary cover shows Christ in Majesty seated on a rainbow, framed in a mandorla. It was intended to be suspended from a chain, as at the top is a loop in the form of an animal body that peers over the top. The reliquary must once have had a backing which is now lost, to hold its sacred contents.

A Latin inscription around the side of the frame gives away the object's function: *Intus quod latet cuncto nos crimine laxet* "May what is hidden within, release us from sin", which suggests that it once held a relic and may have been worn as a protective amulet. Although such amulets may have been common in the Late Anglo-Saxon period, this is the sole metal example to survive. The lack of comparable material make it difficult to place the reliquary stylistically, but there can be little doubt that it is Anglo-Saxon. It is probably an English work of the late 11th century, and represents an important link between Anglo-Saxon and Romanesque art.

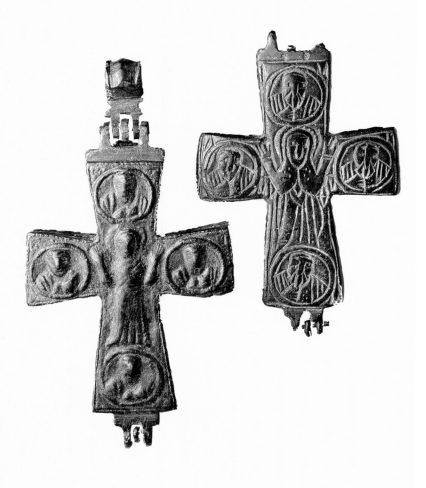

1 See Simon Coleman and John Elsner, *Pilgrimage. Past and Present in the World Religions*. Cambridge, Massachusetts: Harvard University Press (1995): 43.

2 See chapter 4. The account is published in both M.N. Adler, *The Itinerary of Benjamin of Tudela. Critical Text, Translation and Commentary*. New York: Philipp Feldheim (1907) and Manuel Komroff (ed.), *Contemporaries of Marco Polo, consisting of the travel records to the eastern parts of the world of William of Rubruck (1253–1255); the journey of John of Pian de Carpini (1245–1247); the journal of Friar Odoric (1318–1330) & the oriental travels of Rabbi Benjamin of Tudela*. New York: Boni & Liveright (1928).

3 The most extensive evidence for these contacts is found in the Genizah documents analysed by S.D. Goitein, published in the five volumes of *A Mediterranean Society. The Jewish Communities of the Arab World as Portrayed in the Documents of the Cairo Geniza*, Berkeley and Los Angeles: University of California Press (1967, 1971, 1978, 1983, 1988).

4 See Gerald Hawting, 'Pilgrimage.' in Jane Dammen McAuliffe (ed.), *Encyclopaedia of the Qur'an*. Vol. IV: 91–99. Leiden: E.J. Brill (2004): 92.

5 See Martin Biddle, *The Tomb of Christ*. Thrupp, Stroud: Sutton Publishing (1999) for the history of construction.

6 John Wilkinson, *Egeria's Travels to the Holy Land*. Warminster: Aris and Phillips (1981): 153–63; E. D. Hunt, *Holy Land Pilgrimage in the Later Roman Empire*. Oxford: Clarendon Press (1982): 171–74.

7 Wilkinson, *Egeria's Travels*.

8 Susan John, "The Blessed John Shorne. Pilgrim badges from medieval Buckinghamshire." *The Ashmolean* 34 (1988): 8–9

Fig. 35
Two reliquary crosses
Eastern Mediterranean, 10th century. Bronze. Ashmolean Museum, Oxford, AN 1980.8 and AN 2000.34

Hinged reliquary crosses made of bronze were very common from the 10th and 11th century. The decoration usually illustrates the Crucifixion with the Virgin and St John. On the reverse stands the Virgin with her hands raised in prayer. Busts of the Four Evangelists are seen on the arms of the crosses.

Next two pages: Maps showing major
Jewish, Islamic and Christian pilgrimage
sites in Western Europe and the Middle East

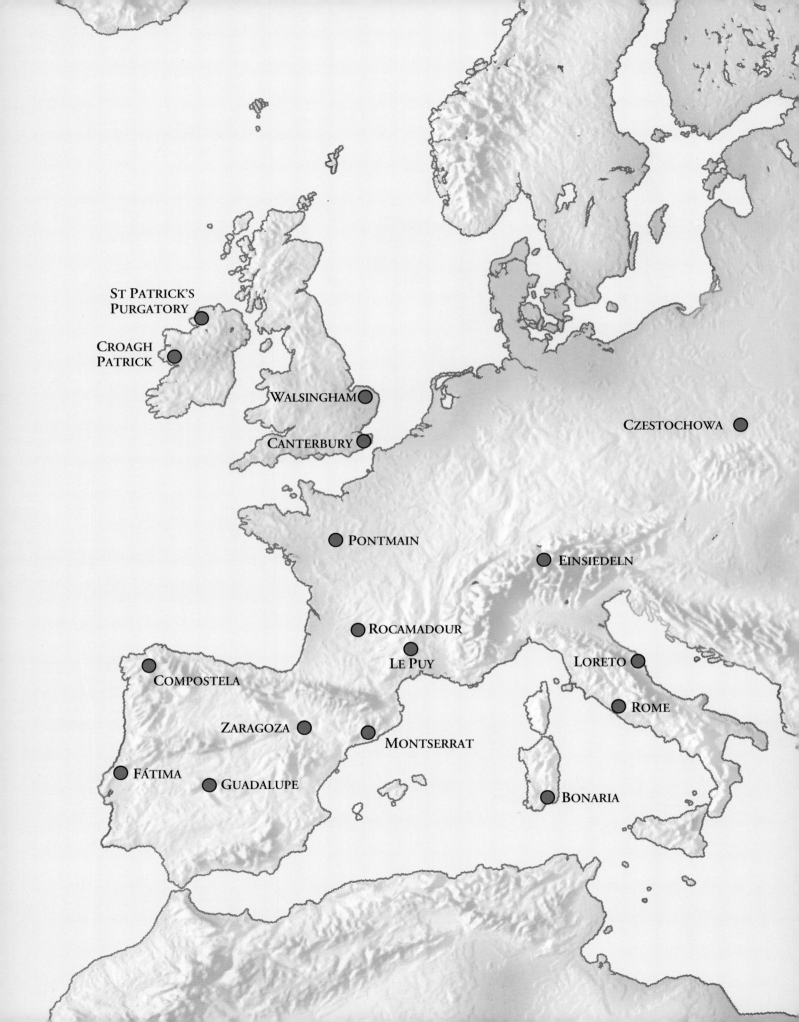

ST PATRICK'S
PURGATORY

CROAGH
PATRICK

WALSINGHAM

CANTERBURY

CZESTOCHOWA

PONTMAIN

EINSIEDELN

ROCAMADOUR

LE PUY

LORETO

COMPOSTELA

ROME

ZARAGOZA

MONTSERRAT

FÁTIMA

GUADALUPE

BONARIA

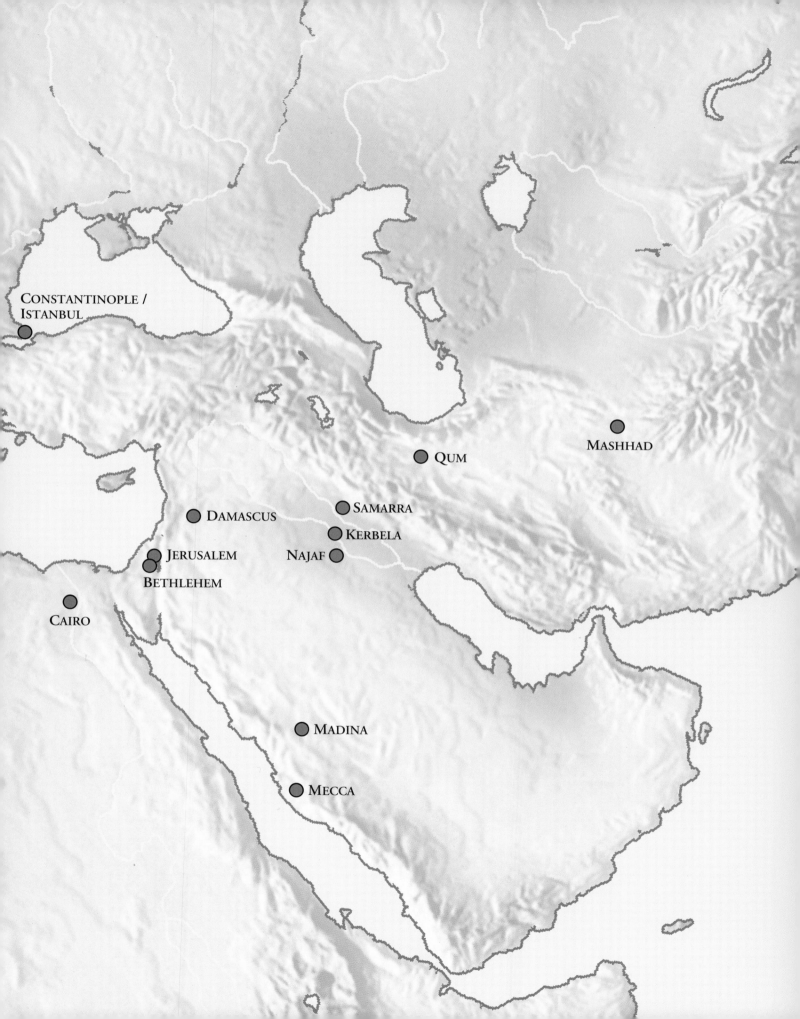

CONSTANTINOPLE /
ISTANBUL

MASHHAD

QUM

SAMARRA

DAMASCUS

KERBELA

NAJAF

JERUSALEM

BETHLEHEM

CAIRO

MADINA

MECCA

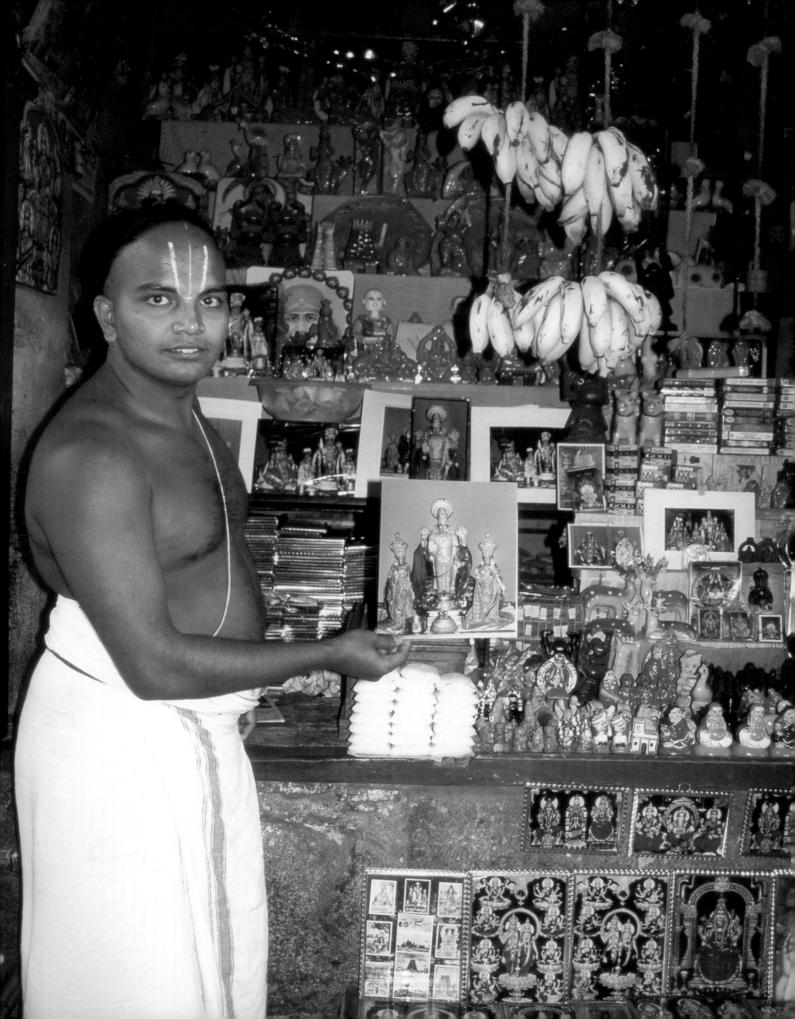

Pilgrimage in South Asia

CROSSING BOUNDARIES
OF SPACE AND FAITH

Crispin Branfoot

"Hari dwells in the East, they say,
 and Allah resides in the West,
Search for Him in your heart, in the heart
 of your heart:
There he dwells, Rahim-Ram!"[1]

Kabir, a 15th century north Indian mystic revered by Hindus, Muslims and Sikhs alike, was reacting against the popular South Asian practice of journeying to sites on earth where divine power is believed to be particularly accessible. Other religious figures have been critical of the practice of pilgrimage, but this only emphasises its importance to the faith communities of South Asia both in the past and especially today. Pilgrimage is a popular practice shared among the many religions of South Asia, both those that developed there – Hinduism, Buddhism, Jainism and Sikhism – and those that have emerged elsewhere and taken root on the subcontinent, especially Islam.

Religion in South Asia

The most important feature of South Asian religion, in the past as well as today, is a broad group of traditions now termed Hinduism. The varied religious beliefs and practices that are encompassed by this umbrella term stretch back over three thousand years, making Hinduism the oldest 'world religion'. But unlike other world religions, Hinduism has no founding figure, no single text that acts as a point of doctrinal reference, and no institutional hierarchy. The term itself is of relatively recent origin. A key feature of Hinduism over the past two millennia is the belief in the power of deities, gods and goddesses, on Earth. Whilst some consider the Divine to be transcendent, the majority of Hindus believe the power of deities to be more accessible, more approachable and efficacious at certain spots. (Figs. 37 & 38) It is these places that define the sacred geography of South Asia that Hindus journey to on pilgrimage. But the many Hindus of

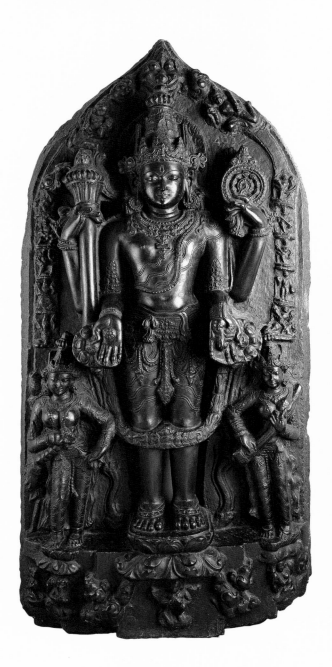

Fig. 37
Vishnu
Ceriticised slate. Sagar Island, West Bengal, Pala period, mid- 11th century.
Gift of Sir William Hedges (1686–87). Ashmolean Museum, Oxford. PRM AM 169.

The great deity is shown standing with his four hands holding the identifying mace, discus and conch in his hands; the fourth hand is in the gesture of beneficence. The highly polished black siltstone and the crisp detail of all the subsidiary figures identify it as dating to the Pala period in eastern India, a flourishing era for Buddhism and Hinduism in the region. It was acquired by Sir William Hedges in 1683 from an island at the mouth of the holy river Ganges; Hedges was Governor of Bengal for three years. It is notable for being one of the earliest recorded major Indian sculptures to have entered a Western museum.

Fig. 36 (On previous page)
Priest holding a photograph of Varadaraja and his two consorts in front of a stall with pilgrimage souvenirs.
Varadaraja (Vishnu) temple, Kanchipuram, south India. (Photo: Crispin Branfoot 2003)

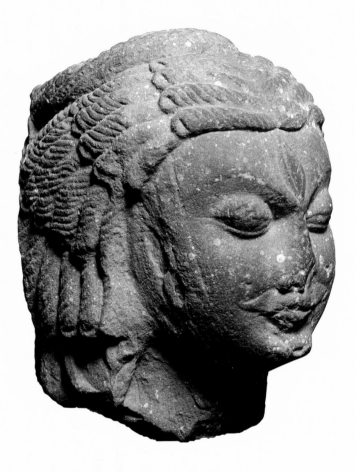

Fig. 38
Head of Shiva
Sandstone. Mathura, Gupta period, early 5th century. Ashmolean Museum, Oxford. EA OS 38.

With Vishnu, Shiva is one of the two greatest Hindu deities alongside the many other subordinate deities. He is commonly identified by his matted hair and the third eye in his forehead. This is among the earliest of Hindu sculptures of the deity, when the identifying iconographic features were being formalised. The head would have been joined to a full body or projected from a *mukha-linga*, the primordial symbol of Shiva, and housed in a temple.

modern India have lived and journeyed to the shared or contested sacred sites of the many other religions of South Asia.

The earliest history of Hinduism is focussed on a group of oral texts, the Vedas, that were composed by around 1200 BC. A range of deities are invoked in these texts, and ritual centres on the practice of an increasingly elaborate sacrifice by religious specialists or brahmins. In a period of developing urbanism and state formation from around 600 BC, many religious figures began to question this sacrificial emphasis of worship and pursued religious experience through renunciation from worldly pursuits. Some renouncers accepted the authority of the Vedas and pursued religious experience through meditation and yoga. From this era two new religions developed, Buddhism and Jainism, that would have continued importance in India and, in the case of Buddhism, across Asia. The founding figures of both religions, Siddhartha Gautama (c. 566–486 BC)[2] or the Buddha ('awakened one') (Fig. 39) and Vardhamana (c. 599–527 BC) or Mahavira ('great soul'), renounced society to find true religious knowledge or enlightenment. As each religion developed so additional Buddhas and saviour deities or *bodhisattvas* joined the historical Buddha; Mahavira came to be considered the final of twenty-four *tirthankaras* ('ford-makers') or Jinas ('conquerors'). (Fig. 40)

Both of these religions advocated austerity as the path to worldly liberation, developing monastic traditions. Buddhism attained great importance in South Asia, spreading across the subcontinent and further afield. Jainism has never achieved the same level of importance, but unlike Buddhism which largely died out in the land of its birth by c. 1200 AD, Jainism has maintained a presence in India to this today, especially in the western regions of Gujarat and Rajasthan, and in the South in Maharashtra and Karnataka.

Hinduism, Jainism and Buddhism developed alongside each other in South Asia over the 1st millennium AD, sharing many

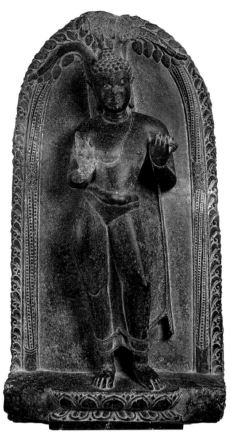

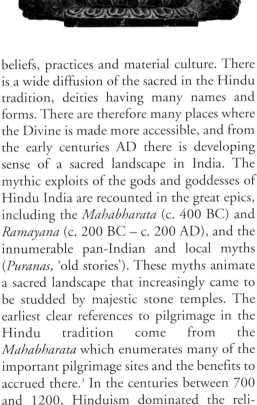

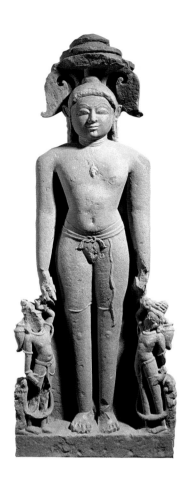

Fig. 39 (Far left)
The Buddha standing beneath the *bodhi* tree
Stone. Probably Bodhgaya, eastern India, 9th–10th century. Ashmolean Museum, Oxford. EA OS 56.

Images like this one were placed in the exterior niches and central shrines of brick temples in eastern India. The broken hand was in the 'have no fear' gesture (*abhayamudra*).

Fig. 40
Jain *tirthankara*
Sandstone, Madhya Pradesh, 11th century. Ashmolean Museum, Oxford. EA 1998.225.

Images of the *tirthankaras* are always depicted seated in a posture of meditation with hands in the lap, very similar to Buddha images, or standing with their arms held on each side. Often the only way of identifying one Jina from another is by the subsidiary symbols or images placed around the main image.

beliefs, practices and material culture. There is a wide diffusion of the sacred in the Hindu tradition, deities having many names and forms. There are therefore many places where the Divine is made more accessible, and from the early centuries AD there is developing sense of a sacred landscape in India. The mythic exploits of the gods and goddesses of Hindu India are recounted in the great epics, including the *Mahabharata* (c. 400 BC) and *Ramayana* (c. 200 BC – c. 200 AD), and the innumerable pan-Indian and local myths (*Puranas*, 'old stories'). These myths animate a sacred landscape that increasingly came to be studded by majestic stone temples. The earliest clear references to pilgrimage in the Hindu tradition come from the *Mahabharata* which enumerates many of the important pilgrimage sites and the benefits to accrued there.[3] In the centuries between 700 and 1200, Hinduism dominated the reli-

gious and political order of medieval India centred on the worship in temples of the pre-eminent gods Shiva and Vishnu.

Buddhism developed a pilgrimage tradition early, from the 3rd century BC at the latest. This was in part because of the monastic tradition of wandering from place to place across the year, and also because of the belief in the sacred presence of the Buddha that inhered in both his relics and places visited by him in his lifetime. Many of these places were marked by hemispherical brick or stone mounds or *stupas*. Jainism by contrast developed a pilgrimage tradition comparatively late, only from the 5th century AD.

Buddhism flourished across India until 1200, but in the period from around 700 on it was challenged by the rise of theistic Hinduism. In this later period from 700–1200, Buddhist culture in India was concentrated primarily in the eastern regions

Fig. 41

Buddha

Bronze. Cambodia, Khmer, 11th century. Ashmolean Museum, Oxford. EA 1999.48.

The face and headdress of this fine image are typical of the sculptures of Khmer Cambodia at the height of the Angkor civilisation between the 9th and early 15th centuries.

Fig. 42

Palmleaf manuscript with scenes from Buddha's life

Eastern India. Late 11th century. Bodleian Library, Oxford. Ms Sansk.a.7(R).

This is one of the earliest illustrated palm-leaf manuscripts from eastern India, perhaps from the great Buddhist monastic university at Nalanda in Bihar. The text is the *Prajnaparamita*, the 'Perfection of Wisdom'. Such manuscripts were often worshipped rather than read; a Buddhist goddess of the same name is a personification of this text. This palm-leaf depicts the eight great scenes from the Buddha's life-story alongside images of *bodhisattvas*.

of Bihar and Bengal under the Pala dynasty. This was also the period when Buddhism, and to some extent Hinduism, spread out from India across Asia. (Fig. 41) Buddhist missions arrived in Sri Lanka as early as the 3rd century BC, and subsequently spread along trade routes to the Himalayas,

Central, Southeast and East Asia - to Burma, Thailand, Cambodia, Indonesia, China, Korea and Japan. In all these areas Buddhist beliefs and practices interacted with those of the existing communities, whether established major religious traditions such as Confucianism and Daoism in China or more local, indigenous traditions such as those in Southeast Asia or in Tibet. Pilgrimage traditions were therefore both created in these new territories and resulted in pilgrims from Southeast Asia and China, for example, returning to the Buddhist homeland in India to seek texts or relics, and visit the sites associated with the birth of the faith. (Fig. 42)

The years around 1200 AD are crucial in the religious development of South Asia, for this period marked the arrival of Islam as a major cultural force and the decline of Buddhism within India. From its early 7th century foundation, Islam had rapidly spread out from Arabia and the pilgrimage hub of Mecca and Medina. Arabian merchants were present on the coasts of South Asia from as early as the 8th century, but from around 1200 Islamic rule over northern India was

established lasting for over five hundred years. Muslim mystics or sufis also arrived in India, and sharing some features of belief and practice with some forms of Hinduism found fertile ground for their message. The cult of saints has gained great following in South Asia, their tombs providing the focus for many regional pilgrimage cults and clearly establishing India as an Islamic land.

Though Hindu ruling elites were displaced from northern India, Hinduism continued to flourish in southern India and under Islamic rule. Of great importance was the rise of devotional movements that stressed the emotional 'participation' and love of God as a central value (*bhakti*), initially in southern India and subsequently across all of India. *Bhakti* poet-saints composed songs and poetry in regional vernaculars – including Tamil, Hindi, Bengali and Gujarati – using imagery from everyday life, and dwelling on their love and closeness to Shiva, Krishna, Kali or Rama. The emotional intimacy of *bhakti* stresses Hindu notions of God's accessibility: the concern is less with an omnipotent creator or ruler of the universe and more with God's immanence amongst us on Earth, not least in particular sacred sites that can be visited.

Out of the religious climate of northern India in the 15th and 16th century, with its interacting traditions of orthodox Islam, Hindu *bhakti* and Sufism, emerged a new religion. Sikhism was founded in the Panjab in northwest India by Guru Nanak (1469–1539), the first in a line of ten *gurus* or teachers, who developed a religious path that both rejected and syncretised elements of north Indian Hinduism and Islam.

The religious diversity of South Asia received a further boost from around 1500 with the arrival of Europeans as traders, missionaries and rulers. Portuguese Catholics were not the first Christians in India, however, for Syrian Christian and Jewish trading communities were present on the southwest coast from at least the 4th century AD. St Thomas is believed to have visited India in the 1st century, and many Christian pilgrimage sites in southern India are associated with St Thomas and major Syrian Christian figures. But the arrival of the Portuguese led to the conversion of South Asians to Catholicism in India and Sri Lanka, and later to Protestantism after the arrival of missionaries during British colonial dominance from the 18th century to 1947. India's own religious communities responded to British colonial rule, developing new traditions and rediscovering older ones.

The Hindu Swaminarayan movement in Gujarat developed from the early 19th century, at the tail-end of medieval devotionalism and the initiation of modern Hindu reform movements. The 19th century 'discovery' of Buddhism in India led to the revitalisation of the Buddhist pilgrimage sites in eastern India, that have subsequently drawn Buddhist pilgrims back to India from Tibet, Korea, Thailand and Japan – and indeed the West. With the spread of South Asian communities outside the region from the 1830s on – to Malaysia, South Africa, the Caribbean, Europe and North America - new sacred lands have been created. The importance of pilgrimage to South Asian religious traditions is emphasised by the development of new sacred landscapes overseas. These local pilgrimages develop alongside the sacred journeys made by Hindus, Sikhs and Jains living in the West back to South Asia, to specific sacred sites and to reconnect with the sacred landscape of India as a whole.

But what is the motivation of pilgrims? Where do they go and why? Many of the South Asian religious traditions declare the popular practice of pilgrimage to be unnecessary: God is everywhere and cannot be limited. Pilgrimage is a quest for the sacred, even without a specific goal. Pilgrimage to Mecca is an obligation on the part of all Muslims, but to many sufis the Ka'ba is in the heart: pilgrimage is an inner journey. Some Hindus would also argue that pilgrimage is unnecessary, for such pan-Indian centres as Kashi (Benares, Varanasi) in northern India lie within the individual. But even if a sufi or Hindu would argue that the journey to the Ka'ba or

Kashi is an internal one, they are still adopting a spatial understanding for pilgrimage. It is the physical journey as much as the spiritual one that is important to the majority of South Asian pilgrims, in the past and indeed today.

Before the advent of modern communications in the 19th century the main way of travelling on pilgrimage was by walking. Pilgrimage marks a break from normal life, but for many Jain or Buddhist monks, sufis or Hindu *sadhus* who have renounced society, walking constantly from place to place makes them perpetual pilgrims. Walking long distances is an essential part of many pilgrimages in South Asia, particularly when the destination is in a geographically remote area, such as Sabarimalai in the hills of southwest India or the sacred Mount Kailash in western Tibet. The advent of the railways in 19th century India made travel over long distances easier and this enabled many Indians to visit far-distant pilgrimage centres that they had previously only heard of. In more recent decades the video-bus pilgrimage tour is a common occurrence, taking villagers well beyond their usual environment to centres of pan-Indian ritual status. For Jains, Hindus and Sikhs living in the West air travel allows them to make pilgrimages to India, to reconnect not only with specific sacred sites, but also to India as the land and culture from which they are descended. Eastern India has similarly seen an influx of wealthy Buddhist pilgrims from Taiwan, Korea and Japan in recent decades, visiting the holy sites of Buddhism. Even if these pilgrimages are physically easier than walking all the way – or prostrating full-length for the most dedicated - pilgrims must still have the right attitude. Physical, mental and ritual purity on pilgrimage is often pursued through fasting, avoiding meat and alcohol, abstaining from sexual activity, sleeping on the ground and wearing clean clothes. Pilgrims going to Sabarimalai take a vow of austerity forty-five to sixty days prior to the start of the journey involving amongst a long list, no sex, no footwear, only two changes of black, blue or ochre garments, no meat or eggs, no intoxicants, no meals in other people's homes, three baths per day, visiting as many temples as possible, no abuse towards others and avoidance of female company; only men go on this pilgrimage.[4]

Mountains and Tirthas: the destinations of South Asian pilgrims

The idea of the landscape as inherently sacred is a key feature of the Hindu tradition. In Hindu and Buddhist cosmology a great mountain is understood to lie at the centre of the universe around which lands and oceans spread. The Himalayas are understood to be the location of this sacred centre, and many identify the centre of the universe as specifically Mount Kailash in western Tibet, a place of pilgrimage for Buddhists and Hindus alike. Rivers are also considered sacred places where the divine is more accessible: the river Ganges in northern India is the most sacred of all rivers and is believed to descend directly from heaven. The Ganges, like many other sacred rivers, is personified as a goddess, Ganga. (Fig. 43)

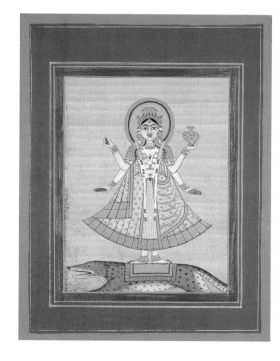

Fig. 43
Ganga
Painting on paper. Early 20th century. Ashmolean Museum, Oxford. EA X2011.

The goddess rides on an aquatic crocodile-like animal (*makara*).

Fig. 44 (Far left)

Ganesha

Gilded bronze. Orissa, 16th century. Ashmolean Museum, Oxford. EA 1980.64.

Ganesha is the Lord of Beginnings and Overcomer of Obstacles, and is worshipped at the start of a new enterprise or journey.

Fig. 45

Painted relief of Bharat Mata ('Mother India')

Ramnath temple, Quelem, Goa (Photo: Crispin Branfoot 2003)

Pilgrimage centres in Sanskrit and Hindi are called *tirthas*, literally a ford or crossing place; pilgrimage is a *tirthayatra*, a journey to a *tirtha*. Many Hindu pilgrimage places are sited by rivers or at points of transition, such as Haridwar where the Ganges leaves the mountains for the plains of northern India or Allahabad where the rivers Ganges and Yamuna converge with the mythical underground Saraswati river. But the notion of *tirtha* is also about the pilgrimage site as a place of transition, a crossing point, from problems in this world or liberation from the cycle of births and deaths. *Tirthas* are thresholds where one's desires are readily fulfilled, prayers are more quickly heard, and rituals are sure to be more effective. (Fig. 44)

India as a sacred land is a deep-rooted tradition and the nation is often considered to be the body or at least the residence of the divine, particularly in a female form. The mythical dismemberment and scattering of the goddess Sati defined the spread of sacred space and deified the whole of India as the goddess. A more recent phenomenon is the conception of India as the goddess Bharat Mata or Mother India. (Fig. 45) Whilst drawing on the Hindu worship of the goddess and western ideas of the nation state and patriotism, this is essentially an invented tradition from late 19th century Bengal, seen in Bankim Chandra Chatterjee's (1838–94) novel, *Anandmath*. The use of Bharat Mata as a nationalist image in late 20th century Indian politics has not resulted in a clear pilgrimage cult to this goddess, though temples have been built to her in Varanasi and Haridwar. But the broad conception of India as a sacred land is widespread.

There are many reasons to go on pilgrimage but the common feature is that it is efficacious. Pilgrims may visit a site in order to acquire the merit to gain a better life, whether in this or the next. Their desires may be more specific, be it help with an approaching exam or the desire for children. Pilgrims may want to be healed by a deity. They may undertake a pilgrimage to a shrine in fulfilment of a specific vow, having been helped by a deity. The Mughal

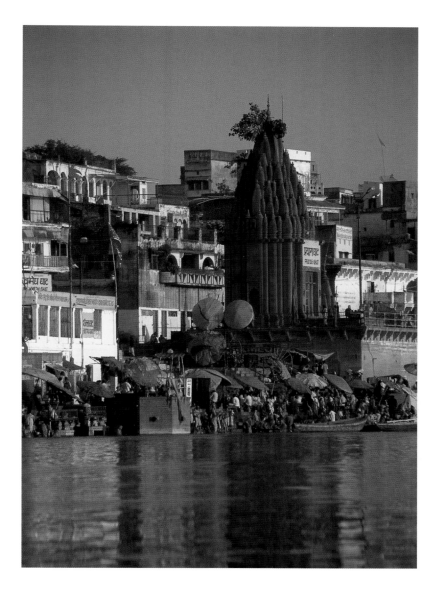

Fig. 46

Pilgrims bathing in the river Ganges at Varanasi (Kashi)

(Photo: Crispin Branfoot 1996)

period in a heavenly abode or ultimate liberation. Kashi or Varanasi is one of the most important pilgrimage sites for Hindus in all of India. To die in the sacred city is to be assured of liberation. If this is not possible then having your cremated remains deposited in the river Ganges there is similarly beneficial. (Fig. 46)

Each of the religions of South Asia has its pilgrimage spots, some shared with other faiths, some of universal significance and others of only local importance. To many Hindus, India itself is a sacred land and four great pilgrimage sites mark the cardinal points of 'mother India': Badrinath or Kedarnath in the North, Puri in the East, Rameshvaram in the South and Dwarka in the West (see map p. 79). This delight in listing important sites continues with the seven holy cities of Ayodhya, Mathura, Gaya, Varanasi, Ujjain, Haridwar and Dwarka; pilgrimage to any one of these ensures liberation from rebirth.[6] There are innumerable other sites, some of pan-Indian importance, others of more local interest: the broad spread of sacred space mirrors the similar diffusion of the divine.[7]

Some pilgrimage sites are considered sacred through natural features - mountains, caves or rivers - or an association with mythic events. Others gain greater status as a result of the perceived benefits to devotees. The hill temple to Venkateshvara or Balaji in southern Andhra Pradesh is a good example, for this pilgrimage site grew over the course of the past thousand years from a small shrine to one local aspect of the deity Vishnu to a large, wealthy temple visited by upwards of 10,000 pilgrims per day (Figs. 47a & b). The veneration of the Buddha's image is a common ritual practice across the Buddhist world, but certain images have gradually acquired greater status as objects of devotion and pilgrimage. In Southeast Asia these include the Mahamuni Buddha in Mandalay and the Emerald Buddha in Bangkok, both images believed by Burmese and Thai Buddhists to have been consecrated by the Buddha himself.

emperor Akbar vowed to journey the 230 miles from Agra on foot to the shrine of the sufi Mu'in al-Din Chishti at Ajmer if the saint would assist in the birth of a son and heir. When his long-awaited son Salim was born in August 1569 Akbar travelled to the shrine at Ajmer, an event recorded in the illustrated history of his reign, the *Akbarnama*.[5] (Fig. 56, p.60) Pilgrimage may be understood as encapsulating the physical and spiritual journey through life; many Hindu destinations are associated with death. But death is about the end of this life and the beginning of a better new life, a

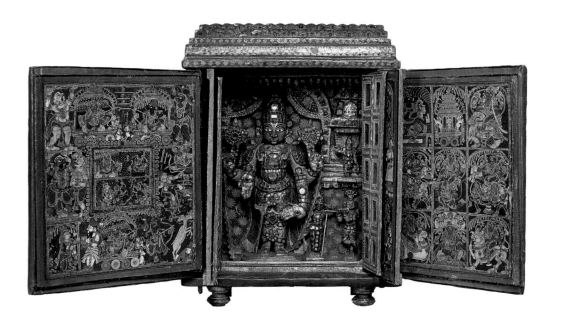

Figs 47a & b
Portable Vishnu shrine
Wood and cloth, painted
and lacquered. Tirupati,
south India, late 18th or
early 19th century.
Ashmolean Museum,
Oxford. EA X264.

Within this portable
shrine is an image of
Vishnu as Venkateshvara
worshipped at the hill
temple of Tirupati in
southern Andhra
Pradesh. On each of the
folding doors are beauti-
fully painted scenes of
the form of Vishnu at
Srirangam and
Kanchipuram, episodes
from the life of Krishna
and the epic *Ramayana*,
and other deities. These
portable shrines were
used by itinerant priests;
early 19th century
'Company' paintings
depict such figures

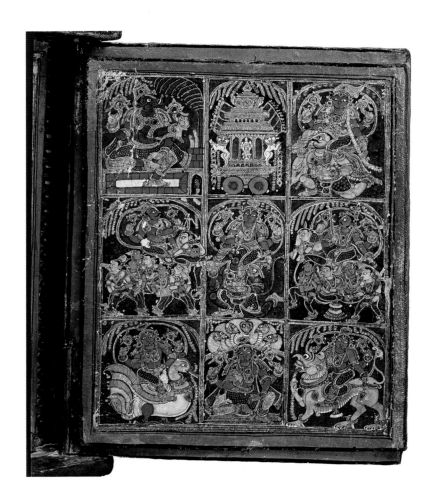

Many pilgrimage sites are associated with religious figures, either through marking on the ground events in their lives or by maintaining the presence of these divine people through their relics, whether their corporeal remains or objects connected to them. The Hindu tradition celebrates the lives of its gods and goddesses through the myths that describe their interaction on Earth amongst humans. These mythic events are rooted in the landscape of India. The events in the epic *Ramayana* are celebrated across South Asia and beyond in written text, paintings, sculpture, song, drama and television. But these events are further revered on the ground: pilgrims travel across India to visit the site of Rama's birthplace in Ayodhya, the land of Kishkindha around the city of Vijayanagara where Rama and his brother Lakshmana encountered the monkey-king Sugriva and his general Hanuman, (Fig. 48) or the causeway that was built across the sea near Rameshvaram to enable the conquest of the demon-king Ravana on the island of Lanka and the return of Rama's wife Sita.

The sacred lives of religious figures - eternal deities and historical teachers - have given rise to many of South Asia's pilgrimage destinations. The early life of Krishna, considered a manifestation or *avatar* of Vishnu or a deity in his own right, took place in and around Mathura in northern India. Though a site of pilgrimage before the 16th century, this region of Braj identified with Krishna's early life received a boost in popularity through the rise of devotional Hinduism (*bhakti*), especially after the visits of the great Bengali Vaishnava Chaitanya (1486–1533). (Fig. 49) Chaitanya and his followers are credited by tradition with identifying the sites where Krishna performed

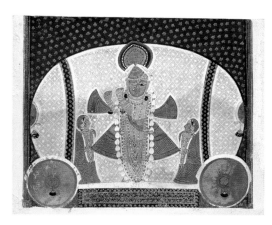

Fig. 49
Krishna as Srinathji playing flute

Painting on paper, early 20th century, Nathdwara style, north India. Ashmolean Museum, Oxford.
EA 1967.165.5

Krishna is worshipped at Nathdwara in Rajasthan as Srinathji. Images of the deity depict him with large downcast eyes and short limbs, often accompanied by the cows and cow-girls (*gopis*) of the Braj region.

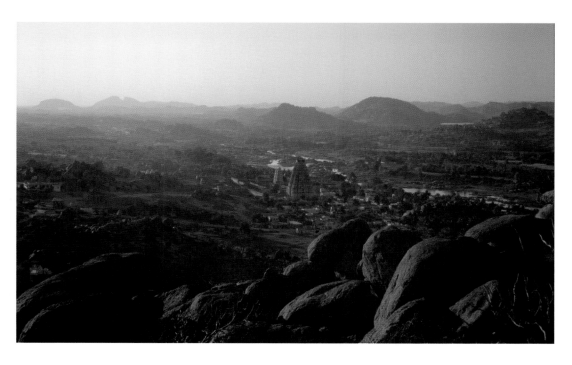

Fig. 48
Vijayanagara or the 'City of Victory' at Hampi, Karnataka

(Photo: Crispin Branfoot 1997)

This is the view from Matanga Hill over the sacred centre, with the processional street leading to the towered entrance to the Virupaksha temple.

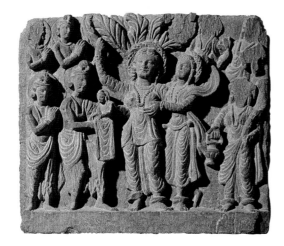
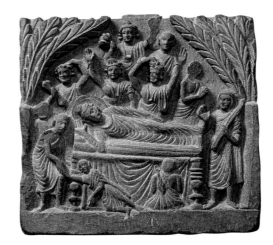

Fig. 50a & b
The Birth and Death (*Mahaparinirvana*) of the Buddha.
Schist Gandhara 2nd–3rd century AD. Murray-Aynsley Gift. Ashmolean Museum, Oxford. EA OS 3, 10.

The northwest region of Gandhara had a flourishing Buddhist culture between the 1st and 6th centuries AD. Huge quantities of stone sculpture survives from this area, often depicting detailed narratives of the Buddha's life. These would have adorned the basement of *stupas*, so that pilgrims could 'read' the Buddha's life story as they walked clockwise around the monument.

various miraculous deeds, such as lifting the mountain Govardhana to protect the cow-herders from the storm sent by the angry god Indra, or defeating the demon Kaliya. By multiplying the number of places identified with Krishna, Braj came to be wholly imbued with the deity's presence.[8] Pilgrims continue to come to this region today, usually during the monsoon season. They visit the sites of Krishna's activities amongst us, both Hindus from across India, as well as North American and European devotees of the Hare Krishna movement that derives from Bengali Vaishnavism.

Pilgrimage was commended by the Buddha himself to his disciple Ananda before his final death in the 5th century BC, as is recorded in the *Mahaparinibbana Sutta*. He specified that the most important sites for disciples to visit, places that would evoke powerful emotion in any who saw them, were those associated with key events in his spiritual biography: his birth at Lumbini, place of enlightenment at Bodhgaya, the preaching of the first sermon at Sarnath and his final extinction and passing into *nirvana* at Kushinagara. (Fig. 50a & b) His spiritual life was thus mapped onto the north Indian landscape, and the inner experience of Buddhism linked with an exterior sacred geography. Further sites associated with key events in the Buddha's or his disciples' lives were added to the list of recommended pilgrimage destinations developing a detailed Buddhist biography. Closely connected with

the early development of Buddhist pilgrimage are the cult of relics and the foundation of *stupas*, large hemispherical burial mounds, which contain them and that create a sense of 'spiritual magnetism' for pilgrims. The establishment of Buddhist pilgrimage owes much to the patronage and activities of the great Mauryan emperor Ashoka in the 3rd century BC. He established the archetypal Buddhist pilgrimage by visiting thirty-two sacred spots associated with the Buddha, starting with the birthplace at Lumbini and finishing at Kushinagara, the site of the *parinirvana* or final death. His legendary division of the Buddha's relics among 84,000 *stupas* further disseminated the Buddha's presence across South Asia, and established a model of kingship, pilgrimage and *stupa* construction that Buddhist rulers would continue to emulate.

As Buddhism spread across Asia – to Sri Lanka, Tibet, Southeast Asia, China, Korea and Japan – the centrality of India was emphasised by the journeys of pilgrims back to the Buddhist homeland. The accounts of the Chinese pilgrims Fa-hsien (c. 400) and Hsuan-tsang (in India 629–645) describe in detail the places visited and motivations of Buddhist pilgrims in India. These pilgrims and those before and after were all aiming to come into the Buddha's 'living presence': the places associated with his life, his corporeal and material relics, or relics by association, such as texts or images. (Fig. 51)

Fig. 51
Reliquary in the form of a *stupa*

Schist. Gandhara, 1st century AD. Ashmolean Museum, Oxford. EA 1978.127.

Reliquaries were often buried inside a Buddhist *stupa*.

Fig. 52 (Far right)
Footprints of the Buddha scattered with flower petals, Bodhgaya, Bihar
(Photo: Crispin Branfoot 1993)

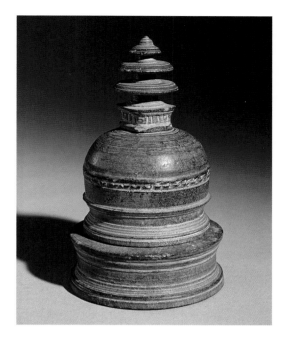

Fig. 53
Entrance to shrine containing the Tooth-relic of the Buddha, Kandy, Sri Lanka
(Photo: Crispin Branfoot 2001)

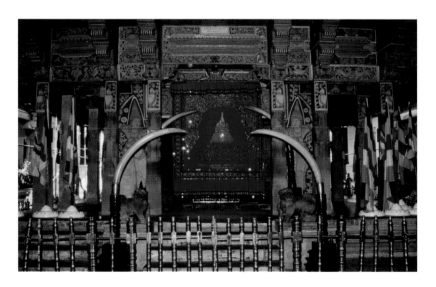

For pilgrims unable to travel to India, local pilgrimage sites developed that traced their sacredness to the Buddha; through miraculous journeys, moveable objects or relics, or with reference to the Buddha's previous lives or even previous Buddhas. In the ancient region of Gandhara (modern north Pakistan and eastern Afghanistan) Buddhists in the early centuries AD visualized the Buddha as having visited their area, relocating known events to the region and introducing new events that took place there. In the Theravada tradition there is the widespread belief in the Buddha's miraculous journeys to Sri Lanka, Burma and Thailand: temples, images or footprints mark the spot where the he is understood to have been. (Fig. 52) Relics of the Buddha - whether corporeal such as a tooth or bone, or material, such as a piece of his robe or begging bowl – imbued a site with the Buddha's presence. The Temple of the Tooth in Kandy houses the tooth-relic of the Buddha, and the possession of it has been a defining element in Sinhalese Buddhist kingship from at least the 11th century. (Fig. 53) Another place of pilgrimage in Sri Lanka is the Bodhi tree at Anuradhapura, believed to be a sapling of the tree under which the Buddha attained enlightenment. It was brought to the island by Ashoka's son Mahinda in the 3rd century BC, marking the establishment of Buddhism on the island.

Everywhere Buddhism has spread, new pilgrimage centres have developed that are understood to be imbued with the Buddha's presence or the abode of a Buddhist deity creating smaller, regional pilgrimage networks. By the 18th century Sri Lankan Buddhists had established a series of sixteen pilgrimage sites across the island associated

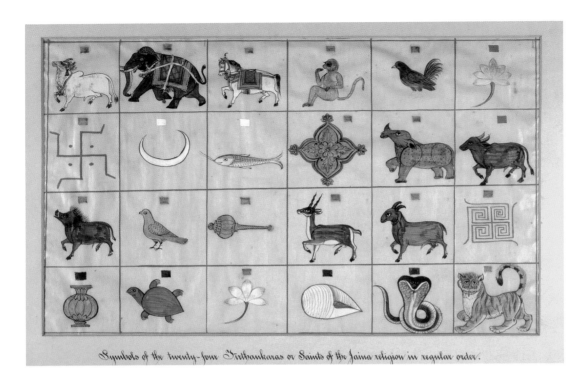

Symbols of the twenty-four Tirthankaras or Saints of the Jaina religion in regular order.

Fig. 54
Symbols of the 24
tirthankaras
Painting on paper. Early 20th
century. Ashmolean Museum,
Oxford. EA X458.

with either the three miraculous visits of the Buddha after his enlightenment or to the monumental efforts by past kings to establish relics of the Buddha in a *stupa*. Paintings of these sixteen sites became a standard visual element in the wall-paintings of temples from this period, so that Buddhists entering these temples were reminded of the sacred geography of the island.[9]

Like other religions in South Asia, the practice of pilgrimage amongst Jains is now common and is focussed on the places associated with the lives of the twenty-four *tirthankaras* or Jinas. (Fig. 54)[10] The idea of pilgrimage started later than for the Buddhist and Hindu traditions, from only around the 5th century AD, but became central to Jain practice in the medieval period. Five key events in the Jinas' lives were identified as central with a corresponding interest in where this happened: the first event is the Jina's descent into his mother's womb, followed by his birth, renunciation from worldly pleasures, attainment of omniscience after a long ascetic career and ultimately the

moment of his final death. The latter is often considered the most important, and many of the most famous Jain pilgrimage sites are those where a Jina or a great disciple died: Sammeda in Bihar owes its great sanctity as a pilgrimage site because twenty of the twenty-four *tirthankaras* died there. Many of these sites are mountains or hills. For all Jains five sites are considered as important: Satrunjaya and Girnar in Gujarat, Sammeda, and Ashtapada in the Himalayas; for Svetambara Jains the fifth is Mount Abu in Rajasthan, for Digambara Jains it is Sravana Belagola in Karnataka.

Pilgrimage sites have also developed in South Asia associated with more recent religious figures, such as the Sikh gurus or recent Hindu teachers. Sikhism developed a network of important *gurudvaras* associated with the spiritual biographies of the ten gurus in Panjab and across north India. The Harmandir or Golden Temple in Amritsar, founded in 1588, is the most important of all Sikh pilgrimage sites. (Fig. 55)

The centre of the Islamic world is Arabia, with pilgrimage to Mecca and Medina an

Fig. 55
The Harmandir ('Golden Temple') at Amritsar
(Photo: Crispin Branfoot 1991)

The holiest Sikh temple was founded c. 1588 but has been substantially renovated many times since.

obligation on the part of all Muslims. But Islam is deeply rooted in the subcontinent, Muslims having lived in South Asia as a consequence of raids, conquest and trade from the first Islamic century. There are now more Muslims in South Asia than the entire Middle East. Most of these were not from outside South Asia, but were historically converts and thus in many ways Islam may be considered indigenous to the region. A notable Islamic tradition relates that Adam descended to the region, to Sri Lanka, after his expulsion from paradise. The 18th century poet Azad (1704–1786) went so far as to conclude from disparate Arabic sources that Adam's Peak is the second holiest place on earth after Mecca, and that India was the site of the first revelation, the first mosque and the place from which pilgrimage to Mecca was first performed.[11]

A key element in the proliferation of Islam on the subcontinent was the role of shrines to sufis (*dargahs*, 'royal court'). These shrines integrated local, regional systems of culture into the worldwide faith community of Islam. *Dargahs* are the burial

places of major sufi teachers whose spiritual power (*baraka*) is believed to reside in the tomb. These shrines are therefore places of intercession, where Quranic authority may be conveyed through the shrines ritual authority and Islam is made accessible to the masses. It was believed "that the saint enjoyed a closer relationship with God than the common devotee could ever have, and that the saint's spiritual power to intercede with God on the devotee's behalf, outlasted the saint's mortal lifetime and adhered to his burial place. The latter therefore frequently evolved into a great centre of pilgrimage for persons seeking divine aid in their personal, matrimonial or business affairs."[12] Modern reformist movements across the Islamic world, especially the Wahhabis of Saudi Arabia, have tried to replace popular devotion to these sufi shrines with the written authority of the Qu'ran, but pilgrimage to *dargahs* (Arabic *ziyara*) remains popular across the Islamic world.

Like the shrines to other deities and saints, there are numerous *dargahs* across

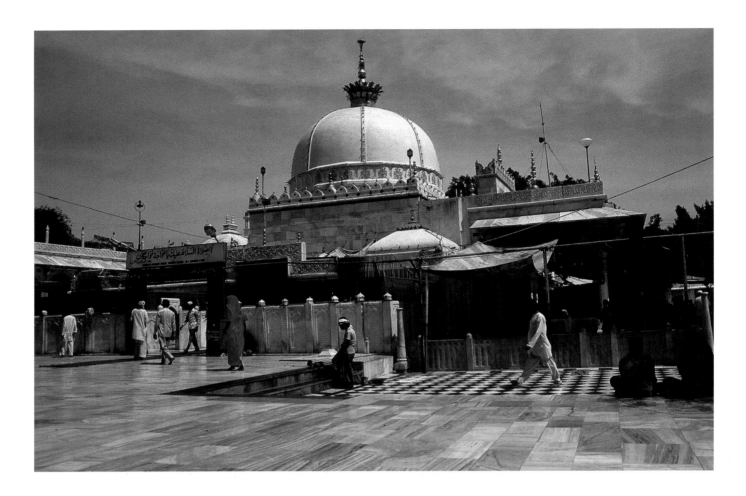

South Asia. One of the best known is the *dargah* of Mu'in al-Din Chishti in Ajmer in Rajasthan. (Fig. 56) Together with the shrine of Baba Farid at Pakpattan in the western Panjab and Nizam al-Din in Delhi, these three great *dargahs* became the first Muslim holy places within India, no longer compelling Muslims in South Asia to exclusively look to the Middle East for spiritual inspiration.[13] There is a widespread tradition, for example, that seven pilgrimages to a particular *dargah*, such as Ajmer in the North or Nagore for Tamil-speaking Muslims, are the equivalent of one to Mecca.[14]

In a similar way to that of the other faith communities in South Asia, so the creation of Christian holy sites focussed on the relics of major religious leaders allowed the various Christian communi-ties to root themselves in the lands of India, rather than being visitors always looking back to a spiritual heartland in the Mediterranean. The holiest site in Catholic Asia is the tomb of Francis Xavier in the Jesuit church of Bom Jesus in Old Goa. Francis Xavier (1506–52) arrived in Goa in 1541 and subsequently travelled to southern India, Sri Lanka and on to Southeast Asia, China and Japan converting many people to Catholicism. After his death in 1552 his remains travelled around Asia before finally coming to rest in Goa; he was canonised in 1621. His remains are the focus of worship for pilgrims visiting the old capital of the Portuguese empire in Asia. (Fig. 57) The Syrian Christians of Kerala similarly have pilgrimage shrines focussed on the burial sites of important religious leaders.

Fig. 56

The *Dargah* of Mu'in al-Din Chishti at Ajmer

(Photo: Crispin Branfoot 1993)

Fig. 57

Reliquary of St. Francis Xavier in Bom Jesus, Old Goa

(Photo: Crispin Branfoot 2002)

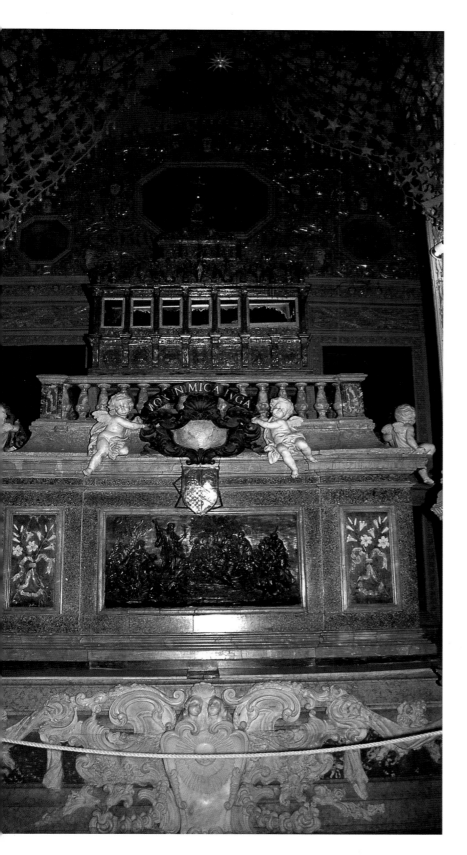

Swaminarayan Hinduism developed in the early 19th century in western India, modern Gujarat. It was founded by Sahajanand Swami (1781–1830), who has been described as the last of the medieval saints and the first of the modern Hindu reformers.[15] As Swaminarayan, he has attained divine status, and is the focus for devotion within the Swaminarayan Hindu community. Visiting the places where holy figures have passed is a widespread South Asian practice, and this continues with recent religious leaders such as Swaminarayan and his successors. Gujarat has been transformed by the proliferation of markers – whether a small stone platform with footprints and other sacred symbols, or more prominently by a large temple – that define the sacred space associated with events in his life in Gujarat. These include the places where Swaminarayan composed an important text or gave a significant discourse. The location of Sahajanand Swami's meeting with the British Governor of Bombay Presidency, Sir John Malcolm in Rajkot on 26th February 1830 is similarly defined: a copy of one of the most important Swaminarayan texts, the *Shikshapatri*, given to Malcolm by the divine Sahajanand Swami is in Oxford's Bodleian Library and is treated as a relic through association.[16] A pilgrimage around these sites is therefore a recreation of sacred time as pilgrims participate in the life of their founding figure in the early 19th century.

As in the past, so today pilgrims may travel to see and be in the presence of a living holy figure whether a living sufi or a renowned Jain monk. Many travel today to meet the exiled spiritual leader of Tibet, the Dalai Lama, in Dharamshala in northern India, considered an incarnation of Avalokiteshvara, the Buddhist compassionate saviour. Satya Sai Baba is another religious figure, considered by many Hindus to be divine and visited by pilgrims at his home in southern India.

Crossing Boundaries

Pilgrimage has been described as the great social unifier, creating a sense among pilgrims of shared group identity that transcends differences in social status, nationality and even religious affinity; pilgrims leave the everyday behind on the sacred journey. Pilgrimage is about crossing boundaries and in South Asia pilgrims of different faiths may visit the same pilgrimage sites, challenging the notion of clear divisions between the varied religions of the region.

Many scholars consider the communal divisions between Hindus, Muslims, Buddhists, Jains and Sikhs in South Asia to be a creation of the 19th century, a combination of British colonial census-takers, European Orientalist scholars and Missionaries attempting to understand South Asia's diverse religions, and upper-class religious reformers in the region.[17] The term 'Hinduism' is of 19th century origin, and ultimately derives from the 12th and 13th century Turkish and Arab conquerors' term for the people of India and subsequently their religion – the beliefs and practices of those who lived across the Indus river. Within each of these modern religious categories are a great variety of language, class and belief, defying neat attempts to categorise groups as 'Muslim' or 'Hindu'. Whilst there have been horrific recent examples of communal aggression, of which the destruction of the mosque at Ayodhya in December 1992 by right-wing Hindu fanatics and the subsequent rioting across India, there is great evidence in both the present and the past of inter-communal harmony, not least in the practice of pilgrimage across the subcontinent. Community identity may be constituted by more than just religious affiliation. The view from outside may see pilgrimage as a social, national, cultural unifier of communities, but at its core is the journey by the individual to the sacred place in pursuit of some individual personal goal.

Pilgrims to the sacred sites of South Asia may come together in shared faith, but also from a sense of tribal, cultural or national identity. Bodhgaya is the site of the Buddha's enlightenment in eastern India. In the period from the 8th to 12th centuries it became a major site of pilgrimage for Buddhists from

Fig. 60 (Right)
Dhamekh stupa, Sarnath, Uttar Pradesh, 5th century and later AD
(Photo: Crispin Branfoot 1993)

This *stupa* marks the spot where the Buddha taught the 'Middle Way', the path to enlightenment for the first time.

Fig. 61 (Below right)
Dargah **of Hazrat Shahul Hamid in Nagore, Tamilnadu**
(Photo: Crispin Branfoot 2000)

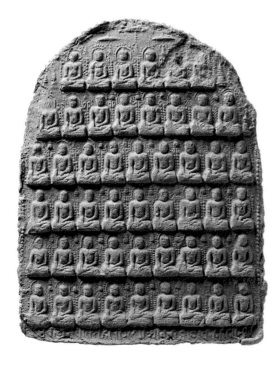

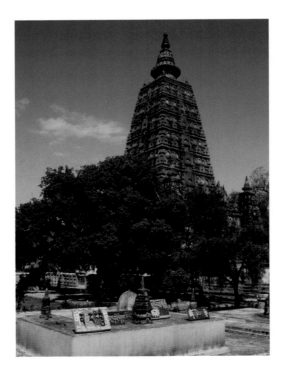

Fig. 58 (Far left)
Terracotta plaque with rows of seated Buddhas
Pagan, Burma, 13th century. Ashmolean Museum, Oxford. EA X421.

Fig. 59
Mahabodhi temple at Bodhgaya, Bihar
(Photo: Crispin Branfoot 1993)

Founded in the 7th century, this temple marking the site where the Buddha attained enlightenment was substantially rebuilt in the late 19th century.

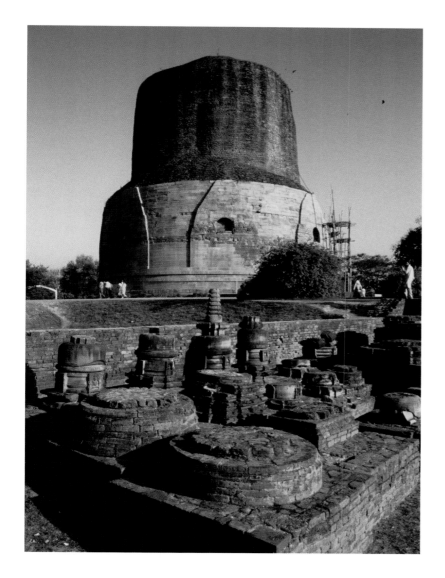

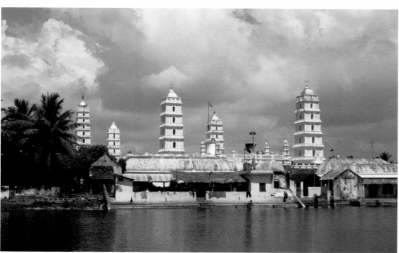

across Asia, reflected in the wealth of material remains at the site – donations of Buddha images and votive *stupas* – and the objects carried home by returning pilgrims, such as stamped clay plaques. (Fig. 58) Bodhgaya was the location where national and ethnic differences among Buddhists were dissolved. Following Buddhism's decline in the land of its birth after the 12th century, Bodhgaya and the other sites marking the Buddha's sacred biography in eastern India, largely disappeared from the pilgrims' itinerary. Bodhgaya re-surfaced as a pilgrimage site in the 19th century, in part through the dedicated efforts of European scholars – both historians and archaeologists – who investigated Buddhism's early history in India and the material remains left behind. (Fig. 59) Over the course of the late 19th and 20th century, Bodhgaya has once again become the focus of Buddhist pilgrims from across the World: it is not an unusual sight today to find wealthy Koreans, Thais, Taiwanese, Japanese or Sri Lankans travelling the dusty roads of rural Bihar along the ancient Buddhist pilgrimage roads. At Bodhgaya itself the diversity of countries where Buddhism has taken root is expressed visually in the variety of Buddhist temples and *stupas* built in distinct regional styles in recent years at this great pilgrimage site.

Both Bodhgaya and Sarnath, where Buddha first taught his 'Middle Way', are very close to important Hindu pilgrimage centres, Gaya and Kashi. (Fig. 60) Many of South Asia's pilgrimage sites are shared by different communities. This may lead to contestation but is also testament to more fluid expressions of faith than today's more rigid categories would suggest. Many sufi *dargahs* are visited by both Muslims and Hindus; the saint's divine power transcends religious identity to his followers. At the *dargah* of Hazrat Shahul Hamid in Nagore, for example, the Tamil-speaking pilgrims are about equally Muslim and Hindu; the ritual practices are similar in many ways to those at nearby Catholic Velankanni and the Tamil country's many Hindu temples. (Fig. 61)

Sculpted footprints are a common way of indicating the presence of a deity or spiritual leader. (Fig. 62) Adam's Peak or Sri Pada in Sri Lanka is a sacred site for all the island's faith communities: the footprint impressed on the mountain's summit is understood to be Adam's after his descent to earth from Paradise, Shiva's, or the Buddha's marking one of his miraculous visits to the isle. Some Christians believe that the footprint was left by St. Thomas who is considered to have brought Christianity to South Asia in the 1st century. At Kataragama the shrine to the Hindu deity Skanda (or Murukan) has been transformed over the course of the 20th century into a major centre of national pilgrimage for all Sri Lankans regardless of expressed faith, whether Hindu, Buddhist, Muslim or Christian. Mount Kailash in western Tibet is also sacred to multiple faiths – Hindus, Jains, Buddhists and practitioners of Tibet's indigenous faith, Bon. In the last fifty years, following the Chinese occupation of Tibet the pilgrimage to Kailash has been a source of cultural unity amongst Tibetan peoples. Some scholars have similarly argued that much of what we understand as 'traditional' in India is substantially a colonial construct. The sense of cultural unity that India acquired in opposition to British rule and the ability to travel widely on pilgrimage to the pan-Indian sacred centres was only a realistic option from the 19th century. But many of these sites have deep historical roots, and the sacred journey of pilgrims across South Asia is one way in which this vast and varied region acquired a sense of cultural unity.[18]

Making Space for the Sacred

Architecture may both define the pilgrimage site, marking the destination of the sacred journey, and also shape the pilgrimage experience there. In South Asia pilgrims may journey to a geographical feature – a mountain or river, for example – but often the destination is marked in the landscape by a single building, a small group of structures or a whole city. Temples and shrines are the ultimate destination of many pilgrims at sacred sites in South Asia. Buddhists have constructed *stupas* made of brick and stone to enshrine relics from the early centuries BC. (Fig. 63) Temples to Hindu deities and Jain religious figures appeared later across India, both as rock-cut caves and structural temples in stone. From the 7th century AD, temples have been built for use by Buddhists, Hindus and Jains across South Asia, from small village shrines to the monumental temple-cities of southern India.

A ritual common to many South Asian religions at a pilgrimage site is clockwise circumambulation (*pradakshina*). This both defines the sacred space and marks the arrival of the pilgrim: people, images, temples, mountains, cities are all circumambulated to honour the sacred presence within. The architecture at the site may reflect this ritual requirement. *Stupas* are invariably round and often have a paved walkway at the base for pilgrims to circumambulate. Narrative sculpture depicting the historical life or previous lives (*jatakas*) of the Buddha may appear on gateways or slabs facing the *stupa*, or rows of prayer wheels may be placed around the *stupa* for pilgrims to spin clockwise as they move around the sacred monument. (Fig. 64) This practice is shared by Hindus, Jains and Sikhs; even Muslims in South Asia circumambulate *dargahs* in a clockwise direction, the opposite of the practice at Mecca.

Other rituals that pilgrims may conduct at the site include bathing, as preparation

Fig. 62 (Far left)
Jain footprints
Marble. Labhapur, Pakistan dated 1725–26. Ashmolean Museum, Oxford. EA 1997.189.

Sculptures of footprints are often used to indicate the presence of a deity or divine teacher, such as the Buddha, Vishnu or as here Jinas or Jain teachers. Jain pilgrimage sites are full of such relief carvings. These white marble footprints carved in relief were made to commemorate two great Jain Svetambara teachers, Jinadattasuri (active 1122–1154) and Jinakushalasuri (an *acarya* of 1320).

Fig. 63 (Above right)
Stupa at Sanchi,
Madhya Pradesh
1st century BC/1st century AD
(Photo: Crispin Branfoot 2001)

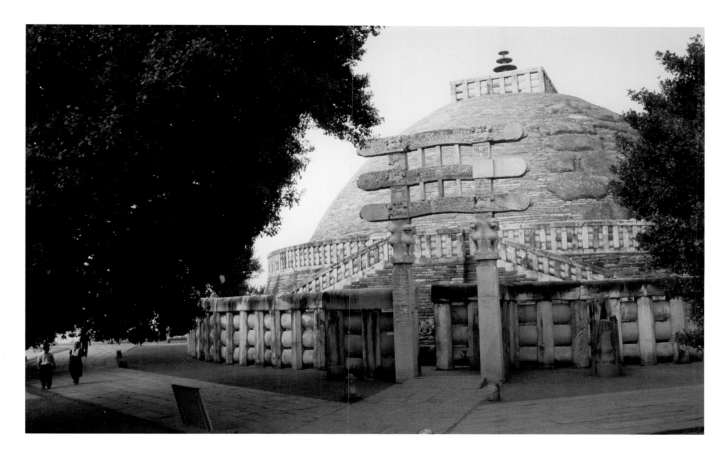

Fig. 64

Gateway to a miniature
stupa

Ivory. Gandhara, 1st century
AD. Ashmolean Museum,
Oxford. EA 1994.39.

Elaborate gateways are a
feature of many early Indian
stupas, often sculpted with
narrative reliefs depicting
the historical life or former
lives (*jatakas*) of the Buddha.
This is a very unusual
miniature representation
of such a gateway, perhaps
from a household shrine.
The style suggests a
Gandharan provenance,
though such gateways
around *stupas* are unusual
in this region.

before entering a sacred area or temple, or
as the aim of the pilgrimage itself. Rivers
are often sacred in the Hindu tradition and
may even be personified as goddesses.
Bathing in important rivers such as the
Ganges in north India is considered very
auspicious, especially at important points
in the river. For the Ganges these include
Gangotri, the source of the river in the

Himalaya, Haridwar, where the river meets
the plains, Prayag (Allahabad) where the
Ganges joins the rivers Yamuna and the
mythical Saraswati, Kashi (Varanasi) where
the river turns to the north, or the point
where it flows into the Bay of Bengal south
of Calcutta. The climax of a pilgrimage
may involve touching or seeing a sacred
person, object or image, and pilgrims may
give and receive offerings, usually money,
flowers and food.

Pilgrimage to a sacred centre often
involves a journey within the place, moving
in a prescribed sequence from one shrine to
the next before reaching the most impor-
tant temple at the centre. A notable feature
of some Jain pilgrimage sites, such as
Mount Shatrunjaya, is the clustering of
many temples all over a hilltop. (Fig. 65)
Pilgrims walk around the hill and impor-
tant shrines on the hill, and follow defined
routes on foot to the summit. The sacred

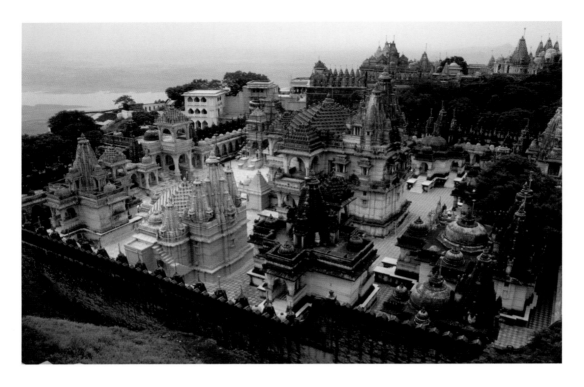

Fig. 65

**Temples on Mount
Shatrunjaya, Gujarat**

(Photo: Crispin Branfoot 1993)

city of Kashi, like other holy cities, is walked around by pilgrims before they proceed in to the heart of the city and its riverside *ghats* and temples. The journey around the Panchakroshi Road may take five days and pilgrims visit 108 shrines along the way; woodblock printed maps from the 19th century depict this sacred geography. (Fig. 66) Within the city itself are innumerable other shrines and temples: some describe the city as containing all the pilgrimage spots of India in one place.

Hindu temples are processional spaces, buildings to move through rather than congregate within. The tower over the main shrine or the huge pyramidal gateways (*gopuras*) in the outer walls of the south Indian temple mark the location in the landscape and draw the pilgrim inward. (Fig. 67 p. 68) Temples in south India have often grown into huge sacred cities, with numerous shrines, columned halls, corridors, gardens and water-filled tanks set within a series of concentric walled enclosures. The pilgrims' journey does not end at the entrance, for often the scale of the building means that the

journey into the sacred heart of the temple through layers of increasingly sacred space is very long. The great pilgrimage temple of Vishnu at Srirangam in Tamilnadu, for example, covers an area of over 150 acres; seven concentric enclosure walls pierced by twenty-one great gateways surround the main shrine with a descending hierarchy of lesser deities around Vishnu at the centre.

Islamic *dargahs* are focussed on the tomb of the saint or sufi, which is often enclosed within a domed structure with a colonnade all around for worshippers to process around. A mosque is usually built in the grounds for communal worship, as well as other structures. The manner in which these buildings are designed in South Asia reflects not only Islamic culture in the Persian and Central Asian world but also more local Indian practices: mosques and mausolea built in Gujarat and Bengal, for example, often share the same architectural vocabulary and ornament as the temples in the same region.

Pilgrimage may take place to these sacred centres at any time of year, but greater crowds congregate in a particular season

Fig. 66

Map of Varanasi

Woodblock on paper. North India, early 20th century. Ashmolean Museum, Oxford. EA 1966.56.

The many shrines and temples of this sacred city are shown surrounded by the encircling Panchakroshi road and the river Ganges.

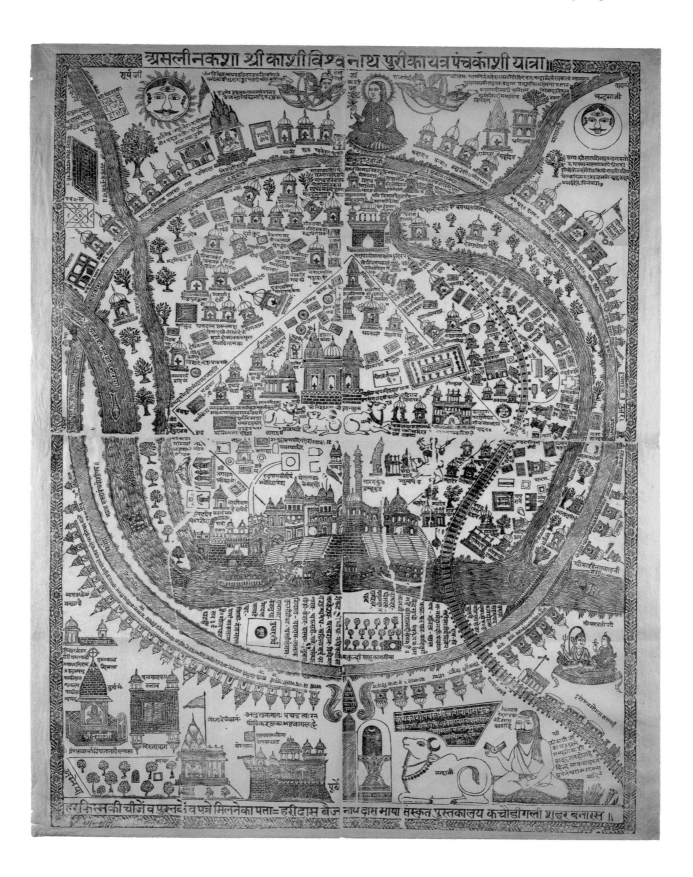

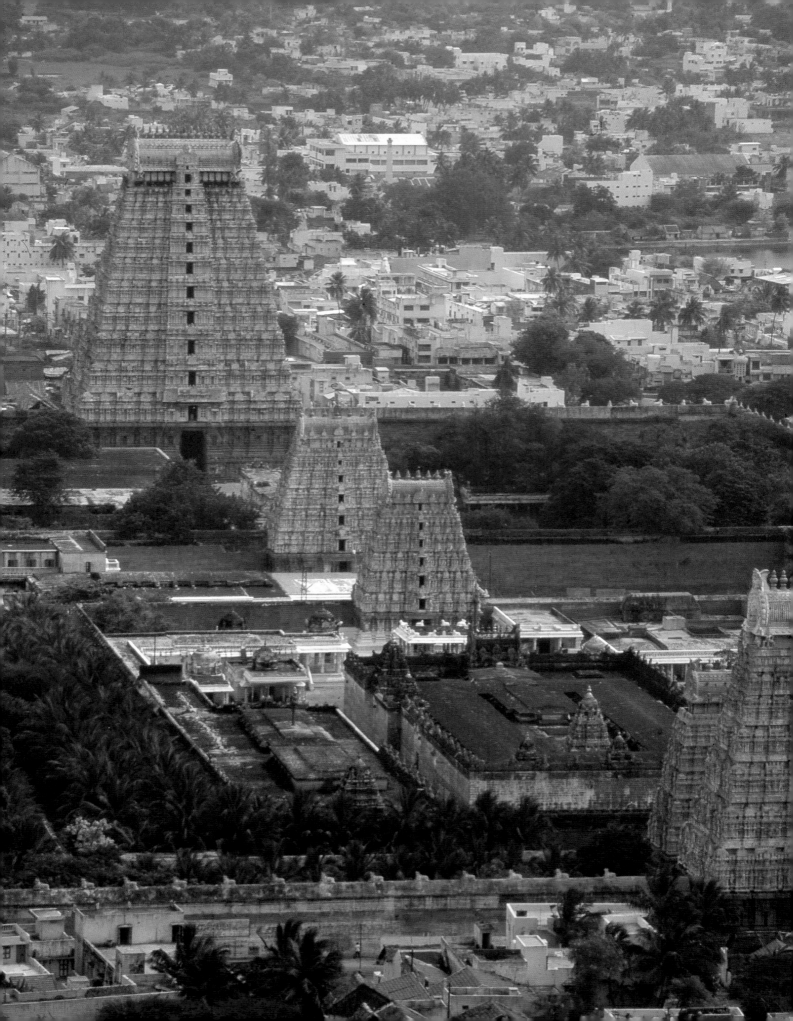

Fig. 67

The Arunachaleshvara (Shiva) temple at Tiruvannamalai in Tamilnadu

(Photo: Crispin Branfoot 1998)

This Hindu temple was built between the 9th and 17th centuries. A series of concentric enclosures are each entered through huge *gopuras* or pyramidal gateways that are larger towards the outside; the most sacred, central shrine is comparatively small.

especially during a named festival or fair. At these times there is an intense emotional and devotional atmosphere among pilgrims, who may come in groups. During the annual divine marriage festival of the Hindu deities Minakshi and Sundareshvara in Madurai, for example, the population of this south Indian city may swell from one to over 1.5 million people. 'Urs festivals at sufi *dargahs*, held each year on the anniversary of the sufi's death are celebrated as spiritual wedding ceremonies, and are the occasion for great gatherings at important pilgrimage sites; special blessings from the saint are available at this time. Other ritual occasions which draw huge pilgrimage groups in South Asia occur less frequently: the Kumbh Mela, for example, is a festival held every three years at one of four Hindu pilgrimage centres in north India; every twelve years a great festival at the

Jain pilgrimage centre at Sravana Belagola in Karnataka sees the huge monolithic statue of Gomateshvara being lustrated over a period of days. (Fig. 68a & b) Festivals at pilgrimage sites are often occasions for other cultural performances including folk theatre and epic recitation. Painted narrative cloths such as the Rajasthani Pabuji *par* or the *kalamkari* cloth-paintings of the Andhra region may be used as the backdrop for these performances, or such cloths are temporarily hung in temple halls. (Fig. 69) These festivals are an opportunity for pilgrims to participate in the re-enactment of a sacred figure's biography: the Ras Lila dramas held in Vrindavan in north India every summer celebrates the mythical life of Krishna among the cowherders of Braj and pilgrims come to this sacred place at a sacred time to participate in the deity's life on Earth.

Fig. 68a & b

The Jain pilgrimage site of Sravana Belagola in Karnataka

(Photos: Crispin Branfoot 2005)

The top of the huge monolithic image of Gomateshvara, completed in the 10th century, can be seen emerging from the temple at the hill's summit.

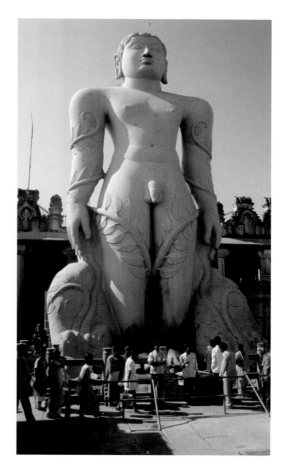

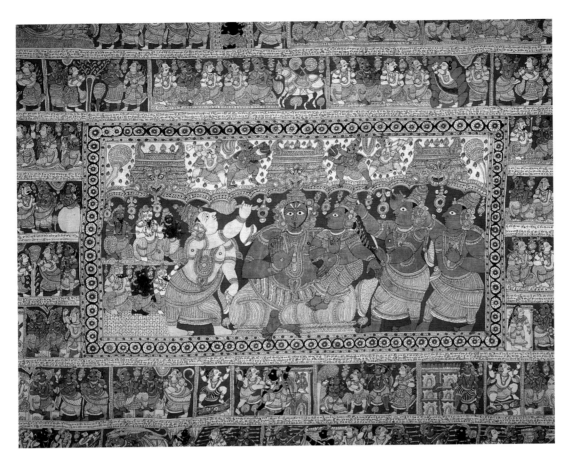

Fig. 69
**Temple hanging
(*kalamkari*).**
Painted and dyed cotton.
Kalahasti region, southern
Andhra Pradesh, c. 1880–90.
Ashmolean Museum, Oxford.
EA X 2067.

The central panel depicts
Rama and Sita seated
beneath three temple
towers. Further registers
all round narrate the epic
Ramayana, with captions
in Telugu identifying each
scene.

Pilgrims unable to travel the great distance to an important sacred centre may often find that a replica of the site is closer to hand. Temples or centres may be understood to be local versions of another more important sacred site, often the major sites of northern India: there are numerous 'southern Kashi's, for example. Important recognisable temples may even be rebuilt elsewhere: there are four important re-creations of the Mahabodhi temple at Bodhgaya in Southeast Asia - two in Burma, at Pagan and Pegu, and two in Thailand, at Chiangmai and Chiangrai – and another at Patan near Kathmandu in Nepal. They were all built between the 13th and 16th centuries when Buddhist pilgrimage to India was difficult. Small-scale images of this famous building have also been sculpted in stone and carried home by pilgrims. (Fig. 70)[19] This reconstruction of a famous temple closer to home continues to this day: a new Hindu temple to Vishnu as Venkateshvara is currently under construction at Tiverton in the West Midlands, complete with the appropriate sacred landscape of seven hills, a reproduction of the better known pilgrimage temple at Tirupati in southern Andhra Pradesh. For British Hindus unable to travel to India, a pilgrimage to Birmingham is more straightforward.

Fig. 70
**Model of Mahabodhi
temple at Bodhgaya**
Stone, eastern India, 11th
century. Ashmolean Museum,
Oxford. EA 1996.4.

Models of the Mahabodhi
temple give an idea of the
early appearance of the
temple before the
substantial renovations in
1880–81.

Fig. 71
Prayer wheel
Copper, wood, gem-stone.
Tibet, 19th century.
Ashmolean Museum, Oxford.
EA 1978.80.

Material and Memory

Pilgrimage is a time away from the everyday, a time when householders may become temporary renouncers. Special dress may indicate their status: male pilgrims travelling to the Ayyappan shrine at Sabarimalai in southern Kerala take a vow to wear black clothes and a *rudraksha* necklace, go barefoot, and abstain from shaving, meat, alcohol and sex during the forty to sixty days leading up to the journey to the shrine during the December-January pilgrimage season. Around ten million pilgrims – mostly Hindu, but also Muslim and Christian - are currently estimated to visit the temple at Sabarimalai during the fifty-one days that it is open each year. Though the site has deep historical roots, its immense popularity has grown only in the last fifty years.[20] Pilgrims in Tibet and the Himalayas may carry a prayer-wheel with

them, that they spin clockwise to send the prayers inscribed on the drum or on paper inside out in to the world. (Fig. 71)

The climax of the sacred journey in South Asia often involves the sight of an important image, enclosed within a temple. Ritual seeing is of great importance in Hinduism: Hindus visit a temple or go on pilgrimage in order 'to take *darshan*', to see and be seen by a deity. Their movement to a sacred centre and gradually through the increasingly sacred precincts of a temple all lead up to this sight of God. These images of Hindu deities, Jinas or Buddhas are made from many substances, but it is the stone and metal images that survive over long periods; the earliest surviving images date to the 1st century BC. Buddha images are not usually associated with a particular site, though a few images have acquired great ritual status: the image in Tibet's most important temple, the Jokhang in Lhasa is a good

example. But the iconography of a Buddha image may refer not only to an event in the Buddha's sacred biography but also the place where this happened: an image of the Buddha in 'touching the earth' hand-gesture (*bhumis-parshamudra*) is a reference to Bodhgaya as much as the Buddha's enlightenment. The popularity of this particular image of the Buddha from the 8th to the 12th centuries in eastern India and throughout Southeast Asia later reflects the pre-eminence of Bodhgaya over other Buddhist pilgrimage sites.

Images of Hindu deities may be of Shiva or Vishnu in transcendent form, (Fig. 72) or may have a name and iconography unique to a particular pilgrimage spot. Krishna at Puri, for example, is named Jagannatha and usually appears alongside his siblings, Subhadra and Balabhadra. Images of these deities in metal, lacquered wood or painted on paper in bright colours are striking for the simplicity of form, with huge eyes and short limbs, suggesting the folk and tribal origins of these deities. (Fig. 73) Ranganatha is not simply another name for Vishnu but specifically the deity reclining on the serpent Ananta at Srirangam in south India.

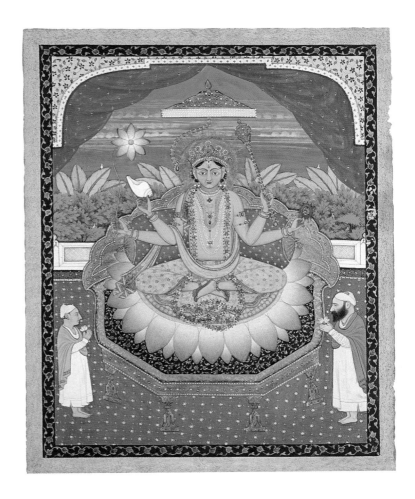

Fig. 73
Jagannatha trio and Sudarshanachakra
Painted wood. Puri, Orissa, early 20th century. Ashmolean Museum, Oxford. 1966.80a–d.

Jagannatha, Krishna as Lord of the World, is shown with black skin and huge eyes alongside his brother Balarama and sister Subhadra; the short post stands for the Sudarshanachakra or Wheel of Vishnu.

Fig. 72 (Left)

Vishnu on lotus petal throne

Painting on paper, early 20th century. Ashmolean Museum, Oxford. EA 1958.117.

Fig. 74

Hand-bell with winged conch finial

Bronze. East Java, 10th to 12th century. Ashmolean Museum, Oxford. EA 1991.68.

Such bells were used in Hindu and Buddhist rituals, often capped with images of Nandi, Shiva's bull, *nagas* (snakes), lions, tridents or other symbols such as this winged conch. Large numbers of bronze bells have been discovered in Java, dating to the 10th to 12th century East Javanese period.

The elaborate rituals that take place at a pilgrimage site involve the use of many objects, such as lamps, vessels for oil or other fluids, offering plates and bells – all ornamented with auspicious symbols or images of divine beings. (Fig. 74) Pilgrims may purchase offerings – food, flowers, small images - at the site or may bring some with them. In Burma and Thailand a common practice amongst pilgrims is the donation of small sheets of gold leaf to be smoothed over a Buddha image or *stupa*; over time the image may become deeply encased in a layer of gold, testifying to generations of devout pilgrims' donations.

At many Indian pilgrimage sites, such as Sarnath or Bodhgaya, clusters of miniature *stupas* crowd around the main monument, mostly dating to the 8th to the 12th centuries. (Fig. 75) These are often described as votives, offerings made by pilgrims; the construction of stupas of any size produced merit.[21] Miniature baked clay *stupas*, some impressed with short inscriptions or Buddhist symbols, have been found in great quantities in eastern India testifying to the great numbers of pilgrims. Larger stone *stupas* up to around 1.5 metres in height were also left at these sites,

Fig. 75

Miniature *stupas* alongside the Mahabodhi temple at Bodhgaya

(Photo: Crispin Branfoot 1993)

often more elaborately carved with Buddha or *bodhisattva* images in niches. Some of these contained relics of deceased monks and were thus funereal in nature, evidence for the belief in the presence of the Buddha in the main *stupa* and the desire to have one's remains close to his beneficent presence.[22]

Many pilgrims return home from the journey with sacred souvenirs and memorabilia, objects that prove the journey was completed and that make a physical connection with the sacred presence or charisma of the site. Buddhist pilgrims to Bodhgaya may return with a leaf from the tree under which the Buddha attained enlightenment. Hindus travelling to the sacred river Ganges may take small sealed metal pots containing holy water home with them. Small images of the deities at a particular temple may return home with pilgrims: the many small images of the Jagannatha trio from Puri are good examples. Paintings and prints are particularly suitable for transporting home, being cheap and light (Fig. 76). The mass-produced prints of the myths and deities of Hindu India sold at pilgrimage sites and in the bazaars today have only proliferated since the foundation of printing presses in India in the late 19th century.[23] Visitors to a temple can return home with a cheap print of the deity seen there, with the local myths of the site arranged around the central image. This printed image may become incorporated into a home shrine, a reminder of the pilgrimage and a material connection with the deity there. There were undoubtedly traditions of folk painting associated with pilgrimage sites prior to the 19th century, but few now survive. One of the best known folk painting traditions from a particular pilgrimage site is the one that developed at the Kalighat temple in Calcutta between the 1820s and 1930s. Vibrant watercolour images of Hindu deities and current social and political events were depicted by rural artists, who adapted their work to an urban, colonial market.[24] (Figs. 77 & 78)

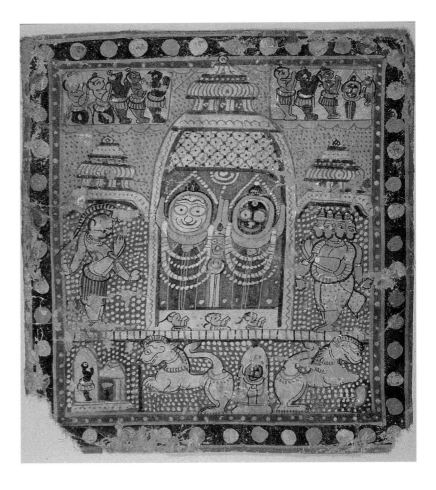

Fig. 76

Jagannatha trio

Painted on paper. Puri, Orissa, early 20th century. Ashmolean Museum, Oxford. EA 1967.209.

These deities live in a great temple in Puri, here shown in this painting. Every year the three deities travel on huge wheeled temple chariots during a great festival at which great numbers of pilgrims regularly attend. The English word 'juggernaut' derives from these festival vehicles.

Huge numbers of Buddhist votive plaques have been found in eastern India, Burma and Thailand. These are made in terracotta from a detailed mould with an image of the Buddha or scenes from his life and perhaps a short inscription, usually the ubiquitous Buddhist creed. (Fig. 79) Like votive *stupas* these could be left at an important temple or *stupa*, or since they are small and portable can be carried home for use in a private shrine. Drawing on a long tradition of terracotta image production across north India, this practice seems to have originated at Bodhgaya but became common in Burma and Thailand.

In addition to paintings or sculptures of the images or deities seen at a pilgrimage sites, are the reproductions of the sacred site's topography. Jains have produced monumental cloth paintings of pilgrimage

Fig. 77
Ganesha

Kalighat painting, Calcutta, Bengal. Late 19th/early 20th century. Ashmolean Museum, Oxford. EA X295.

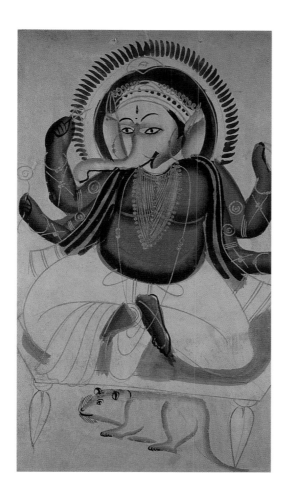

Fig. 78 (Far right)
Kali

Kalighat style, block-print and paint, Calcutta, Bengal. Late 19th/early 20th century. Paper. Ashmolean Museum, Oxford. EA 1966.64.

The fearsome, benevolent goddess Kali is worshipped at the Kali temple in south Calcutta after which the Kalighat style of painting and block-printing derives.

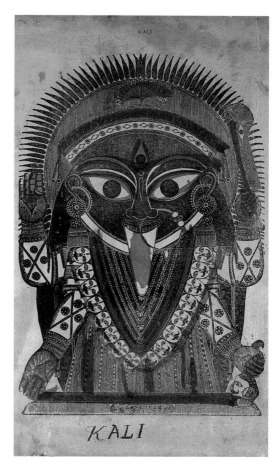

sites. Early examples from the 15th century were small-scale and depicted the five important pilgrimage sites, but by the 18th or 19th century huge cloth-paintings of a single site were produced. These were displayed in temples on special occasions and viewed by Jain congregations as a preparation or substitute for the actual pilgrimage.[25] Their great scale and detailed topography, often with labels identifying temples, meant that viewers could acquire the merit of the pilgrimage without conducting it. Large painted marble slabs of similar depictions are built into the walls of many 19th and 20th century Jain temples. Viewing these pilgrimage paintings or reliefs is a ritual act: the eye moves up the painting to see the temple and *tirthankaras* at the top. Small pilgrimage maps of, for example, Mount Shatrunjaya are often found in Jain domestic shrines alongside photographs or sculptures of Jinas. Maps of Hindu pilgrimage sites have also been produced, particularly of important north Indian sites such as Mathura or Varanasi. Woodblock prints of the main deities, temples and natural features are displayed schematically as a guide for pilgrims at the site and a reminder of the journey once home.

Pilgrimage is time away from daily routine, a time to cross boundaries of class, nationality, ethnicity or religion on a journey in quest of the sacred. For many people in South Asia this may be an inward spiritual journey, as Kabir suggests, but the busy roads, paths and railways of today are enduring testimony to the popularity of the sacred journey in Asia for the past two thousand years.

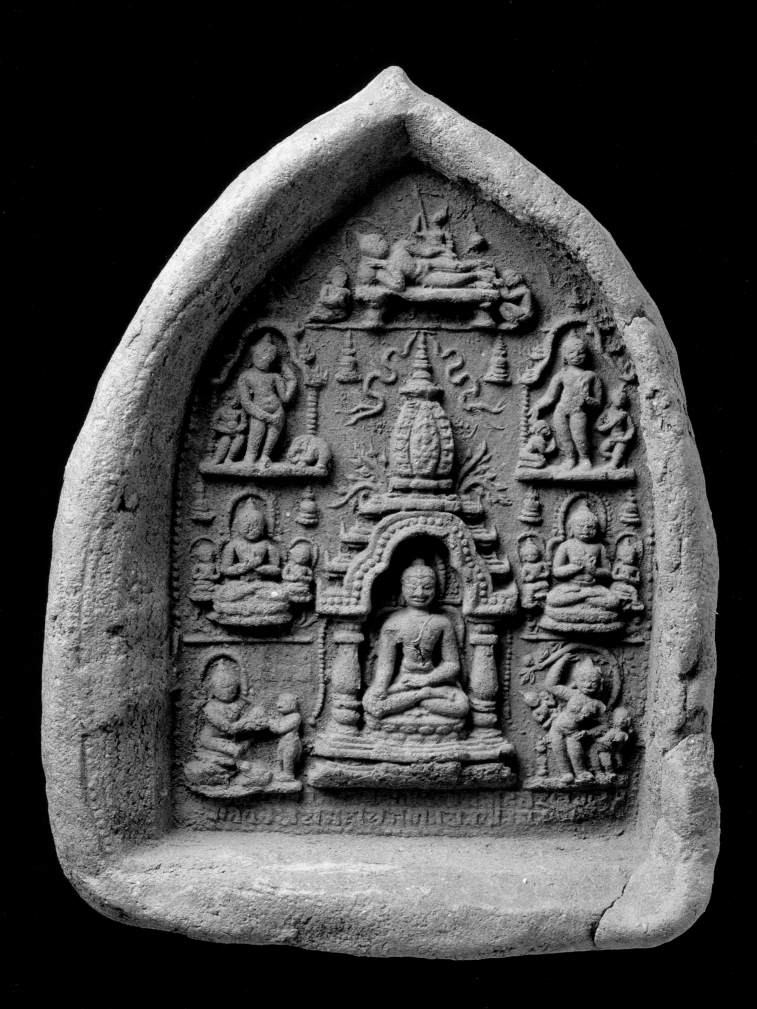

Fig. 79

Buddhist votive plaque

Terracotta. Pagan, Burma, 13th century. Ashmolean Museum, Oxford. EA X 415.

Around the main scene of the Buddha's enlightenment at Bodhgaya are his birth, first sermon and death, and four further miraculous events that came to be included from around the 8th century: the miracle at Shravasti, the taming of the mad elephant, the monkey's offering of the bowl of honey and the descent from the heaven of the thirty-three gods.

1 Charlotte Vaudeville, *A Weaver named Kabir*. New Delhi: Oxford University Press (1993): 218.

2 This dating is controversial; many scholars now date the historical Buddha later, c. 486–400.

3 Surinder Mohan Bhardwaj, *Hindu Places of Pilgrimage in India: A Study in Cultural Geography*. Berkeley, Los Angeles and London: University of California Press (1973): 29–57.

4 A lively account of one anthropologist's participation in this pilgrimage is E. Valentine Daniel, *Fluid Signs: Being a Person the Tamil Way*. Berkeley, Los Angeles and London: University of California Press (1984): 245–287.

5 Susan Stronge, *Painting for the Mughal Emperor: The Art of the Book 1560–1660*. London: V&A Publications (2002): 79-81.

6 The list may vary: Gaya or Haridwar may be replaced by Kancipuram.

7 The common Indian phenomenon of grouping pilgrimage sites together into a numbered group, whether across India or in more regional settings is discussed by Anne Feldhaus focussing on Maharashtra in *Connected Places: Religion, Pilgrimage and Geographical Imagination in India*. New York: Palgrave Macmillan (2003).

8 Alan W. Entwistle, *Braj: Centre of Krishna Pilgrimage*. Groningen: Egbert Forsten (1987).

9 John Clifford Holt, *The Religious World of Kirti Sri: Buddhism, Art and Politics in Late Medieval Sri Lanka*. Oxford: Oxford University Press (1996): 57–63.

10 On Jain pilgrimages see Paul Dundas, *The Jains*. London: Routledge (1992) and Phyllis Granoff, "Jain Pilgrimage: In Memory and Celebration of the Jinas" in P. Pal (ed.), *The Peaceful Liberators: Jain Art from India*. London and New York: Thames & Hudson (1994): 63–75.

11 Carl Ernst, "India as a Sacred Islamic Land" in Donald Lopez (ed.), *Religions of India in Practice*. Princeton: Princeton University Press (1993): 556–563.

12 Richard Eaton, "The Political and Ritual Authority of the Shrine of Baba Farid" in Richard Eaton (ed.), *India's Islamic Traditions, 711–1750*. New Delhi: Oxford University Press (2003): 263–284, 264.

13 Eaton, "Shrine of Baba Farid", 280. For further information about *dargahs* in South Asia see Carl Ernst and Bruce Lawrence, *Sufi Martyrs of Love: The Chishti Order in South Asia and Beyond*. New York: Palgrave Macmillan (2002), Mumtaz Currim and George Michell (eds.) *Dargahs: Abodes of the Saints*. Bombay: Marg Publications (2004) and Anna Suvorova, *Muslim Saints of South Asia*. Richmond: RoutledgeCurzon (2004).

14 S.A.A. Saheb, "A 'Festival of Flags': Hindu-Muslim Devotion and the Sacralising of Localism at the Shrine of Nagore-E-Sharif in Tamil Nadu." in Pnina Werbner and Helen Basu (eds.) *Embodying Charisma: Modernity, Locality and the Performance of Emotion in Sufi Cults*. London & New York: Routledge (1998): 55–76, 60

15 Raymond Brady Williams, *An Introduction to Swaminarayan Hinduism*. Cambridge: Cambridge University Press (2001, 2nd edition).

16 *www.shikshapatri.org.uk*

17 Amongst the many studies examining the shifting formation of religious identities in South Asia are Peter van der Veer, *Religious Nationalism: Hindus and Muslims in India*. Berkeley, Los Angeles and London: University of California Press (1994) and David Gilmartin and Bruce B. Lawrence (eds.) *Beyond Turk and Hindu: Rethinking Religious Identities in Islamicate South Asia*. Gainesville: University of Florida Press (2000).

18 Feldhaus (*Connected Places*: 133) comments that sets of pilgrimage places in India serve to give India a conceptual unity, providing an occasion and means for people to *think* about India as a whole as well as physically circulate to these sacred sites.

19 Janice Leoshko (ed.), *Bodhgaya: the site of enlightenment*. Bombay: Marg Publications (1988) and John Guy, "The Mahabodhi Temple: Pilgrim Souvenirs of Buddhist India." *The Burlington Magazine* 133 (1991): 356–67.

20 Paul Younger, *Playing Host to Deity: Festival Religion in the South Indian Tradition*. Oxford: Oxford University Press (2002): 17–25.

21 Simon Lawson, "Votive objects from Bodhgaya" in Leoshko (ed.), *Bodhgaya*: 61–72.

22 Gregory Schopen, "Burial 'ad sanctos' and the Physical Presence of the Buddha in Early Indian Buddhism: A Study in the Archaeology of Religions" in *Bones, Stones and Buddhist Monks: Collected Papers on the Archaeology, Epigraphy and Texts of Monastic Buddhism in India*. Honolulu: University of Hawaii Press (1997): 114–147.

23 Christopher Pinney, *'Photos of the Gods': The Printed Image and Political Struggle in India*. London: Reaktion Press (2004).

24 Jyotindra Jain, *Kalighat Painting: Images from a Changing World*. Ahmedabad: Mapin (1999).

25 Sridhar Andhare, "Jain Monumental Painting" in P. Pal (ed.), *The Peaceful Liberators: Jain Art from India*. London and New York: Thames & Hudson (1994): 76–87.

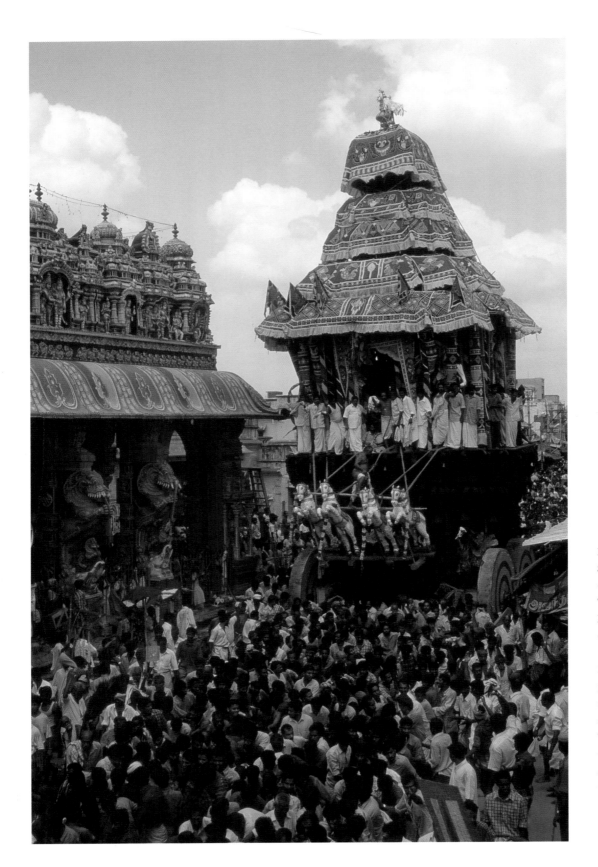

Pilgrims at the Subramanya (Skanda) temple at Tirupparankundram near Madurai in southern India
(Photo: Crispin Branfoot 2002)

Much larger numbers of pilgrims attend the annual festivals held at many southern Indian temples. The highlight of such festivals is the grand procession of the temple's deities through the streets on a mobile temple or chariot (ratha or ter) that is pulled by devotees.

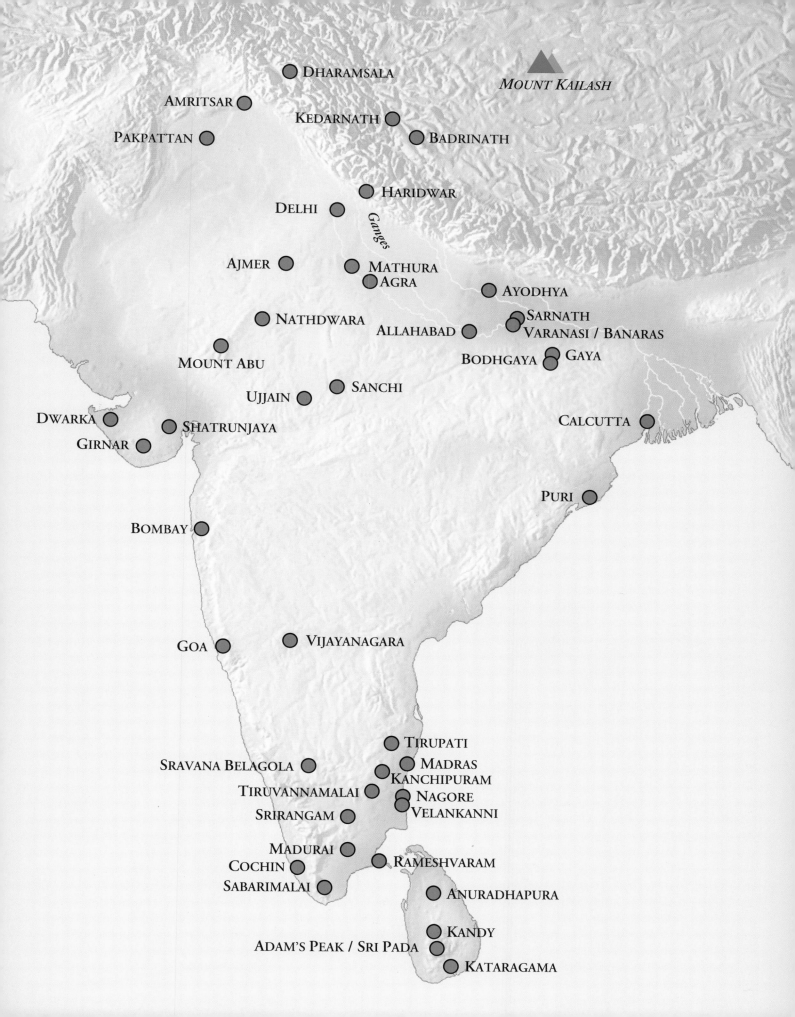

DHARAMSALA

AMRITSAR

PAKPATTAN

KEDARNATH

BADRINATH

MOUNT KAILASH

HARIDWAR

DELHI

Ganges

AJMER

MATHURA

AGRA

AYODHYA

NATHDWARA

ALLAHABAD

SARNATH

VARANASI / BANARAS

BODHGAYA GAYA

MOUNT ABU

UJJAIN SANCHI

DWARKA

SHATRUNJAYA

GIRNAR

CALCUTTA

PURI

BOMBAY

GOA VIJAYANAGARA

TIRUPATI

SRAVANA BELAGOLA

MADRAS

KANCHIPURAM

TIRUVANNAMALAI

NAGORE

SRIRANGAM

VELANKANNI

MADURAI

COCHIN

RAMESHVARAM

SABARIMALAI

ANURADHAPURA

KANDY

ADAM'S PEAK / SRI PADA

KATARAGAMA

William Wey

AN ENGLISH PILGRIM'S
JOURNEY TO JERUSALEM

Francis Davey

*Celeriter propera Jerusalem nec moram
facias.*[1]
Hasten quickly to Jerusalem and make no
delay.

The writer of these words, William Wey, was
a Devonian, born, probably, in 1407, who
died in his 70th year on 30th November
1476. A Master of Arts and a Bachelor of
Divinity, he was a Fellow of Exeter College,
Oxford from 1430 to 1442 and a Fellow of
Eton College from 1441 until his retirement
to the Augustinian Priory of Edington in
Wiltshire, probably at the age of 60 in 1467.
During his time at Eton, apart from the
periods when he was given leave to go on
pilgrimage, he was almost continually one
of the two Bursars who were elected, or re-
elected, each year by the Provost and Fellows.

According to the Statutes of the Founder
of Exeter College, Bishop Stapledon, eight
of the 13 Fellows of the College had to
come from Devon, and Wey was one of
these.[2] The *Register* of Bishop Neville,
Bishop of Salisbury, records that he was
ordained sub-deacon on 7th March, 1433.
The *Accounts* of the Rector of Exeter
College describe various gifts made by Wey
to the College, even after he relinquished
his Fellowship, in 1440, 1451 and 1457.
The Eton College archives contain several
references to him as Bursar together with
the transcript of a letter from Henry VI in
1457 giving Wey permission to absent
himself from the College "to passe over
the See on peregrinage, as to Rome, to
Jerusalem and to other Holy Places".
Another document dating from this period
is the Papal Indulgence granted by Pope
Pius on 29th November, 1460, which gives
him permission to have a portable altar.[3]

Apart from the references in the sources
given above, most of what we know about
Wey has to be gleaned from his bound man-
uscript, *The Itineraries*, which is to be found
in the Bodleian Library (Fig. 80).[4] Wey left
this book, together with several gifts,
including his map of the Holy Land "with

Jerusalem in the midst", to the "chapel
made to the likeness of the sepulchre of Our
Lord at Jerusalem". The foundations of the
chapel, which Wey built to contain the sou-
venirs of his pilgrimages, can still be seen
outside the south wall of the chancel of
Edington Priory, while its splendid entrance
is visible inside. The history of *The
Itineraries* after the Dissolution of the
Monasteries is unknown. B. Badinel, in his
Preface to the Roxburghe edition of 1857
(p. vii), records the names of two men, Mr.
Tempest and John Edwards, who might
have owned the volume.

Wey undertook three pilgrimages, to
Compostella in 1456, to Rome and
Jerusalem in 1458 and to Jerusalem again in
1462. His book contains 15 chapters, the
first three in English and the rest in Latin.
Only Chapters 7 (Rome and Jerusalem), 9
(Jerusalem) and 15 (Compostella) are itiner-
aries in the true sense of that word. The other
chapters contain a variety of supporting
information useful to a pilgrim, and in some
cases duplicate material found in the three
main chapters. It can plausibly be argued that
these passages are earlier drafts by Wey which
he incorporated in the final version. The
most striking example of this is Chapter 2,
entitled "Prevision", which describes the pro-
visions and kit a pilgrim should procure in
Venice before embarking on the galley to
Jaffa. It contains all sorts of practical, not to
say homely, advice about the size of the chest
and the barrel one should buy for dry and
wet supplies. He tells the reader what sort of
food and medicines to take with him. "Make
sure you have a lantern and candles, bedding
and cooking utensils and even a chamber pot
in case you are too sick to go up on deck to
use the normal facilities". He tells the pilgrim
about the chandler in Venice, just beside St
Mark's, who will sell you a feather bed, a
mattress, two pillows, two pairs of sheets and
a quilt for three ducats, and then buy them
back from you, when you return, for one and
a half ducats. The whole of this chapter
appears again, but in Latin, in Chapter 9.

Fig. 80
**William Wey's
Itineraries**
England c. 1470.
Parchment. Bodleian
Library MS Bodley 565,
folio 85v–86r.

The manuscript is writ-
ten in English and
Latin, probably dictated
to a scribe around 1470,
when the author was
living at the Augustinian
priory at Edington,
Wiltshire. The pages
shown here are from his
second journey to the
Holy Land. They give an
alphabetical list of places
of interest to pilgrims;
this is headed 'Nomina
civitatum, opidum,
moncium, vallium,
marium, per literas
Alphabeti in mappa mea
de Terra Sancta' ('an
alphabetical list of the
names of towns, …,
mountains, valleys, seas
on my map of the Holy
Land'). The map illus-
trated in Fig. 81 has
sometimes been identi-
fied as William Wey's.

Quachym · a monasterio sci pauli p[er] ssayr · citad
cayr via ducco ad ethiopia · J[ohann]es citad a monasterio
sci Antony · flumen nylj Insula tum · p[er]stendco
domor paganor lubilomo · linga · citlia i ayabia
mynth columpna altissima · Alexandria magna
Palino stepeu stepreon stastoro · a mono victato
Alexandrio · portg votq. / m / m / m / m / m / m /

¶ Chora citatu opidu monauo villau magnu
p litao alphabeti i mappa mea do tra sta.

Asor	Alexaeth	Betsayda
Abolina	Alexadria	Behyndor
Adalon	magna	Basan
Affech	Arabia	Bethomath
Agio	Antliban	Bethel
Acon	Angolus	Bethsago
tholomaida	apamia	Betol
Anathot kyo	bach	Bethoron
Astaroth	Archedomach	Botama
Ascopolio	Angelyappi	Botulia
Aycham	pastoria	Bethsames
Astol	Aquila	Benoth
Ayan	altissima	Bethsur
Amathia	Arbor siccnor	Betachar
Achaion	sup quo zachos	Bessabe
Astalon	ascendebat	Bulbeo
Azotus	Baalgad	Butold
Ayon	Bolinao	Cananea
Adama	Babyth portq.	
Assinar	Bofra.	
Cryff		

The first chapter of *The Itineraries* is about money. Wey describes 40 different varieties of coinage and gives all sorts of hints about the best places for pilgrims to change their money between England and the Holy Land. He also offers advice on which coins are accepted where. For example: "When you change money at Bruges, get *guilders* with a round ball and a cross above; they will be good as far as Rome and are best all the way. Do not take any English gold with you from Bruges because you will be the loser in the exchange. Indeed for most of the way they will not change it. All along the route they know Rhenish *guilders* well, and with them you will suffer little or no loss." Wey also emphasizes the importance of Venetian currency for the pilgrim, "Venetian *ducats, groats, grossets* and *soldi* are acceptable in Syria, that is to say The Holy Land, but no other currency except at a great disadvantage in the exchange."

A contemporary of William Wey, Richard of Lincoln, who made his pilgrimage to Jerusalem in 1452 and whose account, known as *The Physician's Handbook*, is now in the Wellcome Library,[6] shows equal concern in the matter of finance for the journey. The very first sentence of Richard's narrative is, "Who that will to Jerusalem go, he must make his change at London with the Lombards". While pilgrims were motivated principally by piety, a return journey by land and sea of over 4000 miles, lasting perhaps nine months, required intelligent planning. Richard's mention of Lombards is a hint that Letters of Credit could have formed a much lighter alternative to the weighty coins listed by Wey.

Wey's Chapter 3 consists of a poem, in English rhyming couplets, 352 lines long, describing the sites in the Holy Land which the pilgrim should visit. This poem marks one of the stages in Wey's search for the best literary form for his work. The following lines give some idea of the flavour of the whole:

"Without the chapel door,
Right in the temple floor,
There is a stone round and plain,
Where Jesus as a gardener met with
 Magdalene.
In that stone by Christ was made
An hole wherein he put his spade."[7]

This passage illustrates one of the main objects William Wey had in making his pilgrimage. He was particularly anxious to see and, preferably, touch physical features which were evidence of Christ's time on earth. The sort of evidence Wey sought included imprints made by Christ's hands, feet and tears, and stones coloured by His blood and by the Virgin Mary's milk. The mark made by Christ's spade in the garden on Easter Day is a good example.

Chapter 4 is a truly curious composition. It comprises a set of mnemonic verses which form a checklist of things pilgrims ought to see during their 13-day tour of the Holy Land. In the 15th century the pilgrimage to the Holy Land, from Venice back to Venice, was very much a package tour. The pilgrim needed to secure a place on one of the two pilgrim galleys which set sail from from Venice to Jaffa at the end of May. The start of the sailing season was governed by the wind known as the *Maestro* or *Maestrale* (not the Mistral of the Golfe du Lion), which blows from the northeast at Trieste but then from the northwest in the central and southern Adriatic. It is a wind which appears very punctually around the third week of May and blows fair for the first 1000 miles of the voyage along the coast of Croatia, Albania and Greece. There is a great deal of information in the Venetian state archives about the regulation of these voyages. The authorities were diligent and just in protecting the interests of both the pilgrims and the galley captains. Once the pilgrims had arrived in Jaffa the Franciscans of Mount Sion took over, providing guides and arranging accommodation

for the 13 days the Saracen authorities allowed for the visit. The whole atmosphere, as shown by other writers as well as by Wey, is strongly reminiscent of that in the Soviet Union pre-1989 when a visit could only be made under the auspices of *Intourist*. There are the same restrictions on movement, the same bureaucracy and the same feeling of being watched all the time by suspicious, if not hostile, eyes. There are many other accounts of pilgrimages to the Holy Land by French, German and Italian travellers.[8]

Wey's checklist is written in crude Latin hexameters in a sort of code, and is dismissed, rather insensitively, by the Roxburghe editor as "a record of medieval superstition and barbarous latinity". At first sight the words do appear gibberish but then one can see that whole words have been replaced by the initial letter or the first syllable of the place to be visited. An example of one such line is:-

> *Lap, stat, di, trimum, flent, sudar, sin
> copizavit.*
> i.e. *Lapis, strata, divitis, trivium, fletus,
> sudarium, sincopizavit.*

Fully expanded and translated, this line describes the first seven places to be seen on the *Via Dolorosa*, which pilgrims walked on day five of their visit:

1. The stone marked with crosses on which Christ fell with His cross.
2. The road along which Christ went to His Passion.
3. The house of the rich man who refused to give crumbs to Lazarus.
4. Where Christ fell with His cross.
5. The place where the women wept for Christ.
6. The place where the widow, or Veronica, placed a handkerchief on Christ's face.
7. The place where the Most Blessed Mary fainted.

These verses, which Wey uses as a framework for the next two Chapters, 5 and 6, were an aide memoire he wrote for himself, possibly even while travelling. They are so skeletal and obscure he could not have intended them as a serious *vade mecum*, a handbook, for future pilgrims. In any case pilgrims were not allowed to wander at will in the Holy Land. They had to keep to the permitted route and they had a Franciscan guide to accompany them and to see that they did!

Chapters 5 and 6, entitled "Ten Reasons for Pilgrimage to the Holy Land", have a special relevance here. Wey considers, first, spiritual motives for pilgrimage and, secondly, other reasons for such travels and the benefits they confer. He quotes extensively and accurately from earlier writers, especially St Bridget, St Jerome, Pope Leo, Bishop Grosseteste, Petrus Comestor, Bede and the *Golden Legend*, giving excerpts which urge Christians to see the places where Christ was born, ministered and suffered. Wey describes briefly the pilgrim's schedule and itinerary in the Holy Land, concluding with a mention of relics which may be seen on the return journey. Most of this material is reused and expanded with a minute amount of personal reminiscence in Chapter 7.

One of Wey's favourite sources is the *Revelations of St Bridget*, and on five occasions he quotes at length and verbatim from her writings.[10] There is an intriguing link between Wey and the Bridgettines. The writings of St Bridget of Sweden (1303–1373), who was herself an experienced pilgrim, were popular in the 15th century. The one Bridgettine House in England was Syon Monastery, whose famous library was used extensively by scholars. Originally built at Twickenham by Henry V, it soon moved to Isleworth. After the Dissolution it passed into the hands of the Dukes of Northumberland. Some of the 15th-century buildings, notably a barn, which is now a garden centre, still survive.

A magnificent catalogue, worthy of the medieval library, was made in the late 15th century. It is now in the Parker Library at Corpus Christi College, Cambridge, and includes the name of William Wey, recording his gift of a volume of his sermons to Syon Monastery.[11] In *The Itineraries* Wey gives the Latin texts of four of his sermons and the locations where he preached them during his various pilgrimages. These include the House of the Franciscans in Corunna on 27th May, 1456 and the Temple in Jerusalem on 30th June, 1458. While the present whereabouts of this volume of his sermons are not known, Eton College still has three other books, once owned by William Wey, which he presented to the College.

Chapter 8 is simply an unembroidered list of places between Calais and Rome, Rome and Venice and Venice and Calais, and the distances between them, which enables one to trace the route he followed. From this list it appears that in 1458 Wey travelled a considerable distance by water, although he does not say this explicitly. He reached the Rhine at Sinzig and probably travelled from there to Speyer, with one detour via Odername to avoid the notorious Loch rapids near Bingen, by river barge, the *Oberländer*. These vessels were used from Celtic times until the beginning of the 18th century to carry freight and passengers both up and down the Rhine. Contemporary illustrations show that the tow-rope, pulled either by oxen, horses or men, was attached to the mast of the barge. Tow paths were usually on the left bank. Whenever the bank was too steep the horses were transported by ship to the opposite bank or specially built tow-path bridges were used. The places Wey mentions along the Rhine mark stage points where passengers could disembark and pilgrims could sleep ashore. The present writer has followed this route and it is significant that the distance Wey gives between the places he names along the

Rhine (three German miles, i.e. twelve English miles) is a reasonable distance for one day's towing against the stream. Even more significant is the fact that each of these places had a monastery, usually Franciscan, which would provide a night's accommodation for the pilgrim.[12] Four years earlier, in 1452, Richard of Lincoln travelled by river all the way from Cologne to Basel. The Rhine was not the only river used by pilgrims: Richard also took advantage of the Po from near Pavia to reach Piacenza, Cremona, and Corbola, whence he continued "all by water" via Chioggia to Venice. Roman roads and rivers were very important for those undertaking long pilgrimages.

Chapter 9 resembles Chapter 7 in that it is much more a piece of travel writing, but differs from it since approximately half the chapter is devoted to Venice, where Wey spent nearly five weeks in the late spring of 1462. He reached Venice in time to witness the magnificent procession of the Doge to St Mark's on St Mark's Day, 25th April. A week later this same Doge, Pascale Malopero, died and so our pilgrim was present both at his sumptuous funeral procession and the even more splendid coronation ceremony of his successor, Christophero Mauro. The *Serenissima* at the height of her glory in the Quattrocento made an impression on Wey which he never forgot. This was the Venice of Giovanni Bellini and the Italy of Piero della Francesca, Botticelli, Mantegna and Donatello. One can still feel, quivering beneath his narrative, the thrill of admiration Wey felt at what he saw and heard in Venice.

Just as modern guide books often contain a glossary of useful words and phrases, Wey's Chapter 10 offers three word lists. The first contains 132 common English words or phrases, and their Greek equivalents, which the pilgrim will need to obtain food, drink and lodging. There are also key words from the Lord's Prayer, the Ave Maria and the Creed, together with a list of

the Greek numerals. The second list is a long one with well over 700 Greek words and their Latin equivalents. The final list contains 92 Latin words and their Hebrew equivalents. The chapter closes with the Hebrew alphabet. While only a specialist linguist might be interested in seeing how William Wey transliterates Greek words and in observing his attempts at phonetics, the general reader might relish the information he gives us about the items of food and the situations which he considered sufficiently important to be included. After such vital phrases as, "Where is the tavern?", and "Woman, have ye good wine?" Wey gives us an appetising list of comestibles, starting with butter, milk and cheese, going on to pork, mutton, goose and oysters, with onions, garlic and parsley included to add flavour, and closing with apples, pears, grapes, figs and cherries. This menu, of course, does not mean that Wey and his fellow pilgrims dined in such luxury every day, but it does show what he thought was worth asking for. Wey inserts a fourth word list two chapters later at the end of Chapter 13. This one contains 90 Latin words or phrases and their Greek translations, and almost all the items of food given earlier in the English-into-Greek list appear here as well. The fact that this duplicated list appears apart from the other vocabularies – almost as though Wey was filling in space at the end of the folio – may be further evidence that the book from the Bodleian now displayed here contains preliminary draft notes as well as the polished, final, version of Wey's pilgrimages.

This impression is reinforced by Chapter 11. Just as on a medieval *Mappa Mundi*, thumbnail sketches of legendary creatures like the phoenix or the skiapod appear around the borders of the map and tucked into the corners, so Chapter 11 is a patchwork, a common-place book, with little items which William Wey did not incorporate into his main narratives.

He talks, for example, of places like Patmos and Bodrum, Nuremburg and Constantinople, which were not on the routes he followed. He quotes a letter from Saladin to the Grand Master of the Knights Hospitaller and describes the Frankish kings of Jerusalem. One of his many interests is botany, and he notes the way Saracen women use roses of Jericho (*Anastatica hierochuntia*) in childbirth. In a longer passage he discusses the cultivation and harvesting of pepper. This paragraph alone opens up a whole series of research topics as it was at this time that the Portuguese were exploring sea trade routes round Africa to India, a process which eventually led to the collapse of Venice's trading wealth and, indirectly, to the cessation of the pilgrim galley voyages to Jaffa. There is just the very slightest hint also of the legendary kingdom of Prester John. The armchair strategists of the Middle Ages hoped that somehow the Christian West could link up with his fabulous Christian kingdom in the East, beyond the Holy Land, and, attacking the Muslims in a pincer movement on two fronts, liberate Jerusalem. Wey does not mention the name of Prester John, but he does talk of a mysterious kingdom called Mynbar with two cities named Flandrina and Gynglyn. In Flandrina, he writes, live Jews and Christians who are continually at war. There is a grove there, full of serpents, where pepper is harvested like grapes. There is also a city called Polumbum where the finest ginger grows. The feeling that one is sailing around the very edge of the then known world grows even stronger.

Wey's interest in geography is amply proved by the next two chapters, 12 and 13. The sub-title reads, "In the following list are contained all the things in the Map of the Holy Land". Wey goes on to revise this, apparently haphazard, list, which was presumably his initial rough draft, into a more formal "fair copy" headed, "The Names, in Alphabetical Order, of the

Cities, Towns, Mountains, Valleys and Seas on my map of the Holy Land", *in mappa mea de Terra Sancta*. The word "my" is significant.

When Badinel was preparing his transcription of *The Itineraries* in 1865 for the Roxburghe Club, he naturally visited the Bodleian to consult the original, and only, copy of the work. While he was there, he writes, a Mr Coxe showed him the large, coloured map of the Holy Land, also in the possession of the Bodleian (MS Douce 389, see Fig. 81). Badinel believed that this was the map William Wey himself had made and which he mentions on the flyleaf of his book among the bequests he wishes to make to the Chapel at Edington. Recent research, however, indicates that the Bodleian map was made in the 14th century, in which case Wey was not its creator.[13]

Many of the places shown on Douce 389 can be linked to passages in Wey's *Itineraries*. While a large number of the important sites which he mentions would appear on any medieval *Mappa Terrae Sanctae*, some of the ones on the Bodleian map are so germane to Wey's narrative and interests that they appear to confirm that he knew, perhaps even owned, the map. Indeed, his Chapters 12 and 13 provide a gazeteer with cross-references to it.

The most striking example is where the map shows the location of "The Wood Where the Birds Die For Christ and Rise Again". This phrase would be almost unintelligible if one did not have the story, taken from Robert Grosseteste, whom Wey calls *Lincolniensis*, given in his Chapter 6.[14] This story, told by a Saracen, describes how, in a certain wood, wild songbirds die every year on Passion Sunday but come back to life a week later on Easter Day.

Almost as striking is the location of "the river which bubbles on the Day of Epiphany" – *fluvius qui ebbulit* (sic) *in die Epiphanie*. This refers to the miracle which Wey describes in Chapter 6, *In via ad*

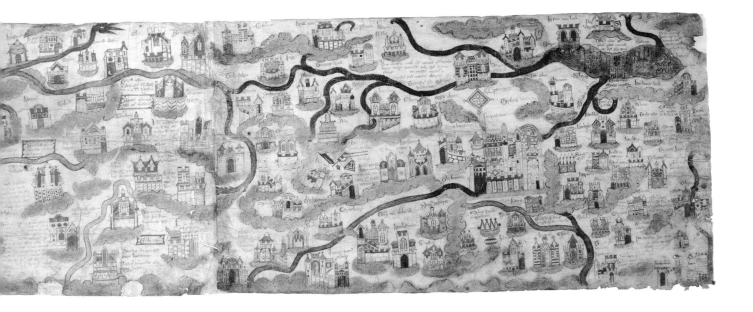

Fig. 81
Map of the Holy Land
England c. 1350–1400. Illuminated parchment. Bodleian Library Douce 389.

To read this map of Palestine in a way familiar to us, it needs to be turned approximately 90⁰. The left of the map is equivalent to North, the right to South. The base shows the Mediterranean shore; unlike other waterways on the map, the sea is not painted blue but is left blank. The northernmost port is Sidon, the last one in the South is Gaza. Damascus is prominently drawn above (i.e. East of) Sidon, and inland the towns extend to Hebron and Beersheba. Jerusalem is most prominently shown in the upper centre of the map's right (South-East) side.

The cities are indicated by buildings, with towers and gates. These may be quite specific, as is most obvious in the depiction of Jerusalem, where the dome of the Church of the Holy Sepulchre can be made out. The locations are inhabited by little figures, and some locations may be further identified by the drawing of events they are associated with, e.g. Cana of Galilee has six stone water jars, a reference to the miracle performed when he turned water to wine. The land is painted green, lakes, seas, and rivers are blue. The Sea of Tiberias is filled with fish, and at the bottom of the Dead Sea one can make out the outlines of the four sunken cities.

The map was written about in some detail by Reverend George Williams, who published it as a facsimile in 1867. He had also worked on William Wey's *Itineraries* and believed that this was the map that Wey referred to in his list of place names and sacred locations in the Holy Land. He thought that William Wey had actually written and drawn the map himself; as it predates Wey's pilgrimage possibly by as much as 100 years, this is impossible to maintain. It is remarkable, though, that the place names listed in Wey's manuscript and on the map very closely overlap. Of course he may have owned this very map; he certainly had a map that would have been similar.

Bethlehem... aqua ebullit de terra et currit super viam a primis vesperis Epiphanie Domini usque ad secundas vesperas et postea cessat: "On the road to Bethlehem water bubbles out of the ground and runs on the road from the first vespers of Our Lord's Epiphany until the second vespers and then stops."[15]

These two "recurrent" miracles are examples of a special interest Wey had in pilgrimage, which will be discussed further below. Their appearance in the *Mappa* and Wey's mention of them, both in Chapter 6 and in Chapters 12 and 13, which appear to catalogue the map, indicate that even if Wey did not draw the map himself, he was very familiar with it or with one like it. The word *mea*, "my", could indicate ownership rather than authorship, as Badinel believed. On the flyleaf of *The Itineraries* Wey also lists, in addition to his *Mappa Terrae Sanctae*, a *Mappa Mundi*, but the whereabouts of this latter map are unknown.

Chapter 14 is entitled "Indulgences in the Roman Curia". Wey describes not only the seven principal churches normally visited by pilgrims to Rome but also a very large number of other churches and monasteries, with details of the holy relics each contains and the tariff of indulgences available to pilgrims viewing them.

The final Chapter, number 15, deals with William Wey's first pilgrimage, made by sea from Plymouth to Compostella in 1456. This chapter was written while Wey was living in retirement at Edington since, in the title to it, he refers to himself as *quondam socius*, "sometime fellow" of Eton College. Like Chapters 7 and 9 it is an interesting piece of travel writing, giving glimpses, not only of the hazards of the journey *ad limina Sancti Jacobi*, but also of Wey's fellow pilgrims and persons he met in Corunna and Santiago. His references to the House of the Friars Minor in Corunna and the Spanish Jew whom he met in that city will be considered below.

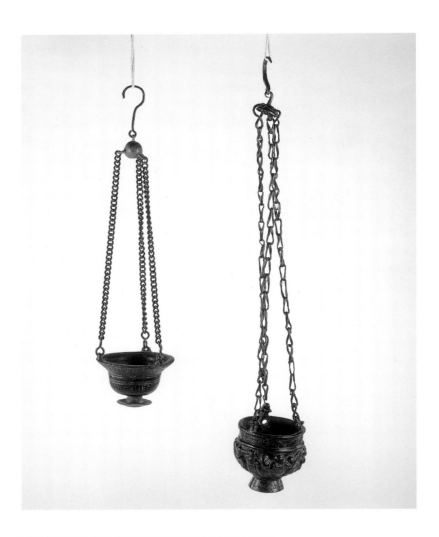

Fig. 82
Two censers
Brass. Syria and Greece, possibly 6th or 7th century. Ashmolean Museum AN 1970.591, AN 1980.17.

Fig. 83
Glass bottle associated with pilgrimage to Jerusalem
Ashmolean Museum AN 1949.144.

The bottle held holy water and may have been used by a Christian, Muslim, or Jewish pilgrim.

William Wey and Reasons for Pilgrimage

Among the "Ten Reasons Inspiring Christians to Go on Pilgrimage to the Holy Land" which Wey gives in Chapters 5 and 6, the award of indulgences appears twice. Chapters 14 (Rome) and 15 (Compostella) contain detailed lists of the indulgences available to pilgrims at various churches in those two cities. In their descriptions of their tours of Jerusalem both William Wey and Richard of Lincoln adopt the convention of inserting a red cross in the text to pin-point the places where indulgences may be granted. Richard's words, "Ye shall understand that where ye find the sign of the cross is plenary remission *a poena et culpa* and in other places, where the sign of the cross is not, are 7 years and 7 Lents of indulgence, and the said indulgence was granted of Saint Sylvester at the instance of and the prayer of Constantine, the Emperor, and Saint Helena, his mother". This sentence is an almost exact translation of Wey's, "*Ubi ponitur crux est plena indulgentia a pena et culpa, ubi non ponitur crux sunt indulgentie septem annorum et septem quadragenarum dierum. Predicte indulgentie concesse fuerunt a Sancto Silvestro papa ad preces Sancti et Magni Constantini, imperatoris, et Sancte Helene matris ejus*". This is the most striking similarity between the narratives of the two pilgrims, and one suspects that these identical quotations came from a common source, perhaps one supplied by the Franciscan guides.[16]

Wey, however, had other reasons for his pilgrimage, apart from the gaining of indulgences. He was a Christian and did not need reassurance about the truth of *what* had happened. What he did hanker for was evidence of just *where* notable events in Christ's life and ministry had taken place. This evidence should verify something which had occurred, initially, outside the normal laws of nature, but which also continued to be observable up to the present time. Of the two categories of evidence the first consists of what Wey terms *vestigia*, literally "traces" or "footprints", and the second of what may be described as "recurrent miracles".

The first of these *vestigia* was the mortise for Christ's cross, mentioned by St Bridget. Wey found this "stone with a hole" and measured it:

> "The mortise is a foot of breadth
> Who will mete it with a thread."[17]

On his return home Wey copied this measurement on "a board", which was displayed behind the choir in Edington church. He refers twice more to this stone saying that it was there that "Our Lord designated the centre of the world to be", and "Adam's head was found in that hole after the flood as a sign that therein lay redemption".[18] This is a reference to the tradition, first found in Origen, which placed Adam's tomb on Calvary so that at the Crucifixion the blood of the Second Adam was poured over the head of the First. On his second visit to Jerusalem, Wey copied out the Greek inscription from this stone, which records that "Here God wrought salvation in the centre of the earth".[19] It was this tradition, whose origins can be found in *Ezekiel* 5:5, which led medieval cartographers to place Jerusalem in the centre of their maps, as Wey says, "wyth Jerusalem in the myddys". There is an interesting parallel here with the ancient Greeks, who regarded the *omphalos* at Delphi – in many ways a pilgrimage centre for them – as the navel of the Earth.

Another group of *vestigia* are the marks made by Christ's feet, knees and fingers. Wey had a particular problem with the marks, believed to have been left by Christ's feet at the time of His Ascension, shown on Mount Olivet.[20] He was aware that further research was needed and in 1462, on his second pilgrimage to Jerusalem, he revisited the site for a closer look, citing Supplicius and Petrus Calo.[21] In Chapter 11 Wey reveals the reason for his disquiet: "Remembering that part of the print of Christ's foot is shown on Ascension Day at Westminster, are there footprints of Christ, as He ascended into heaven, on Mount Olivet?"

The fact that Wey refers to this particular *vestigium* five times and at such length shows that he did not feel entirely at ease with the tradition. In the end he leaves the problem of the duplication of the footprint unresolved. He says a great deal about the reasons for considering the set on Mount Olivet as genuine, but does not go so far as to say that the footprint in Westminster Abbey is spurious. Wey's investigations could have led him into contentious, not to say dangerous, areas, when one remembers the theological climate during his lifetime. The Lollards were increasingly active after 1400, and Huss was burned in 1415. In theology, as well as in so much else, Wey was living at a time when Europe was emerging from the Middle Ages.

Other *vestigia* were associated with the site of the Lord's Leap: *Mons saltus Domini*, which Wey also showed on his map (this is referred to again below, since Jews were held responsible for this act of violence to Christ); the cave at Gethsemene and the house of Simon the leper.[23]

Marble frequently shows flecks of colour, which were interpreted with the eye of faith as indications of some significant event. The Franciscan guides had a wealth of such anecdotes dealing with milk dropped by the Virgin Mary, the Virgin's tears and Christ's blood.[24]

Among the "recurrent miracles", the wood where the birds died on Passion Sunday and the Epiphany spring have already been mentioned. Other examples of this category are two miraculous lamps, one at Kassiópi on the northeast coast of Corfu, and the other in the Church of the Holy Sepulchre.[25] Wey is careful to give this latter story as hearsay. He investigated it further on his second visit and reports that the miracle no longer happens, because "The Faith has now been extinguished there. It is said, however, that on Easter Day a Saracen saw fire descending from heaven and falling on the tomb".[26]

Where Wey describes miracles he has not witnessed himself he sometimes adds the words *ut dicitur*, "so it is said", or *ut legi*, "as I have read", as with the wine jar from Cana displayed in Constantinople which refills itself once a year.[27] The window at Damascus, used by St Paul, which can never be closed and the window in St Catherine's prison in Alexandria are other examples.

Some of the miracles Wey recounts are mentioned by other 15th-century pilgrims. Richard of Lincoln describes both the miraculous lamp at Kassiópi and the thorn from Christ's crown, one of the most precious relics of the Knights Hospitaller on Rhodes, while Felix Fabri described the miraculous cross of St Dismas, the Good Thief, which hung in the chapel of the monastery of Stavrovouni in Cyprus without any visible means of support – *sine pendiculo visibili*.[28]

Wey's travels brought him into contact with both Jews and Muslims. He does not display personal hostility to Jews; indeed his almost defiant description of his conversation with a Jew at Corunna, with the words "and no other nation held communication with a Jew" does him credit. The identity of this Jew has been discussed elsewhere.[29] Since Wey was a bibliophile the Jew whom he met might well have shared this interest, being a member of the important family of Mordecai ben David ibn Mordecai. Their Bible was copied for Isaac, the son of Don Samuel de Braga, and this beautiful copy is now in the Bodleian.[30] (Figs. 2 & 3, p.17)

In the Middle Ages a number of scurrilous anti-Semitic tales were in circulation. One of these, which appears in the *Golden Legend*, is related by both William Wey and Richard of Lincoln. This is the apocryphal story of how the Jews tried to seize the body of the Virgin Mary on Mount Sion when the Apostles were taking it out for burial.[31] Another anti-Jewish story is that describing the Lord's Leap, which Wey quotes from Bede's *Commentary* on St Luke.[32] Richard of Lincoln further traduces the Jews by describing the altar "where the Jews diced for Christ's clothes", and the place "where the Jews constrained Simon to take the cross from Christ".[33] These events are both recorded by St Matthew and St Mark.[34] Both Gospel writers describe those who impressed

Fig. 84
Reliquary of St. Remedius. Silver gilt metalwork
Belgium, Mosan region, c. 1400. Ashmolean Museum Loan 521 (The Fathers and Brothers of the Oratory of St Philip Neri at Oxford)

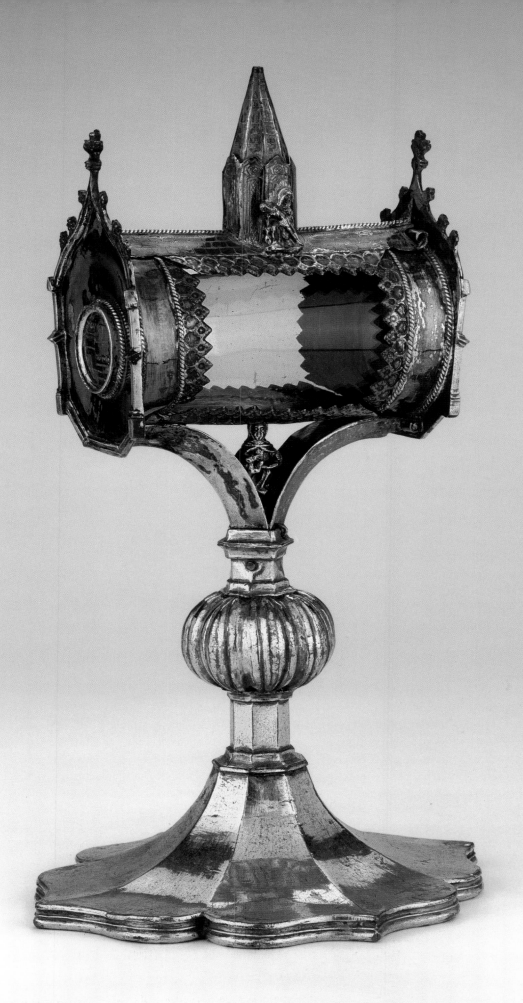

Simon of Cyrene and later diced for Christ's seamless robe as "soldiers". They would not have been "Jews" and William Wey, who knew the Gospels well, would not have subscribed to this error. In perpetuating these items of anti-Semitic propaganda, Richard, who was less familiar with the Bible than William, was probably repeating misinformation given by the guide. Even Wey was not immune to such propaganda. He repeats the tale of the picture of Christ in St Mark's Cathedral in Venice, which was stabbed by a Jew and then dripped blood, and the very high tower in Beirut which the Moors used to climb to call their people to prayer, "Through the power of St Barbara," he writes, "those who call tumble from the tower and perish. For this reason the pagans no longer dare to climb it."[35]

A striking difference between the accounts of Richard and William is the lack of any reference by Richard of Lincoln to the Saracens, until his final page, when he says that on the last lap every man must pay two groats of Venice to the Sultan for safe conduct. In Wey's accounts their hostility is ever-present. In 1458 they appear as soon as the Venetian galleys arrive in Jaffa harbour, pitching their tents on the seashore to ensure that no pilgrims land without permission. After two days' delay (three days in 1462), confined to their ships, the pilgrims are permitted to land but are then immediately shut up in three caves underground for the night. Here the Saracens count them, a procedure which occurs several times during their stay in the Holy Land. These caves were notorious for filth and lack of amenities, but indulgences could be gained by those who endured the discomfort in the right spirit. Two days later, as the pilgrims journeyed from Rama to Jerusalem, a detachment of Saracen cavalry made a hostile demonstration, but without actually launching an attack on the line of pilgrims who were partly on foot and partly on donkeys. Once in Jerusalem the Saracens refused to allow the pilgrims to enter the Church of the Holy Sepulchre until nightfall and, when they did let them in, they counted them and wrote their names down.

The final extortion occurred on their departure in 1462, when the new lord of Jerusalem demanded another 50 ducats before he allowed the galley to depart for home.

Constantinople had fallen in 1453, only five years before Wey's first pilgrimage to Jerusalem, and the Eastern Mediterannean had become a dangerous area, not only because of Turkish galleys. There were over-zealous Hospitaller captains who could be just as dangerous, as is shown by the attack by Grand Master Pedro Zacosta on Venetian galleys en route from Alexandria in 1465.[36] Wey's account of the atrocities committed by the Hospitallers and Baron Flak, Vlad V, Count of Wallachia, (also known as "The Impaler", who is supposed to have been the original of Bram Stoker's Count Dracula) on the Turks still makes the blood run cold. In 1458 Wey was anxious about possible pursuit by Turkish galleys bent on revenge on Christians in general and Knights Hospitaller in particular. His relief on stepping ashore safely at Venice on 6th September after a voyage of 64 days is palpable. In 1462 the situation was even more tense. When Wey arrived in Rhodes on 19th August the Grand Master was preparing for a siege, and had given orders for two years' supply of wheat and wine to be collected. The frightening rumours continued. Doubtless the pilgrims on Wey's galley, the *Morosina*, cast frequent glances astern, dreading the sight of the rise and fall of the oars of a Turkish galley in pursuit. On 5th September a man in Cande told Wey and his companions that the Turk was at sea heading for Rhodes with 300 ships. Again one can feel Wey's relief on reaching Venice unscathed on 11th October.

Like many other pilgrims Wey brought back tangible reminders of his travels. In his retirement at Edington Priory he had a small chapel built to house his mementoes. These included the board inscribed with various dimensions, such as the size of Christ's foot and the replica of the mortise stone of the Cross. Other items in his collection included six stones, one each from Calvary, the Holy Sepulchre, the hill of Tabor, the Pillar, the Place

of the Invention of the Cross and Bethlehem, together with wooden models of the Chapel of Calvary and the Church at Bethlehem. The Bodleian has a 17th century model of the Church of the Holy Sepulchre, which well illustrates this type of souvenir (Fig. 19, p.30)). Wey was well aware of the damage caused by pilgrims. After his visit to Compostella and Padrón in 1456 he says that because so many pilgrims were breaking pieces off the stones where St James's body and miraculous boat had come to rest the authorities had placed what was left of them out of reach of visitors.

In their accounts of their journeys William Wey and Richard of Lincoln have left descriptions which, though brief, yet rouse our admiration and stir our imagination. They provoke questions about late medieval travel which one would gladly pursue further, but, terse though they are, they still give the reader of today faint echoes of the sounds, sights and smells, as well as the emotions, experienced by two devout and intrepid pilgrims, one a priest and the other a doctor, who crossed Europe to the Holy Land five centuries ago.

1 *The Itineraries of William Wey, from the Original Manuscript in the Bodleian Library*; London: The Roxburghe Club (1857): 26. (Hereafter *Itineraries*)

2 *The Register of the Rector, Fellows and Other Members of the Foundation of Exeter College, Oxford*. Oxford Historical Society: C.W. Boase (1894).

3 Lateran Regesta vol. DLXXX *De Altaribus Portalibus*.

4 Bodleian MS. 565.

5 Possibly Bodleian MS. Douce 389.

6 The Wellcome Library for the History and Understanding of Medicine: MS. 8004. (Hereafter referred to as "Richard of Lincoln".)

7 *Itineraries*: 9.

8 Some of these journals are discussed by Rosamund J. Mitchell in *The Spring Voyage*. London: John Murray (1965). Other important descriptions are given by Felix Fabri, who went to Jerusalem in 1480 and 1483, and by Canon Casola in 1494 – see H.F.M. Prescott, *Jerusalem Journey, Pilgrimage to the Holy Land in the Fifteenth Century*. London: Eyre and Spottiswoode (1954) and Margaret Newett, *Canon Pietro Casola's Pilgrimage to Jerusalem in the year 1494*.

Manchester: Manchester University Press (1907).

9 *Itineraries*: 20, 33, 60.

10 These five quotations are all taken from Book 7 of the *Revelations*. According to the edition, *Rev. sanc. Birg.*, by Anton Koberger, Nuremberg, 21st Sept. 1500, in the Lambeth Palace Library, the differences between Wey's version and St Bridget's words are few and trivial.

11 MS. 141.

12 See Peter Brommer and Achim Krümmel, *Klöster und Stifte*. Koblenz: Gorres Verlag (1998).

13 Otto Pächt and J.J.G. Alexander, *Illuminated Manuscripts in the Bodleian Library Oxford. Vol. 3: British, Irish, and Icelandic Schools*. Oxford: Clarendon Press (1973): 67.

14 *Itineraries*: 54.

15 *Itineraries*: 135; 55.

16 Richard of Lincoln: 154; *Itineraries*: 57.

17 *Itineraries*: 10.

18 *Itineraries*: 44, 5l, 68, 70.

19 *Itineraries*: 97, 123.

20 *Itineraries*: 36, 63.

21 *Itineraries*: 98.

22 *Itineraries*: 127.

23 *Itineraries*: 54, 120, 129, 139; 35; 98.

24 *Itineraries*: 52, 123, 97, 126.

25 *Itineraries*: 51–52, 56.

26 *Itineraries*: 97, 126.

27 *Itineraries*: 52.

28 *Itineraries*: 93, 95.

29 *Itineraries*: 154; F. Davey, *Confraternity of St James Bulletin* 72 (December 2000): 23–25.

30 MS Kennicott l.

31 *Itineraries*: 35, 65; Richard of Lincoln: 157

32 *Itineraries*: 55; Luke 4: 29.

33 Richard of Lincoln: 153–154.

34 Matthew 27: 27–35; Mark 15: 16–24.

35 *Itineraries*: 89, 122.

36 Rawdon Brown (ed.) *Calendar of State Papers and Manuscripts relating to Englsih Affairs, Exisiting in the Archives and Collections of Venice, and in other libraries of Northern Italy. Vol. I. 1202–1509*. London: Longman, Green, Longman, Roberts and Green (1864): 115.

37 *Itineraries*: 78.

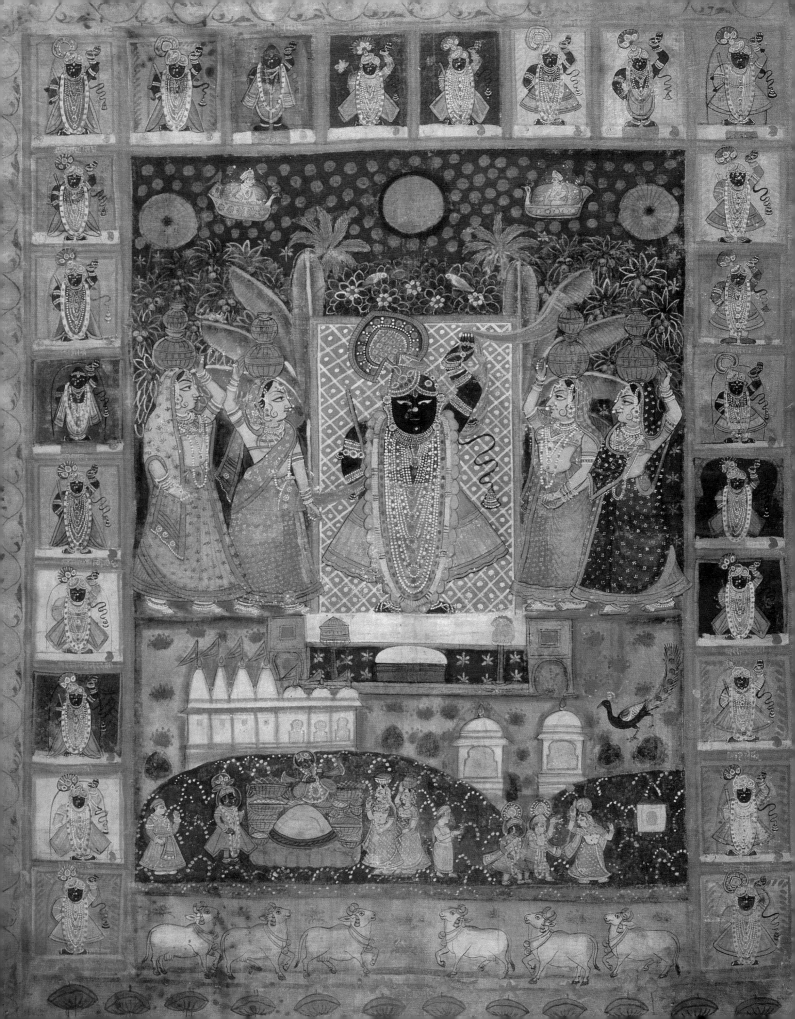

Travellers of Faith

PILGRIM TALES

James W. Allan and Crispin Branfoot

A Jewish Traveller in the Near East

Between 1166 and 1171, a Jewish rabbi by the name of Benjamin, from the Spanish town of Tudela in Navarra, made an extensive tour of the old world. He travelled across southern Europe to Constantinople, went on to Cyprus and the Near East, then through Iraq and Iran to India and China, returning by way of Aden and Ethiopia to Egypt, before travelling back to Spain via Sicily, Italy, and central and western Europe. Rabbi Benjamin was therefore a remarkable traveller for his day. He was also a man with wide interests. His writing shows a fascination with antiquities, and with the history of the lands he visited. (Fig. 86) It also emphasises the importance he attached to meeting his brethren, the different Jewish communities scattered around the globe. Moreover, given the concern he shows for commercial matters, there seems little doubt that he was on the look-out for trading opportunities in the towns he visited. But, most important from our point of view, he also took the opportunity to visit the Jewish holy sites, and his descriptions of those buildings and remains show that he was a man of piety who had a definite feeling for pilgrimage. Hence his inclusion here.

These extracts from Benjamin's *Itinerary* are taken from his visits to Rome, to Jerusalem and to the tomb of Ezekiel in Iraq. It is natural to include the Jerusalem extract, but we have included part of his account of Rome to give a flavour of the way the author was interested in visiting any site which had Jewish connections or remains. We have also included his visit to the tomb of Ezekiel as a reminder that in every faith a small site may often be a focus not only for local pilgrims but also for pilgrims from much further afield.

The extracts below are taken from M.N. Adler's translation, though the copious footnotes have been omitted.[1]

Rome

"In Rome there is a cave which runs underground, and catacombs of King Tarmal Galsin and his royal consort who are to be found there, seated upon their thrones, and with them about a hundred royal personages. They are all embalmed and preserved to this day. In the church of St. John in the Lateran there are two bronze columns taken from the Temple, the handiwork of King Solomon, each column being engraved 'Solomon the son of David'. The Jews of Rome told me that every year upon the 9th of Ab they found the columns exuding moisture like water. There is also the cave where Titus the son of Vespasianus stored the Temple vessels which he brought from Jerusalem. There is also a cave in a hill on one bank of the River Tiber where are the graves of the ten martyrs. In front of St. John in the Lateran there are statues of Samson in marble, with a spear in his hand, and of Absalom the son of King David, and another of Constantinus the Great, who built Constantinople and after whom it is called. The last-named statue is of bronze, the horse being overlaid with gold. Many other edifices are there, and remarkable sights beyond enumeration."

Jerusalem

"From there it is three parasangs to Jerusalem, which is a small city, fortified by three walls. It is full of people whom the Mohammedans call Jacobites, Syrians, Greeks, Georgians and Franks, and of people of all tongues. It contains a dyeing-house, for which the Jews pay a small rent annually to the king, on condition that besides the Jews no other dyers be allowed in Jerusalem. There are about 200 who dwell under the Tower of David in one corner of the city. The lower portion of the wall of the Tower of David, to the extent of about ten cubits, is part of the ancient foundation set up by our ancestors, the remaining portion having been built by the Mohammedans. There is not structure in the

Previous page
Fig. 85
Krishna as Sri Nathji, Nathdwara, Rajasthan
Painting on cloth (*pichhavai*), 19th century. Private collection.

These ritual hangings are a distinctive feature of the Vaishnava Pushtimarg sect based at Nathdwara in India. The largest hangings are suspended behind the image during the daily *darshana* (ritual viewing) of the deity. They may be embellished with jewels, appliqué work, embroidery or brocade in addition to painting. Smaller hangings such as this example have been sold as souvenirs of the journey to this pilgrimage site for use in home shrines.

Fig. 86
Jonah and the Whale
Illuminated vellum. Spain 1476 AD. Bodleian Library MS. Kennicott 1, fol. 305r

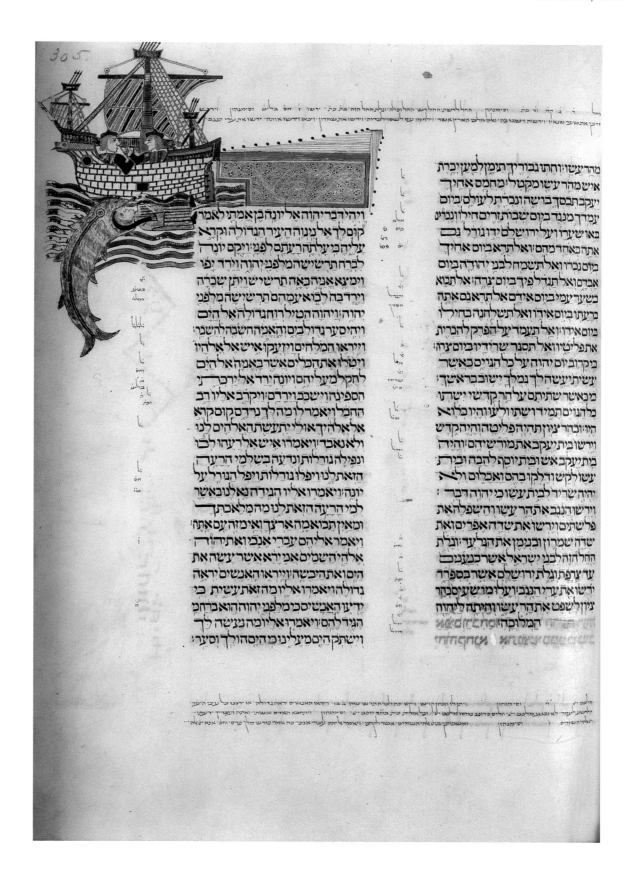

whole city stronger than the Tower of David. The city also contains two buildings from one of which – the hospital – there issue forth four hundred knights; and therein all the sick who come thither are lodged and cared for in life and in death. The other building is called the Temple of Solomon; it is the palace built by Solomon the king of Israel. Three hundred knights are quartered there, and issue therefrom every day for military exercise, besides those who come from the land of the Franks and the other parts of Christendom, having taken upon themselves to serve there a year or two until their vow is fulfilled. In Jerusalem is the great church called the Sepulchre, and here is the burial-place of Jesus, unto which the Christians make pilgrimages.

Jerusalem has four gates – the gate of Abraham, the gate of David, the gate of Zion, and the gate of Gushpat, which is the gate of Jehoshaphat, facing our ancient Temple, now called Templum Domini. Upon the site of the sanctuary Omar ben al Khataab erected an edifice with a very large and magnificent cupola, into which the Gentiles do not bring any image or effigy, but they merely come there to pray. In front of this place is the western wall, which is one of the walls of the Holy of Holies. This is called the Gate of Mercy, and thither come all the Jews to pray before the walls of the court of the Temple. In Jerusalem, attached to the palace which belonged to Solomon, are the stables built by him, forming a very substantial structure, composed of large stones, and the like of which is not to be seen anywhere in the world. There is also visible up to this day the pool used by the priests before offering their sacrifices, and the Jews coming thither write their names upon the wall. The gate of Jehoshaphat leads to the valley of Jehoshaphat, which is the gatheringplace of the nations. Here is the pillar called Absolam's Hand, and the sepulchre of King Uzziah.

In the neighbourhood is also a great spring, called the Waters of Siloam, connected with the brook of Kidron. Over the spring is a large structure dating from the time of our ancestors, but little water is found, and the people of Jerusalem for the most part drink the rain-water, which they collect in cisterns in their houses. From the valley of Jehoshaphat one ascends the Mount of Olives; it is the valley only which separates Jerusalem from the Mount of Olives. From the Mount of Olives one can see the Sea of Sodom, and at a distance of two parasangs from the Sea of Sodom is the Pillar of Salt into which Lot's wife was turned; the sheep lick it continually, but afterwards it regains its original shape. The whole land of the plain and the valley of Shittim as far as Mount Nebo are visible from here.

In front of Jerusalem is Mount Zion, on which there is no building, except a place of worship belonging to the Christians. Facing Jerusalem for a distance of three miles are the cemeteries belong to the Israelites, who in the days of old buried their dead in caves, and upon each sepulchre is a dated inscription, but the Christians destroy the sepulchres, employing the stones thereof in building their houses. These sepulchres reach as far as Zelzah in the territory of Benjamin. Around Jerusalem are high mountains.

On Mount Zion are the sepulchres of the House of David, and the sepulchres of the kings that ruled after him. The exact place cannot be identified, inasmuch as fifteen years ago a wall of the church of Mount Zion fell in."

Tomb of Ezekiel in Iraq

"Thence it is three parasangs to the Synagogue of Ezekiel, the prophet of blessed memory, which is by the river Euphrates. It is fronted by sixty turrets, and between each turret there is a minor Synagogue, and in the court of the Synagogue is the ark, and at the back of the Synagogue is the sepulchre of

Ezekiel. It is surmounted by a large cupola, and it is a very handsome structure. It was built of old by King Jeconiah, king of Judah, and the 35,000 Jews who came with him, when Evil-merodach brought him forth out of prison. This place is by the river Chebar on the one side, and by the river Euphrates on the other, and the name of Jeconiah and those that accompanied him are engraved on the wall: Jeconiah at the top, and Ezekiel at the bottom. This place is held sacred by Israel as a lesser sanctuary unto this day, and people come from a distance to pray there from the time of the New Year until the Day of Atonement. The Israelites have great rejoicings on these occasions. Thither also come the Head of the Captivity, and the Head of the Academies from Bagdad. Their camp occupies a space of about two miles, and Arab merchants come there as well. A great gathering like a fair takes place, which is called Fera, and they bring forth a scroll of the Law written on parchment by Ezekiel the Prophet, and read from it on the Day of Atonement. A lamp burns day and night over the sepulchre of Ezekiel; the light thereof has been kept burning from the day that he lighted it himself, and they continually renew the wick thereof, and replenish the oil until the present day. A large house belonging to the sanctuary is filled with books, some of them from the time of the first temple, and some from the time of the second temple. And he who has no sons consecrates his books to its use. The Jews that come thither to pray from the land of Persia and Media bring the money which their countrymen have offered to the Synagogue of Ezekiel the Prophet. The Synagogue owns property, lands and villages, which belonged to King Jeconiah, and when Mohammed came he confirmed all these rights to the Synagogue of Ezekiel. Distinguished Mohammedans also come hither to pray, so great is their love for Ezekiel the Prophet; and they call it Bar (Dar) Melicha (the Dwelling of Beauty). All the Arabs come there to pray."

Two Medieval Muslim Pilgrims

Ibn Battuta, like Benjamin of Tudela, was an indefatigable traveller. He was born in Tangier in 1304 into a highly educated family, with a strong legal tradition. In 1325, at the age of 21 he set out to make the Hajj, no doubt with a view to using the opportunities such travelling offered to improve himself and his future job prospects, and to make contact with scholars along the road. Having completed the pilgrimage, however, travelling became almost a way of life for him. He now toured Iraq and Iran, before returning to Mecca a second time. Then, having spent two or three more years in Mecca, his next journey took him to Yemen, East Africa and the Persian Gulf. Another pilgrimage to Mecca in 1332, and then he was off to Anatolia, the Crimea, southern Russia and then to India overland, via Khiva, Bukhara and Samarkand. After some time in India we find him in the Maldives, and then off to China on a diplomatic mission. Having reached China, by 1347 he was heading west again, for another Hajj, back to Spain, and then off to West Africa, before finally ending up in Fez in Morocco, where the story ends. The extracts we have chosen focus on the twin holy cities, Medina and Mecca, the objectives of all Muslim pilgrims.

We pick up the story as the caravan, with Ibn Battuta, approaches Medina from the north.

"Al-'Ula, a large and pleasant village with palm-gardens and water-springs, lies half a day's journey or less from al-Hijr. The pilgrims halt there four days to provision themselves and wash their clothes. They leave behind them here any surplus of provisions they may have, taking with them nothing but what is strictly necessary. The people of the village are very trustworthy. The Christian merchants of Syria may come as far as this and no further, and they trade in provisions and other goods with the pilgrims here. On the third day after leaving al-'Ula the caravan halts in the outskirts of the holy city of Madina.

That same evening we entered the holy sanctuary and reached the illustrious mosque, halting in salutation at the Gate of Peace; then we prayed in the illustrious "garden" between the tomb of the Prophet and the noble pulpit, and reverently touched the fragment that remains of the palm-trunk against which the Prophet stood when he preached. Having paid our meed of salutation to the lord of men from first to last, the intercessor for sinners, the Prophet of Mecca, Muhammad, as well as to his two companions who share his grave, Abu Bekr and 'Omar, we returned to our camp, rejoicing at this great favour bestowed upon us, praising God for our having reached the former abodes and the magnificent sanctuaries of his holy Prophet, and praying Him to grant that this visit should not be our last, and that we might be of those whose pilgrimage is accepted. On this journey our stay at Madina lasted four days. We used to spend every night in the illustrious mosque, where the people, after forming circles in the courtyard and lighting large numbers of candles, would pass the time either in reciting the Koran from volumes set on rests in front of them, or in intoning litanies, or in visiting the sanctuaries of the holy tomb...."[2]

Ibn Battuta arrives in Mecca

"We presented ourselves forthwith at the Sanctuary of God Most High within her, the place of abode of His Friend Ibrahim and scene of mission of His Chosen One, Muhammad (God bless and give him peace). We entered the illustrious Holy House, wherein 'he who enters is secure' [Qur'an 3:97], by the gate of the Banu Shaiba and saw before our eyes the illustrious Ka'ba (God increase it in veneration), like a bride who is displayed upon the bridal-chair of majesty, and walks with proud step in the mantles of beauty, surrounded by the companies which had come to pay homage to the God of Mercy, and being conducted to the Garden of Eternal Bliss. We made around it the [seven-fold] circuit of arrival and kissed the holy Stone; we performed a prayer of two bowings at the Maqam Ibrahim and clung to the curtains of the Ka'ba at the *Multazam* [venerated part of the Ka'ba façade] between the door and the Black Stone, where prayer is answered; we drank of the water of Zamzam, which, being drunk of, possesses the qualities which are related in the Tradition handed down from the Prophet (God bless and give him peace); then having run between al-Safa and al-Marwa, we took up our lodging there in a house near the Gate of Ibrahim. Praise be to God, Who hath honoured us by visitation to this holy House, and hath caused us to be numbered amongst those included in the prayer of al-Khalil (blessing and peace upon him) [Qur'an 2:121–2], and hath rejoiced our eyes by the vision of the illustrious Ka'ba and the honourable House, of the holy Stone, of Zamzam and the Hatim [sacred enclosure]. (Fig. 87)

Of the wondrous doings of God Most High is this, that He has created the hearts of men with an instinctive desire to seek these sublime sanctuaries, and yearning to present themselves at their illustrious sites, and has given the love of them such power over men's hearts that none alights in them but they seize his whole heart, nor quits them but with grief at separation from them,, sorrowing at his far journey away from them, filled with longing for them, and purposing to repeat his visitation to them. For their blessed soil is the focus of all eyes, and love of it the marrow of all hearts, in virtue of a wide disposition of God which achieves its sublime purpose, and in fulfilment of the prayer of His Friend [Abraham] (upon him be peace) … May God Most High number us amongst those whose visitation is accepted, whose merchandise in seeking to perform it brings him gain [in the world to come], whose actions in the cause of God are written [in the Book of Life], and whose burdens of sin are effaced by the acceptance [of the merit earned by Pilgrimage], through His loving kindness and graciousness."[3]

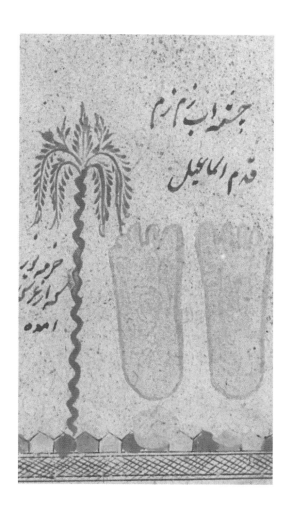

Fig. 87

Detail from Fig. 15, showing the Garden of Zam Zam at Mecca, with the foot imprint of Ismael

Pilgrim's manual of holy places, India, 18th century. Watercolour on paper. Bodleian Library MS Pers. d. 29, fol. 8v.

Fig. 88

Return of the Mahmal

Edward Lane
Pen drawing on paper.
Griffith Institute, Sackler Library, Oxford.

In medieval times a palanquin perched on a camel was sent by Egyptian and other Muslim rulers with the pilgrim caravans to Mecca. Known as the *mahmal*, it served to stress the prestige of the ruler concerned. It was pyramidal in shape, and was covered with embroidered material, usually bearing a Qur'anic text, e.g. the Throne Verse (Sura 2:255). In the 19th century the *mahmal* came to be excessively venerated, and the tradition was finally suppressed in Egypt in 1952.

Extract from the Travels of Ibn Jubayr

Ibn Jubayr, born in Valencia in 1145, became the secretary to the Moorish Governor of Granada. He was a pious Muslim, who abstained from alcohol. However, one day he was constrained by the governor to drink seven cups of wine, and in order to expiate the sin he had thereby committed, Ibn Jubayr set off the following year on the Hajj, the pilgrimage to Mecca. He left Granada on February 3, 1183, and finally returned on April 15, 1185.

A 14th century Muslim historian records Ibn Jubayr as a man 'clear in doctrine, and an illustrious poet distinguished above all others, sound in reason, generous-spirited, and of noble character and exemplary conduct. He was a man of remarkable goodness, and his piety confirms the truth of his works... His reputation was immense, his good deeds many, and his fame widespread; and the incomparable story of his journey is everywhere related. God's mercy upon him.' His fame today rests on the chronicle which he wrote of his pilgrimage to Mecca, a work which covers some 350 pages in translation. We have chosen the following extracts to give modern audiences some idea of the problems faced by medieval pilgrims of whatever faith, as they risked natural hardships, and the predatory instincts of the people through whose lands they passed. The town of 'Aydhab is on the Egyptian shore of the Red Sea, roughly opposite the Saudi Arabian port of Jeddah. (Fig. 88)

"The new moon of this month rose on the night of Friday, the 1st of the month of Rabi' al-Awwal [June 24, 1183], when we were at the end of al-Wadah and about three stages from 'Aydhab; and on the morning of Friday we halted at the waters of 'Ushara', two stages from 'Aydhab…The water of this place is not especially sweet,; it is an uncased well, and we found that the sand had fallen into it and covered the water. The camel-masters sought to dig it that they might bring forth water, but failed, so that the caravan remained without it. We marched that night, the night of Saturday the 2nd of the month, and after sunrise we encamped at the waters of al-Khubayb, within sight of Aydhab. Here both the caravans and the people of the country take water, which suffices for them all, for the well is large, like a huge cistern.

On the evening of Saturday, we entered 'Aydhab, a city on the shores of the Jiddah sea. It has no walls and most of the houses are booths of reeds. It has now, however, some houses, newly-built, of plaster. It is one of the most frequented ports of the world, because of the ships of India and the Yemen that sail to and from it, as well as the pilgrim ships that come and go. It is in the desert with no vegetation and nothing to eat save what is brought to it. Yet its people, by reason of the pilgrims, enjoy many benefits, especially at the time of their passing through, since for each load of victuals that the pilgrims bring, they receive a fixed food tax, light in comparison with the former customs duties which, as we said, have been raised by Saladin. A further advantage they gain from the pilgrims is in the hiring of their *jilab*: ships which bring them much profit in conveying the pilgrims to Jiddah and returning them when dispersing after the discharge of their pious duties. There are no people of easy circumstances in 'Aydhab but have a *jilabah* or two which bring them an ample livelihood. Glory to God who apportions sustenance to all in divers forms. There is no God but He…

The journey from Jiddah to 'Aydhab is most calamitous for pilgrims, save those few of them whom Great and Glorious God preserves, for the wind takes most of them to anchorages on the desert far to the south of 'Aydhab. There the Bujat, a type of Sudanese living in the mountains, come down to them and hire them their camels, and lead them through a waterless track. Often the greater number of them perish from thirst, and the Bujat seize the money and other things that they have left behind. Not seldom pilgrims will stray on foot through the wayless desert and, being lost, die of thirst. Those who survive and reach 'Aydhab are like men quickened from the shroud. While we were there we saw some who had come in this manner, and in their ghastly shape and changed form was 'a portent for those who observed carefully' [Qur'an 15:75]…

The people of 'Aydhab use the pilgrims most wrongfully. They load the *jilab* with them until they sit one on top of the other so that they are like chickens crammed in a coop. To this they are prompted by avarice, wanting the hire. The owner of the craft will exact its full cost from the pilgrims for a single journey, caring not what the sea may do with it after that, saying, 'Ours to produce the ships: the pilgrims' to protect their lives.' This is a common saying amongst them…

On Monday [July 18] we embarked on a *jilabah* to cross to Jiddah. We waited that day at anchor because of the stillness of the wind and the absence of the sailors. But with the morning of Tuesday, we sailed with the favour of Great and Glorious God and in the hope of His gracious aid. Our stay in 'Aydhab, not including the Monday now mentioned, had been three and twenty days, of which God, Great and Glorious is He, will hold count for us because of our adversities and ill-condition and for the ravages on our health from want of proper food. It is enough for you of a place where everything is imported, even water; and this (because of its bitterness) is less agreeable than thirst. We had lived between air that melts the body and water that turns the stomach from appetite for food. He did no injustice to this town who sang, 'Brackish of water and flaming of air.'"

Fig. 89
Temples around the holy lake at Pushkar in Rajasthan
(Photo: Crispin Branfoot 1993)

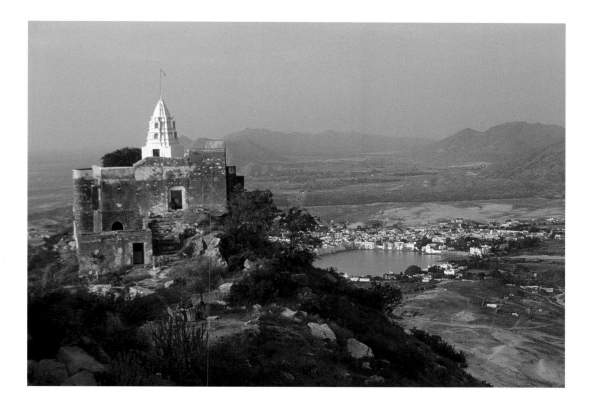

Hindu Journeys to See God

Journeying to sacred places or *tirthas* is a central feature of Hindu practice. Hindu literature, from the earliest written texts to contemporary oral literature, extols the virtues of travel and the merit to be attained at particular sacred places. Whilst the pilgrimage tradition known today is around two thousand years old, references to the importance of spiritual wandering are to be found much earlier. In the *Aitareya Brahmana*, an early commentary on Vedic ritual, the god Indra urges a young man named Rohita to travel.

> "There is no happiness for him who does not travel, Rohita! Thus have we heard. Living in the society of men, the best man becomes a sinner….therefore, wander!
>
> The feet of the wanderer are like the flower, his soul growing and reaping the fruit; and all his sins are destroyed by his fatigues in wandering. Therefore, wander!

> The fortune of him who is sitting, sits; it rises when he rises; it sleeps when he sleeps; it moves when he moves. Therefore wander!"[5]

The destinations for Hindu pilgrims are enumerated in the great epic, the *Mahabharata*, composed over a long period from c. 400 BC to 400 AD. In the third book of the eighteen major sections of this immense epic there is an account of the major places of Indian pilgrimage, the earliest clear enumeration of the merits of travelling to specific places. Though many of the places mentioned are difficult to identify with precision, they are mostly in north India where the events in the *Mahabharata* are located. In this account, the hero Bhishma asks the sage Pulastya about the merits of pilgrimage to *tirthas* ('ford, crossing-place'). Pulastya tells him about the merits of visiting these sites and then discusses the famous pilgrimage site of Pushkar in Rajasthan, one of the few sites with a temple dedicated to the creator-deity Brahma in all of India: (Fig. 89)

"Bhishma said:

I have, blessed lord, a doubt concerning the Law that derives from the sacred fords; and this I should like to hear explained by you, with respect to every one of them. A person who makes a sunwise tour of the earth, boundlessly mighty Brahmin seer, what reward does accrue to him, tell me that, ascetic!

Pulastya said:

Aye, I shall propound to you the final goal of the seers; listen with attentive mind to what reward accrues from the sacred fords. He who has mastered his hands, feet, mind, knowledge, mortification, and good repute attains to the rewards of the fords. He who has retired from possessions and is contented, restrained, pure, and without selfishness, obtains the rewards of the fords. He who is without deceit, without designs, of lean diet, in control of his senses, and free from all vices, he obtains the rewards of the fords. ...

But hear to what injunction even the poor can rise, equalling the holy rewards of sacrifices. This is the highest mystery of the seers – the holy visitation of sacred fords, which even surpasses the sacrifices. Poor indeed becomes only he who has never fasted for three nights and days, has never visited the fords, and has not given away gold and cows. ...

A man of good fortune will visit in the world of men the famous ford of the God of Gods, renowned in the three worlds, which is called Pushkara. At the three joints of the day ten thousand crores of sacred places are present in Pushkara. ... The Gods led by the seers all together found perfection together in Pushkara, possessing great merit. The man who, devoted to the worship of Gods and ancestors, does his ablutions there attains, the wise say, to ten Horse Sacrifices. If he visits the Pushkara wood and feeds but a single Brahmin, he rejoices because of his act both here and hereafter.

... When one with folded hands calls Pushkara to mind in the morning and the evening, it is the equivalent of bathing at all the fords; and in the seat of Brahma he earns worlds without end. Whatever evil a woman or man has done since birth is all destroyed by just one bath at Pushkara..."[6]

One of the most important and best-known pilgrimage sites in all of India is Kashi, often better known as Varanasi or Banaras, the sacred city of Shiva on the river Ganges in north India. (Fig. 90) In the *Kashi Khanda*, one of the seven sections of the *Skanda Purana*, the sacred status of the city is outlined, as discussed in Diana Eck's excellent account. Like the previous extract, the pilgrimage site under discussion is presented as superior to all other *tirthas*; often a site is said to contain all other pilgrimage sites within its boundaries thus apparently negating the need to go anywhere else.

Fig. 90

Pilgrims bathing in the river Ganges at Varanasi

(Photo: Crispin Branfoot 1996)

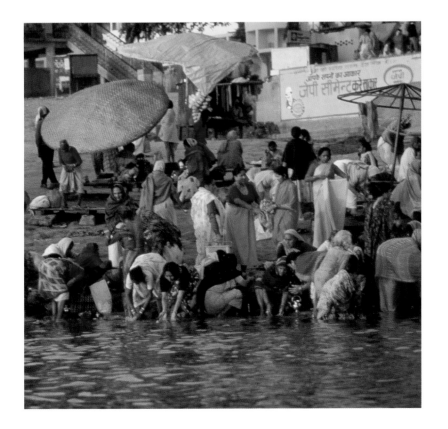

"Are there not many holy places on this earth?
Yet which of them would equal in the balance
 one speck of Kashi's dust?
Are there not many rivers running to the sea?
Yet which of them is like the River of Heaven
 in Kashi?
Are there not many fields of liberation on
 earth?
Yet not one equals the smallest part of the
 city never forsaken by Shiva.
The Ganges, Shiva, and Kashi: Where this
 Trinity is watchful,
no wonder here is found the grace that leads
 one on to perfect bliss."

All across India, local myths celebrate the virtues of pilgrimage to particular shrines and temples. In the south Indian Tamil country, the poet-saints of the *bhakti* tradition celebrated the immanence of the great gods Shiva and Vishnu in a direct, poetic Tamil vernacular between the 6th and 9th centuries. Emotional devotion and partici-pation in the love of God was to be experi-enced in great intensity at certain sites. Their devotional poetry is a central feature of Tamil Hinduism to this day, sung in both homes and temples, and the places they cel-ebrated continue to define the sacred land-scape of the Tamil country.

In this poem, the Shaiva poet-saint Appar celebrates the pilgrimage site of Rameshvaram, dwelling on the mythic actions of the gods amongst humans on earth. This was where Rama, an incarna-tion of Vishnu (here called Mal), stopped to worship Shiva before constructing a causeway from India to Sri Lanka, with help from his army of monkeys, in order to rescue his abducted wife Sita from the clutches of the demon Ravana, events recounted in the epic *Ramayana* and illus-trated in temple paintings and sculpture. The temple at Rameshvaram remains a vibrant place of pilgrimage for Hindus from all over India. (Figs. 91 & 92)

Fig. 91

Pilgrims bathing in the sea in front of the Ramanatha temple at Rameshvaram, Tamilnadu

(Photo: Crispin Branfoot 1996)

Fig. 92

Ceiling painting of mon-keys building the bridge to Lanka

Alagarkoyil, Tamilnadu,
17th century

(Photo: Crispin Branfoot 1996)

"With deep love, think every day
of holy Irameccuram,
abode of the brilliant god,
temple built with devotion
and consecrated with ritual offerings
of fragrant flowers by pious Mal
when he had killed the sinful demons.

Though I ceaselessly have on my tongue
the holy name of Irameccuram,
temple built on the causeway by Mal
when he had bridged the ocean with great
 rocks,
and achieved his goal,
swayed by five who dwell in my flesh,
I whirl about with an impure mind.

O heart, if you seek a good end, go worship
at holy Irameccuram, be saved
at the temple built with love
by beautiful Mal with the mighty discus
when he had killed the evil demons
with shoulders like hills."

In South Asia today there are great numbers of pilgrims travelling to the sacred sites of their immediate locality or to the major *tirthas* known across the region. Many anthropologists have travelled with these pilgrims, discussing their motivation for the sacred journey and sharing their experiences. Pilgrimage has inspired rich traditions of art and literature in India, and this includes oral literature, such as the songs and tales about the deities and places of this sacred land. Kathleen Erndl's study of the goddess tradition in northwest India includes songs sung by devotees drawn to the temples to Devi (the Goddess). In this popular song, pilgrims at her temples address the Goddess as Sheranvali or 'Lion-rider', the animal on which Devi always rides. The song emphasises the personal closeness and accessibility of deities to their pilgrim devotees.

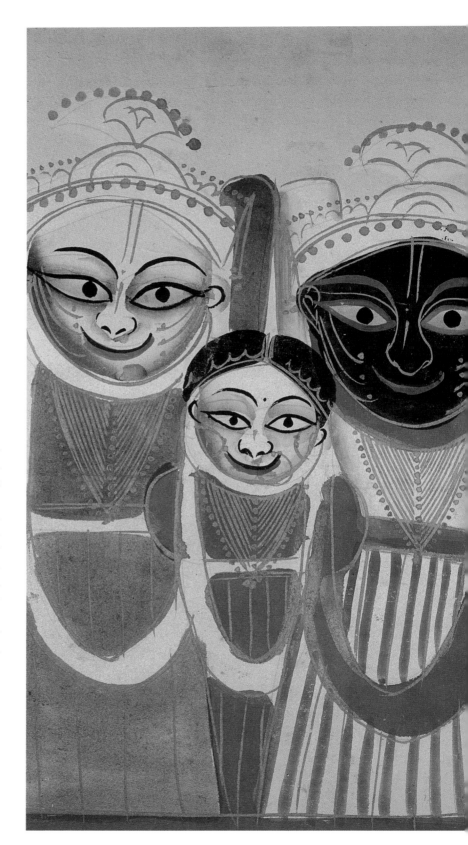

Fig. 93
**Jagannatha trio
from Puri**
Painted on paper. Kalighat
style, Calcutta, early 20th
century. Ashmolean Museum,
Oxford, EA X297.

"You called me, Sheranvali
Here I am, here I am, Sheranvali.
O Flame Mother, Mountain Mother,
 Gracious Mother.

The whole world is but a wayfarer
Whose destination is your door.
High mountains, long roads
Couldn't keep me away, Sheranvali.

In an empty mind, a flame has ignited
On your path, friends have joined.
How can I open my mouth and ask you,
Without asking, I get everything, Sheranvali.

Who's a king; who's a beggar?
All your worshippers are equal.
Giving *darshan* to all,
You draw them to your breast, Sheranvali."

In her superb account of a month-long
pilgrimage by bus across north India from
Rajasthan to Puri in Orissa with a group of
villagers, Ann Grodzins Gold recorded many
of their stories of the gods and the songs they
sang about their journey away from home. In
this women's song, the devotional experience
of pilgrimage to the temple of Jagdish or
Jagannath at Puri is celebrated as a conversa-
tion between a 'paired' wife and husband,
named Radha and Ram, travelling as part of
a group. (Fig. 93) Devotion on the journey is
about speaking or singing the love of God
from deep within one's heart.

"Hey Radha, there's a company going to
 Ganga;
Let's both make the journey, Oh Lord,
Let's go paired on pilgrimage, Oh Lord.

Hey Radha, your husband's father is
 going too;
How will you praise God? Oh Lord.
Hey Ramji, I will join both my hands to
 husband's father;
With my mouth I will praise God, Oh
 Lord,
In my heart I will praise God, Oh Lord.

Hey Radha, there's a company going to
 Ganga;
Let's both make the journey, Oh Lord,
Let's go paired on pilgrimage, Oh Lord.

Hey Radha, your husband's mother is
 going too;
How will you praise God? Oh Lord.

Hey Ramji, I will press both of husband's
 mother's feet;
With my mouth I will praise God,
Oh Lord,
In my heart I will praise God, Oh Lord.

Hey Radha, this company's going to
 Jagdish;
Let's both make the journey, Oh Lord,
Let's go paired on pilgrimage, Oh Lord.

Hey Radha, the people of Mehru are with
 this group;
How will you praise God? Oh Lord

Hey Ramji, I will veil my face slightly;
With my mouth I will praise God,
Oh Lord,
In my heart I will praise God, Oh Lord."

To Gaze Upon the Sacred Traces of the Buddha

Buddhism established a tradition of pilgrimage from very early in its history. The 3rd century BC Mauryan emperor Ashoka is an important figure in Buddhist tradition for promoting the faith, establishing the ideals of Buddhist kingship and for his gathering and distribution of the relics of the Buddha amongst 84,000 *stupas* or burial mounds. He is also considered the archetypal Buddhist pilgrim. By his construction of the *stupas* (or *caityas*) and his pilgrimage Asohka maps the life and teachings of the Buddha into the landscape of north India where they can be experienced thereafter. In this account from the 2nd century AD Sanskrit text of the 'Legend of Ashoka' (*Ashokavadana*) translated by John S. Strong, Ashoka goes on pilgrimage with the monk Upagupta to the sites associated with the Buddha's life, starting with the place where he was born, Lumbini in modern Nepal.

"The king then fell at the feet of the elder Upagupta and said: 'Elder, I want to honour the places where the Blessed One lived, and mark them with signs as a favour to posterity.'
'Excellent, great king,' Upagupta replied, 'your intention is magnificent. I will show the sites this very day.' [And he added:]
 The places where the Blessed One lived
 we will honour with folded hands,
 and mark them with signs
 so that there will be no doubt.

Then Ashoka equipped a fourfold army, procured perfumes, garlands, and flowers, and set out with the elder Upagupta.

First, Upagupta took him to the Lumbini Wood, and stretching out his right hand he said: 'In this place, great king, the Blessed One was born.' And he added:
 This is the first of the *caityas*
 Of the Buddha whose eye is supreme

Here, as soon as he was born,
the Sage took seven steps on the earth
looked down at the four directions,
and spoke these words:
'This is my last birth
I'll not dwell in a womb again.'

Ashoka threw himself at Upagupta's feet, and getting up, he said, weeping and making an *anjali*:[11]
 They are fortunate and of great merit
 Those who witnessed
 The birth of the Sage
 And heard his delightful voice.

Now for the sake of further increasing the king's faith, the elder asked Ashoka whether he would like to see the deity
 who witnessed in this wood the birth
 of the most eloquent Sage,
 saw him take the seven steps,
 and heard the words he spoke.

Ashoka replied that he would. Upagupta, therefore, stretched out his right hand towards the tree whose branch Queen Mahamaya had grasped while giving birth, and declared:
 Let the divine maiden who resides in
 this ashoka tree
 and who witnessed the birth of the
 Buddha
 make herself manifest in her own body
 so that King Ashoka's faith will grow
 greater still.

And immediately, the tree spirit appeared before Upagupta in her own form, and said, making an *anjali*:
 Elder, what is your command?

The elder said to Ashoka: 'Great king, here is the goddess who saw the Buddha at the time of his birth.'
Ashoka said to her, making an *anjali*:
 You witnessed his birth and saw
 his body adorned with the marks!
 You gazed upon his large lotus-like eyes!

Fig. 94
Buddhist reliquary locket
Tin and turquoise stone.
Tibet, 19th century.
Ashmolean Museum, Oxford,
EA 1978.72.

moment of the Blessed One's
 birth?'
'I cannot fully describe it in words,'
 answered the deity, 'but, in
 brief, listen:
Throughout Indra's three-fold world,
 there shone a supernatural light,
 dazzling like gold and delighting the eye.
The earth and the mountains,
 ringed by the ocean,
 shook like a ship being tossed at sea.'

Hearing this, Ashoka made an offering of one
 hundred thousand pieces of gold to the
 birthplace of the Buddha, built a *caitya*
 there, and went on."[12]

As Buddhism spread across Asia following
the final death of the historical Buddha,
Siddhartha, so Buddhists outside India
started to travel back to the Buddhist
holy-land to study, collect manuscripts
and by visiting the sites associated with
his life come into the presence of the
Buddha. (Fig. 94) Some of the most
famous pilgrims are those from China,
well known from the accounts of their
travels to India and the Buddhist regions
around. They provide valuable details
about the history, myths and geography of
the places through which they travelled,
and the state of Buddhist communities.
The best known of these were the travellers
Fa-Hsien around 400 AD and the later
Hsuan-tsang, who travelled from China
to India and back between 629 and 645
AD. The latter's account became especially
celebrated in China, inspiring the great
16th-century tale *The Journey to the West*
based on Hsuan-tsang's account but
relocating the events to more familiar
southeast China.

You heard in this wood
the first delightful words
of the leader of mankind!

The tree spirit replied:
 I did indeed witness the birth of the
 best of men,
 the teacher who dazzled like gold.
 I saw him take the seven steps,
 and also heard his words.
 'Tell me, goddess,' said Ashoka, 'what
 was it like – the magnificent

In the following excerpts from the
travels of Hsuan-tsang, he describes the
bodhi tree under which Siddhartha
attained enlightenment at Bodhgaya. (Figs.
59, p.62 & 95, p. 112)

"It is surrounded by a brick wall…of consider-able height, steep and strong. It is long from east to west, and short from north to south. It is about 500 paces round. Rare trees with their renowned flowers connect their shade and cast their shadows; the delicate *sha* herb and different shrubs carpet the soil. … Within the surrounding wall the sacred traces touch one another in all direc tions. Here there are *stupas*, in another place *viharas* [monasteries]. The kings, princes, and great personages throughout all Jambudvipa, who have accepted the bequeathed teaching as handed down to them, have erected these monuments as memorials.

In the middle of the enclosure surrounding the *bodhi* tree is the diamond throne. … It is the place where the Buddhas attain the holy path. … When the great earth is shaken, this place alone is unmoved. Therefore when Tathagata [Shakyamuni] was about to reach the condition of enlightenment, and he went successively to the four angles of this enclo sure, the earth shook and quaked; but after-wards coming to this spot, all was still and at rest. From the time of entering on the con-cluding part of the *kalpa*, when the true law dies out and disappears, the earth and dust begin to cover this spot, and it will be no longer visible."

"The *Bodhi* tree above the diamond throne is the same as the *Pippala* tree. In old days, when Buddha was alive, it was several hundred feet high. Although it has often been injured by cutting, it still is 40 or 50 feet in height. Buddha sitting under this tree reached perfect wisdom, and therefore called it the tree of knowledge. The bark is of a yellowish-white colour, the leaves and twigs of a dark green.

Fig. 95

Monk walking around the Mahabodhi temple at Bodhgaya

(Photo: Crispin Branfoot 1991)

The leaves wither not either in winter or summer, but they remain shining and glistening all the year round without change. But at every successive Nirvana-day (of the Buddhas) the leaves wither and fall, and then in a moment revive as before. On this day…the princes of different countries and the religious multitude from different quarters assemble by thousands and ten thousands unbidden, and bathe (the roots) with scented water and perfumed milk; whilst they raise the sounds of music and scatter flowers and perfumes, and whilst the light of day is continued by the burning torches, their offer their religious gifts."[13]

Bathing in a Pool of Nectar: Sikh pilgrimage to Amritsar

The most sacred site for Sikhs is the Golden Temple (Harimandir, Darbar Sahib) in the Panjabi city of Amritsar, named after the pool within which the temple is built. The foundation of the city in the late 16th century by the Guru Ram Das, fourth guru in succession after the founding Guru Nanak, is described in the 18th-century *Mahima Prakas Kavita*:

Fig. 96

Harmandir at Amritsar

(Photo: Crispin Branfoot 1991)

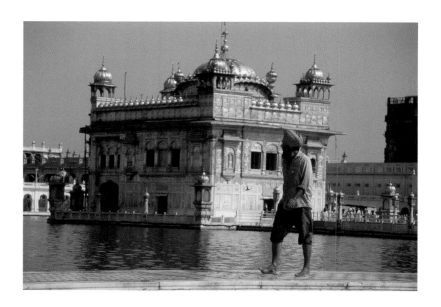

"Mounting his horse, the Guru set forth to perform a wondrous deed. When he reached Sultanvind he paused there in its wasteland and gazed at the countryside around him. As he sat there on his horse viewing his surroundings the members of his retinue asked him to tell them about the area. 'This is a most sacred place,' replied the Guru. 'Behold its beauty. This, truly, is the gateway to deliverance. I shall now explain to you why this place will be for all people the source of true happiness in this present world and of deliverance in the world to come.' The Sikhs who were with him were filled with joy when they heard these words, knowing that whatever the Guru says must indeed be true."

Summoning the people from a nearby village, he instructed them to excavate a pool. On its completion by the devoted group, the Guru filled the pool with *amrit*, or 'nectar', the fluid which confers immortality or deliverance from the transmigratory cycle on whoever drinks or bathes in it.

"The Guru then pronounced his blessing on the sacred pool. 'He who bathes here with a heart filled with devotion to God shall thereby receive the deliverance which I confer. … They who obtain this salvation will find blissful peace in mystical union with God. By the grace of our merciful Lord and Master this sacred pool has been filled with *amrit*, brought to this place for the deliverance of all. Our blessed Master, Giver and Sustainer of the Truth, has provided the source of joy in this world and the means of deliverance in the next.

'Sing praises to this most sacred of all places dedicated to the Name of God, to the sacred water which banishes all pain and distress. Let all who come here sing its praises. Let them here discover the bliss of mystical union with God. Only those who know true devotion will come, for this is no place for hypocrites and deceivers. Here divine music will be sung, sublimely beautiful music which will

bring joy to all who hear it. Here one will witness wonders; here one will meet the truly devout; here one will find peace…'

This, then, is the story of how the Guru so gloriously created the Lake of Amritsar. Let all who love the Guru hear and obey his words, for thus they shall know the joy of true devotion."

Extract from "The Man in the Red Turban": a Sikh experience of the Golden Temple at Amritsar.

The following extract is taken from a novel by an Australian writer, David Martin, called "The Man in the Red Turban". However, it came to our notice through an article in the *Sikh Spectrum* no. 21, August 2005 (www.sikhspectrum.com). The article, entitled "My Experience of Wearing a Turban", is by Monmohan Singh Koli, to whom we are indebted. He describes David Martin's novel as follows: 'The book revolves around a character Ganda Singh, who is known and liked by hundreds along Australia's Murray River. The story is set in 1933 when many had no work. Travelling through villages and towns, and meeting rogues and adventurers, Ganda Singh was depicted as a man of courage and high morals. "The Man in the Red Turban" is an exciting novel with haunting quality.' This extract comes from the final chapter of Martin's book, and includes themes common to pilgrimage in so many faiths: travel and special costume, water and cleanliness, prayer and belief.

"It was just as he had dreamt it. He was in Amritsar, and although he was tired from the long train journey from the coast he went straight to the Golden Temple. No one knew him as a home comer, not even the beggars who could always tell a pilgrim to the holy capital of the Sikhs. There were any number of red turbans, and almost every man wore the bracelet of the Brotherhood. If you wanted one you could buy it from any of the numberless shops and stalls that crowded the temple's precincts.

Ganda Singh took off his shoes. And his socks, since they were not new and unsoiled. Barefoot, as in his dream, he walked through the shallow trough filled with clean water. He mounted the broad staircase and passed under the archway, and there before him lay the tank that held the purifying Amrit. It was wide like a lake and square, shimmering under a cobalt sky. The people on the far bank looked small as toys.

When he came to the causeway that led to the Shrine he knelt. His lips touched the marbled paving. He crossed over to the noble hall, its dome covered with gold-leaf. And as he came near he heard the chanters sing.

He is one. He is the first. He is all that is.
His name is Truth. He has created all.
Fearless yet without enmity.

The sacred song, evenly falling and rising, went on beyond what he remembered of it.

Fearing nothing, making none afraid,
Timeless and birthless
He rests in Himself.
By the grace of our Teacher he is known.
He is the first. True in all ages,
True for ever.

He wanted to make a small offering and was given the communion sweet. He ate it. He prayer, one Sikh amongst hundreds. He went out onto the terrace, the processional path. He descended a few steps and cupping his hand, scooped up some water from the lake-like tank. He drank a few drops. As he poured the rest of the divine nectar over his face and neck and felt its coolness, he thought of the Murray River. Then he went to the temple treasury and gave

Fig. 97
Edward Lane,
Interior of a Mosque

Pen drawing on paper. Griffith Institute, Sackler Library, Oxford.

up a tenth part of what he had brought from home, the money from the sale of all his goods and chattels in Australia, including his two horses."

1 M.N. Adler, *The Itinerary of Benjamin of Tudela. Critical Text, Translation and Commentary*. New York: Philipp Feldheim (1907): 7, 22–24, 43–45.

2 *Ibn Battuta. Travels in Asia and Africa 1325–1354*. London: Routledge & Kegan Paul (1984, reprint of 1929 edition): 74.

3 C. Defrémery and B.R. Sanguinetti, *The Travels of Ibn Battuta A.D. 1325–1354*. Cambridge: Cambridge University Press for the Hakluyt Society (1958): 188–90.

4 R.J.C. Broadhurst, *The Travels of Ibn Jubayr*. London: Jonathan Cape (1952): 63–67.

5 Martin Haug (trans.), *The Aitareya Brahmanam of the Rig Veda*, 7.15 cited in Diana Eck, *Banaras: City of Light*. London: Routledge & Kegan Paul Ltd. (1983): 21.

6 J.A.B. van Buitenen (translator and editor) *The Mahabharata: 2. Book of the Assembly Hall, 3. The Book of the Forest*. Chicago and London: University of Chicago Press (1975): 373–4.

7 Eck, *Banaras*: vii.

8 Indira Viswanathan Peterson, *Poems to Shiva: The Hymns of the Tamil Saints*. Princeton: Princeton University Press (1989): 199.

9 Kathleen M. Erndl, *Victory to the Mother: The Hindu Goddess of Northwest India in Myth, Ritual, and Symbol*. Oxford: Oxford University Press (1993): 61.

10 Ann Grodzins Gold, *Fruitful Journeys: The Ways of Rajasthani Pilgrims*. Berkeley, Los Angeles and London: University of California Press (1988): 272–73.

11 A gesture of greeting or devotion with palms placed together and fingertips pointing up.

12 John S. Strong, *The Legend of King Asoka: A Study and Translation of the Asokavadana*. Princeton: Princeton University Press (1983): 244–46 (slight modifications).

13 Samuel Beal, *Si-Yu-Ki, Buddhist Records of the Western World – Translated from the Chinese of Hiuen Tsiang (AD 629)*. London: Kegan Paul, Trench, Trübner & Co. (1906)(2 volumes), volume II: 115–117.

14 W.H. McLeod (editor and translator), *Textual Sources for the Study of Sikhism*. Manchester: Manchester University Press (1984): 28–9.

A Time
of Miracles

Caroline Friend

It is a commonplace to say that what matters about the *Chemin de St Jaques* is not the kilometres you cover but the spirit in which you walk. Discovering this to be true was one of the many revelations that occurred on my journey. It was the element that I hoped would endure when the tan had faded, the muscles weakened and the inches crept back round my waist.

I should begin with explaining why I went. The last four or five years had brought an awful lot of bad times. My mother developed cancer and, after two terrible years, died, leaving me profoundly shocked by what I had witnessed and what she had been through. My son nearly lost his life in a road accident in New Zealand during his gap year. My daughter was very ill with food intolerances. My brother and my brother-in-law both had heart attacks. Our family seemed to have a black cloud hanging over it.

Black clouds bring rain, and the storm that finally broke was the breakdown of my marriage and my leaving the business I had run with my husband for the last seventeen years. The landscape of my life suddenly changed beyond recognition: I was alone and more miserable than I had thought possible.

Friends were wonderful and I found a good therapist, but I felt that if I was ever going to come to terms with what had happened, I was going to have to take stock pretty seriously. Something needed to change inside me to equip me for a new life. This was not just for me. I did not want to be a problem for everyone forever, a miserable, bitter, disappointed person. That was no credit to my wonderful family and to the relationship that my husband and I had shared for twenty-five years.

So I thought that going on this long walk would be an opportunity to find a turning point. Everything I read about it indicated that it was the sort of thing you did when your life was changing direction. Principally, I wanted it to teach me how to be alone. I thought that by spending my days walking without anyone to read the map for me and

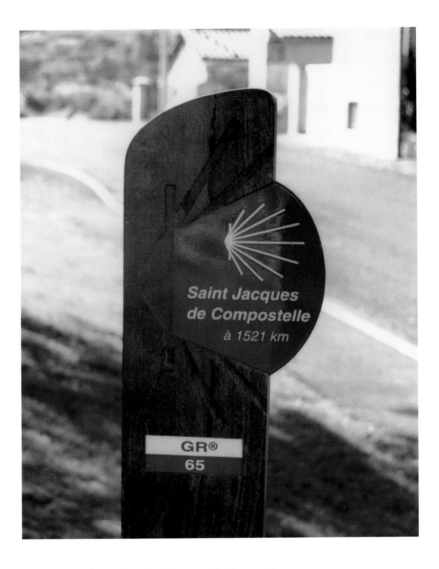

no-one to share the decisions with, I would build up a self-sufficiency that married life and then the difficult separation had weakened. I hoped that I would have enough distance from home life to be able to reflect on and understand what had been going on. I imagined day after day of solitary walking with evenings spent ordering a simple meal, writing my diary and reading my book, judiciously avoiding eye contact. This aloneness was going to teach me how to live alone, rather like re-habilitation for a drunk. It was going to be difficult and possibly dreary, but it would stand me in good stead.

Actually, I was scared. Dead scared. This lonely walking: How would I find the way?

Fig 99
The start of the walk: there was a long way to go, and what lay ahead?

Fig 98 (Previous page)
One of the many ancient crosses I passed along the way.

Where would I be sleeping? Would my wretched back stand the strain (it has always given me grief, and collapsed a few weeks before the walk, causing terrible pain), and what would happen if I could not carry my pack? Oh, that pack. It sat in the bedroom and haunted me. The pile of things to go in grew and grew, as did my back-ache just thinking of lifting it. What would I think about all day and how could I step off the hamster wheel of depressive thoughts with no-one to distract me? I went to a physio-therapist for strengthening exercises; I spent two weeks in Scotland walking on the moors with a lot of very heavy sandwiches; I read a book on Zen and practised meditating; and I packed pounds of painkillers.

Well, I could have saved my breath to cool my porridge. Almost the minute I start-ed the walk, a huge spring of joy bubbled up inside me and stayed there, irrepressible, for the duration of the five weeks. I am going to

attempt to explain it, but to be honest, I am hard put to explain it to myself. It was a gift, unlooked for, undeserved, amazing.

It first made itself known under the most banal circumstances. I had travelled by train from Stonesfield to Le Puy and arrived exhausted at nine o'clock at night. I had booked myself in to a hostel called 'Les Capucins' and imagined a monastery sort of place where I would be welcomed by kindly friars in long robes and be given a simple cell in which to sleep. After trudging through the town on four different sets of wrong direc-tions, I spotted the building in a very unpre-possessing street, walked in and found - nobody. There was a tiny municipal hall and four doors, on one of which was written my name. I shoved my huge pack through it, before realising that there were two women fast asleep in bunk beds with the lights out. I whispered my apologies and backed out again. No, there was no mistake, that was where I

Fig. 100
Would it all be as beautiful as this?

was sleeping. What to do? I shoved my pack back through the door with more apologies and went and found supper and quite a lot of red wine. When I came back (having cunningly peed at the restaurant since I had not seen a bathroom), I crept back in to the small and stuffy room, climbed up to the top bunk and lay there, fully clothed, listening to the women snore. And I laughed. I laughed at my ridiculously naive vision, at this mad situation, at the fact that I had not cleaned my teeth or opened the window and that neither seemed to matter very much; that two complete strangers were asleep next to me; that my long day's travelling had led to this funny place in the pitch dark. I felt ludicrously happy.

Walking to the pilgrim mass in the cathedral at six o'clock the next morning, that happiness grew. It was as if I was beginning my life again. The day was new, I was new, the smell of new bread filled the air. It was cold, the stars were still out in the dawn sky and the moon hung over tiled roofs. I was as excited by my independence - by my aloneness - as I had been when I first went abroad as a student, and to be excited by aloneness, rather than frightened or depressed by it, was wonderful. The mass was by candlelight and beautifully atmospheric. At the end, all the pilgrims were invited to state their name, where they had come from and where they were going; special prayers were said and we were each given a tiny medallion. It was tremendously moving, to find myself one of a group of people who had come from so many different countries to undertake this huge project, and to know that we were, each one of us, blessed on our way. That notion persisted throughout the pilgrimage, reinforced at the major abbeys but ever present and always awesome.

And maybe this presence, this physical presence of the church during my walk accounted for much of my happiness. I loved the welcome that had nothing to do with my ordinary life, that was impersonal and yet spoke directly to me as pilgrim. However bad and tainted my life as Caroline had become,

my life as a pilgrim was blessed and cherished. The buildings were so lovely, imbued with a sense of peace and otherness; the candles were so brave and symbolic. When we were blessed at Conques, about one third of the way down, I was in tears at the beauty of the service and at the intensity with which the abbot prayed for us; I felt proud to be one of the pilgrims continuing down the route and humbled by the spiritual responsibility that I seemed to be carrying.

This sense of spiritual awareness grew fast. I spent an hour or so in Le Puy cathedral writing down what I thought my walk was about. I could see that I needed forgiveness for all the wrongs I had done my husband, and a generosity of spirit that would enable me to forgive him. Simply by spending time in the cathedral, thinking about this, I found myself praying, and this itself was a miracle. I had asked my Rector to bless me before I set

Fig. 101
Conques Abbey from my window at dawn. The pilgrim Mass here which blessed us on our way was the spiritual high point of the walk.

Fig. 102
Drinking the
healing waters of St Roche
(very good for blisters).

out from Stonesfield, but throughout the bad years and all my troubles, especially the very recent ones, I had found it impossible to pray. What on earth could I say other than 'please make all this stop'? There was too much to confess, too much to ask for: I felt embarrassed and excluded. There in Le Puy, I admitted that I was not going to be praying to the Virgin or to St James - I am not a Catholic - but I declared that I was going to be addressing God the Creator, who made me, who made our beautiful world and to whom I could give thanks and say sorry. It was so simple. And out here in France, I could do that in complete privacy. Nobody was watching. I could indulge.

That prayerfulness became a major part of each day. Once I had got going on the first few kilometres, I would give half an hour to a sort of morning service, thanking God for all the wonders of the place I was

in, for the energy and ability to continue to walk and to carry my pack, for the friendship and love with which I was constantly surrounded and for all the blessings with which He was showering me. The rest of the morning was given over to a person or a relationship or an aspect of my life that was troublesome back home. I would turn it over in my mind, argue with myself, bring out all the evidence and try to come to some sort of understanding. In the evening I would write it up. Whenever I passed a chapel, I turned in and lit a candle for whoever I had carried in my sack that day: I love to think of those candles, notionally still burning and shedding light.

This thinking required a certain amount of self-discipline. I wanted to do the Walk justice. I wanted it to bear fruit, and I wanted to be sure I would come home having tried my hardest to work at my problems. This meant

Fig. 103
Elevenses

Fig. 104
A typical view. Note the
underwear pinned out to
dry...

saying to people who might have liked to walk with me that I wanted to walk alone for much of the time, and that was fine: everyone respected each other's privacy. But the funny thing is, despite all that thinking and praying, God simply would not let me be serious. That image I had of myself before I set out, trudging through France completely alone, fighting off depressive thoughts, writing them up over my lonely *steak frites* simply never materialised. In fact, I never stopped laughing. I was happier than I have ever been in my life before: more deeply happy, more reliably happy than I thought possible. I was steeped in happiness, literally transformed by it. What was going on?

Some of it was obvious. I was away from home with all its pain and uncertainties. No-one was asking me how I was, with anything in their mind other than my blisters; no-one was asking me where I was going, expecting anything other than the name of tonight's hostel. The pressure was off. No-one has any status on the *Chemin* other than that of pilgrim, so we are all the same; the fact that I had lost everything at home - business, career, job, husband, position, sense of self - was not only not known but did not matter. And anyway, it was replaced, out there, in this marvellous parallel universe, with a sense that one had everything one could possibly want and that one's self was certainly present. The weight of my pack on my back and the sound of my boots coming down on the path day in, day out, was enough to confirm that. The pilgrim's role is to smile, to laugh, to share, to encourage, to help, to be open to everything that lies on the way: that is how one earns one's position. A hand reaches out to clasp another hand, which in turn offers help further down the line. I met pilgrims who put me to shame with their generosity, their quickness to give, their thoughtfulness and their love. It was a place where one's faith in the goodness of human nature was restored.

And of course, there was fresh air and exercise all day every day for six weeks, and

real time off, rare for one who has raised a family and worked literally all her life.

Solitude coupled with the regular rhythm of walking is cleansing, therapeutic, a precious experience. I had not appreciated that it would also be endlessly entertaining. When I had finished my morning's thinking, I would spend the afternoon letting myself drink in the countryside. This would be a lovely lazy thing to do - following the lines of the horizon, gazing at fields or trees, peering into barns, endlessly stopping to talk to the animals. The number of cows' bottoms I stared at, all pink and full of folds, spattered with shit and satisfyingly on display, was splendid. There were woodpeckers flying into oak trees and taking up their famous profile; there were goats with evil eyes and funny beards; there were turkeys with hideous wattles and ducks with fat breasts that were only days away from the table. Trout in streams, a kingfisher, herds of deer, one slithery snake and lots and lots of tiny lizards enjoying the sun.

The countryside was so varied. France is huge and underpopulated; vast acres of farmland stretch away with scarcely a house to interrupt them. I walked through areas that looked and felt like Dorset but a thousand times wider, full of undulating hills, valleys rich in pasture and fields of creamy dairy herds, each with their own bull; I walked across a huge, bleak moorland called the Aubrac which had nothing in it but boulders and cattle (just like Bodmin Moor in Cornwall); I took three days to cross the vast oak forests of Quercy; I slogged through the maize country: nothing but 'sweetcorn' for mile after mile, higher than the horizon and blotting out all interest; and finally I reached the Pays Basque and the Pyrenees, all red and white alpine huts, tall church spires and the magnificent mountains behind. Perhaps the best part was what seemed to be the orchard of France: I scrumped figs, plums, apples and grapes and saw peaches, nectarines and even kiwi growing. Everywhere was rich and fruitful: everyone grew their own tomatoes, peppers, aubergines, *haricots verts* and spinach, not to mention car-

rots and cabbages. There was always something to look at and wonder about - the huge wood piles, for instance; log walls to die for. Sometimes a cat would come out to play, but more often a *chien mechant* would give me a heart attack and I would wish I had a big stick. There was no chance of the hamster wheel getting stuck: there was always a diversion.

And if the countryside was not enough, the people certainly were. Some of the strange and wonderful characters I came across are described at the end of this piece. What was so nice about these encounters was that we did not grill each other on why we had come out and what we had left behind; we certainly did not compare jobs, income, houses or holidays: '*on a fermé la porte sur tout ça*' (we've shut the door on all that). We simply inhabited our parallel universe on equal terms with identical needs and identical pleasures, enjoying a sense of love, friendship, generosity and warmth. Everyone was walking for a reason, and everyone experienced their own individual *chemin*, but the common ground was that

we were all walking in order to make a difference to the quality of our spiritual lives, and this was our unspoken bond. We would criss-cross through the days, sometimes walking together, sometimes sharing a picnic, often ending up at the same hostel and having wonderful evenings.

Ah, those hostels. They are like Christmas, the Christmas you have inside you as an ideal, not the one we all struggle through. They are full of warm smiles, welcomes and friendship between strangers. You arrive exhausted, dripping with sweat, hardly able to stand, longing only to be rid of your pack, and you find a bunk. If there are people you know - maybe you have not seen them for a few days - you fall on each other like long lost friends. You then gather your sponge bag, clean clothes and all your courage to do battle with the shower. Perfecting the art of stripping, showering, drying and dressing in a tiny, fairly insalubrious cabinet has to come quickly and involves a good pair of flip flops and the blessings of short sight: if I could have seen where I was I would have stayed dirty. There may be

Fig. 105
Ah, those suppers!

Fig. 106
Dawn

time for a rest, or you may be able to coax your aching back into sitting at a table to write. In any event, supper is at seven so there is never very long, and then it is everyone down both sides of the table, baskets of bread, jugs of red wine and huge bowls of soup followed by *cassoulet* or *daube*, chicken or duck, then cheese or pudding or, if very lucky, both. Despite all the languages being spoken - or maybe because - the conversations are hilarious. I do not think I have ever laughed so much in my life as I did those evenings, especially in the first two weeks. It felt as though there was nothing to life but laughter, that cares and bad times had not even been invented, and I was someone who was palpably happy and was sharing that happiness with everyone I came across. It was wonderful. We were all in bed by 9.30, having paid our money and had our pilgrim passports stamped, and so to sleep.

Or not. I was shocked the first time I had to sleep in a mixed dorm. Men in their underpants tending to their feet on the ends of their beds are rather terrifying: they have hairy chests and strange stomachs and might smell. And how could I do all my little arrangements in front of them, where they could see? However, after one evening of behaving as though I was in a space rocket, lying rigidly on my mattress and trying to put nivea on my legs under the blanket, I abandoned all privacy and ran around in my knickers and vest like the rest of them. Hugely liberating. I even grew to like the different snores that rippled round the room all night. It felt cosy.

But the best was yet to come. The day always started at 6 am with a tiny bleep going off on someone's alarm. I would be instantly awake, and lie there listening, fascinated. A body would turn over; someone would get up using only the light from his phone or a tiny

torch to find the door. We would still be in pitch black darkness. And then the bag rustling would begin. Again, only by torchlight, people would start to pack away their kit, ready to leave. Everything in rucksacks lives in plastic bags, so the sound people make is the sound of Christmas: secret rustlings, methodical but silent sorting, the tiniest of whispered questions, the quietest of tiny replies. It was as if each pilgrim was packing away surprises for the day, careful not to wake those still asleep, marvellously awake themselves. And outside, now just visible through the window, the sky lightening and the stars bright in a cobalt sky.

I would wriggle out of my sleeping bag, climb down my ladder with great difficulty (back always so stiff first thing) and find breakfast: still like Christmas, with day breaking and a sense of excitement in the air, a sense that the day was special, incredibly special, that I could not wait to get out into it. Bowls of black tea, hunks of bread and fabulous home-made jam. Butterflies in the tummy. Wonder at the miracle of us all doing this mad thing, this great walk, and sharing our breakfast in the half-dark. And finally putting on the boots and walking out the door, where the joy of another pristine dawn hits you in the stomach and you feel like crying for the beauty of the world and your place in it.

I did not always stay in hostels. I stayed in bed-and-breakfasts, farms, religious communities and in foul, evil, one-star hotels. There were nights in damp basements with no hot water, nights when the communal loo smelt of cooked cauliflower and the mattress sagged, nights when my attic room looked like the scene of Chatterton's death. Getting over my squeamishness, conquering that fear of lying down in a room that was anything less than lovely, on a mattress whose cover had not been washed since April, under a blanket used by hundreds of bodies; feeling genuinely glad to have somewhere to wash and sleep, however awful: that gave me a deep sense of justified pride and confidence. There were also, I have to admit, houses where I slept under feather duvets and swam in glorious swimming pools,

farms where calves were born almost before my eyes, rooms with bathrooms that had towels *and* soap *and* a plug for the basin *and* a bedside light, and there were wonderful, wonderful characters welcoming and feeding me. But the night I slept on the dining room floor because there were no bunks left was one of my happiest. I felt I had really arrived.

The Walk provided many metaphors for life. You do not know what is ahead - easy, difficult, beautiful, boring - so you sink into and savour the present. Whatever the terrain, it is your Walk: yours to enjoy, your achievement. You cannot carry anyone else's pack for them but you can make it feel lighter with a smile or the offer of some food, and you can be sure that if you give away your last plum, a plum tree will present itself within the next five kilometeres. Your own pack contains, when you set out, all the emotional baggage of your life; the further you walk, the stronger you become, the lighter your pack feels, the better able you are to carry it or even forget it. Because you have no home, you find a home in every welcome. There is no hill too steep, no track too long: it is their very steepness and their very height that makes them what they are and they are there for you to experience. It all sounds impossibly smug. It was improbably, impossibly, incontrovertibly true: truths proved upon the pulses, as Keats would say; life-changingly so.

There were some aspects of other people's *Chemin* that I did not understand. It was Alain who voiced for the first time the idea of walking for someone: in his case, his beloved father who had Parkinsons and would never walk again. This was a strange idea to me. I understood that one could walk to remit sins, to buy time off Purgatory, to try to make amends for past wrongs or to give thanks for blessings already conferred, but to walk *for somebody else*: what did that mean? Cecile, a very self-confident Quebecoise, said she would carry the names of anyone who couldn't walk the Spanish leg this year in her rucksack to Santiago. What on earth did that achieve? And then there were the people in Le Puy who wrote their '*intentions*' on pieces of

Fig. 107
Crossing the Pyrenees on my last day's walking

paper and left them in a basket for the pilgrims to take with them, hoping, I suppose, that the physical transportation of their prayers would bring them to places where they were more likely to be heard. These, it seemed to me, were simply superstitious, Catholic habits. But I did turn Alain's selfless mission over in my head. He was putting himself through considerable hardship in order to do, to *celebrate*, something which other less fortunate people could not experience.

The trouble was, it was not hardship. However much Alain said his legs hurt or his pack was heavy or he was missing his family, nothing could disguise the broad grin that perpetually wreathed his face, nothing could hide the simple joy with which he listened to the silence of the forest, nothing could dim the sparkle in his eyes as he took the head of the table and poured wine for his charming neighbours, swapped the stories of the day and tucked into the glorious food. We were all the same. As Simon, the wry Australian, said, 'How can we be earning time off Purgatory when we've just spent six weeks in Paradise?'

And what was it that grew out of all this? What was it that sent home ecstatic postcards, filled my journal and stays with me now I am home? What is the factor that links the parallel universe of the *Chemin de St Jacques* to the real world?

It is a sense of gratitude. A sense of tremendous thankfulness for everything I saw, everything I did. Having nothing, I seemed to have everything. I felt absolutely and unquestionably in my element, connected to life as never before. The days seemed packed with good things, packed with blessings, packed with joy. I found myself actually sinking to my knees in the middle of the path to thank God for everything he was giving me, from wild figs for my lunch to fellow pilgrims who were more loving and more generous than I had any right to expect. That the sun did not stop shining, either literally or spiritually, for six weeks is only the tiniest of exaggerations. It was a time of miracles, and I feel extraordinarily privileged to have experienced it.

Some of the people I met along the way

Patrick was from Belfast but lived in Glasgow. He was celebrating turning sixty. The remarkable thing about him was that he had everything but the kitchen sink in his pack, including six T-shirts which he had numbered so as to be sure to wear them in strict rotation, half a dozen self-addressed jiffy bags for posting home unwanted maps, a medical kit that put *Casualty* to shame and, carefully to hand, that special cloth you are meant to clean your glasses with but always lose. He had even - and I really could not believe this - packed an old newspaper so that he could stuff his boots if they got wet. He was a wonderful pilgrim to travel with: if his pack did not have what you wanted, either his shorts pocket or his bum bag - both hugely capacious and giving him the appearance of a slightly misshapen Celtic marsupial - certainly did, from the New Testament to nappy pins, from spare boot laces to an apparently endless supply of yoghurt-coated raisins. He was the most generous person I have ever come across - I really believe he packed for two, just in case others were less well prepared - and he would have given the shirt off his back to any pilgrim that needed it, provided of course he could renumber his remaining stock ...

The Austrian Pilgrims. One night, we were well into supper (we had finished with the fabulously ripe pink melon and the chicken cooked in lemon and onion on a bed of cous cous, and were on to goat's cheese, apple sponge and custard) when two elderly men walked in. They looked as if they could have been Christ's disciples: both bearded, stooped under their packs, staff in hand and cockleshell round their necks. Madame said they could have a bed but they were too late for supper. Well, we were not having that so I drew up a chair next to me and a battery of plates came down the table with melon, bread, cheese and desert. The wine went round, and there I was, talking to a figure out of Caravaggio: deep eyes, prominant cheek bones, slim and wiry body, gentle hands. His whole demeanour was one of humility. He was seventy-five years old, had walked from Vienna and was going all the way to Compostela.

His companion went straight to bed, but he sat up, enjoying the talk and the wine. As he paid for their beds when supper was over, I was extremely annoyed to see Madame charging him for the food they had eaten. Since that food was offered from our plates, it had already been paid for by us, they were in fact our guests and if I had had my wits about me I would have paid whatever the mean-fisted madame was asking, but I was too slow. An opportunity lost, which I still regret.

I met an **old man** who was permanently bent double. He addressed all his kind remarks to my knees. He wore a very fetching pair of elastic-sided bootees which presumably he spent a great deal of time admiring.

Pierre, a quiet man in every sense, was deaf. He wore a hearing aid in each ear, but he could not hear you unless you stood in front of him and spoke to his face: remarks thrown across the room or down the lane were useless. He was a gardner in Paris and was taking a sabbatical; we learnt almost nothing else about him, even though our paths crossed numerous times: he was not given to talking. He was an inveterate loner - I never saw him walk alongside anyone - but his contributions to the evening meals were as friendly as he could make them with his smile and his willingness to try.

When I came home, one of my ears blocked up, leaving me partially deaf for two weeks. It brought home to me the precise nature of Pierre's handicap: you feel as though life is happening all around you but you are not part of it. It is most disconcerting, and made me think about Pierre's *chemin*. Presumably it was not the escape into the silence of the countryside and of the solitary walking that everyone else was valuing; perhaps it was more a question of putting himself into an environment where silence was deemed precious and where people would be kind and benevolent. In any event, I admired his courage.

Fig. 108

The canal outside Moissac, scene of Matthew's crisis

Matthew looked exactly like Kenneth Branagh. In fact, the first time I met him, I thought he *was* Kenneth Branagh, and in a heady split second, imagined the rest of my walk being spent alongside him discussing roles I could play and films we would make. Strangely, there did turn out to be something dramatic about him, but by no means glamorous.

That same first evening we shared one end of a noisy table and enjoyed a lot of good food and wine, though I was struck by his refusing the chicken 'because it was Friday' and making do with plain rice instead. Over the last bottle, he told me that four years ago he had suffered a nervous breakdown and lost not only his prestigious job in ecology but also his wife, his son, his house: everything, in fact, which defines a man in our society. He was so ill he had been unable to speak or eat. This walk was his way of giving thanks for the fact that he was now speaking, eating and teaching basketwork to people with mental health problems. He had no house, no car, no partner, but he was well and that needed marking.

He was one of the funniest people I have ever talked to: his wit was razor sharp and very quick. It all seemed to hinge on the fact that the only word he knew in French was *escabou* which, apparently, meant 'step ladder'. Such a drawback, he would say, to go into a shop wanting a loaf of bread and to come out with a step ladder - it never seems to fit in my pack and makes a useless picnic.

One day I was walking with Patrick along the canal coming out of Moissac and we met Matthew coming towards us. He was walking slowly with his shoulders slumped; as he drew nearer I saw his face was long and gloomy. I asked him what was up. "That's it. Enough. I'm stopping. Can't go any further." O come on Martin, we're all tired. ''No. It's not that. I can't do it. I'm not worth it. I don't believe in it any more." After a little more probing, it transpired that he was demoralised because he had been walking with a 'friend' for two weeks and had been completely overpowered by him. All the courage he had mustered in England to set out on this long and arduous trek had been diluted: the friend had made all the daily decisions about the route, the distances, the food, the hostels, and had essentially taken over Matthew's pilgrimage. All the demons that lurked just beneath the surface of Matthew's new-found sanity were clawing their way up as his self-confidence wavered. He had broken his lovely pilgrim staff in two over his knee, and as we spoke, we saw it drifting towards us on the canal, horribly symbolic.

It was clear that if he went home now, he would never forgive himself. So we persuaded him to turn around and walk with us until lunch time, just to try out a few thoughts about that. He did so, and we shared a picnic of tinned *escabou* with *escabou* salad. The jokes were a little thin, but he agreed to walk on for the afternoon, during which time I encouraged him to think about doing a few days completely alone: ditching his friend and proving his own mettle to himself. By the end of the day he was reasonably settled, and during supper I phoned the friend to say that Matthew was dropping back for a day or two to rest and he was to go on without him. The next morning Matthew was a new man. He took a day off and I lost him for a while, but when I next bumped into him in a café sheltering from a rain storm, he was walking well, he had struck up a lovely friendship with a German girl and, best of all, had cut a new staff and was carving it. Monsieur Escabou was alive and well and would make it to Santiago.

Further Reading

Coleman, Simon and Elsner, John *Pilgrimage. Past and Present in the World Religions.* Cambridge, Massachusetts: Harvard University Press (1995).

Eck, Diana *Banaras: City of Light.* London: Routledge & Kegan Paul Ltd. (1983).

Gold, Ann Grodzins *Fruitful Journeys: The Ways of Rajasthani Pilgrims.* Berkeley, Los Angeles and London: University of California Press (1988).

Hopper, Sarah *To Be a Pilgrim. The Medieval Pilgrimage Experience.* Thrupp, Stroud: Sutton Publishing (2002).

Hunt, E. D. *Holy Land Pilgrimage in the Later Roman Empire.* Oxford: Clarendon Press (1982).

Mills, Margaret, Peter Claus and Sarah Diamond (eds.) *South Asian Folklore: An Encyclopaedia.* London and New York: Routledge (2003).

Peters, Francis E. *The Hajj: the Muslim pilgrimage to Mecca and the holy places.* Princeton: Princeton University Press (1994).

Sumption, Jonathan *Pilgrimage.* London: Faber & Faber (1975).

Glossary

Ark of the Covenant: Sacred container built at the command of Moses, to hold the stone tablets containing the Ten Commandments.

Bhakti: Hindu devotional tradition stressing emotional intimacy with a personal deity.

Dargah: 'Royal court'; burial places of major Sufi teachers whose spiritual power (*baraka*) is believed to reside in the tomb.

Diaspora, Jewish: Dispersal of the Jews from Jerusalem and Palestine, following the destruction of the Temple by Titus in 70 AD.

Eid ul-Adha: Completion of the *hajj*, with ritual slaughter of animals in the village of Mina near Mecca.

Hadith: Muhammad's comments and sayings (see also *sunnah*).

Hajj: Pilgrimage to Mecca, carried out in the twelfth month of the Muslim lunar year.

Hijra: 'Flight', referring to Muhammad's flight from Mecca to Medina in 622 AD; it marks the beginning of the Islamic era of reckoning dates.

Iconoclasm: Controversy over the worship through images; it divided the Eastern Christian church in the 8th/9th century.

Imam: Arabic word meaning 'leader'; it is used for a person leading Muslim congregational prayers. In the Shi'a context, Imam also has a meaning more central to belief: an Imam is able to lead mankind in all aspects of life and is to be followed, as he is appointed by God.

Ka'ba: The 'House of God', central shrine of all Muslims, located in Mecca and the focus of Muslim pilgrimage; it contains the black meteorite once kissed by the Prophet.

Kailash: Mountain in western Tibet sacred to Hindus, Buddhist and Jains.

Kiswah: Black embroidered cloth that covers the Ka'ba.

Menorah: The seven-branched candlestick used in the Temple in Jerusalem, and by extension in synagogues and Jewish homes.

Milan, Edict of: Legalised Christian religion in 313 AD; proclaimed by Emperors Constantine and Licinius.

Miraj: Muhammad's journey to Heaven.

Mount Sinai: Location in Sinai where God called Moses and gave him the Ten Commandments.

Nicaea, Council of: Summoned in 325 AD to resolve doctrinal disputes in early Christianity, in particular the definition of the Trinity.

Pradakshina: Clockwise circumambulation around an image, building, person, city or other geographical feature.

Ramayana: Popular epic tale of Rama, his brother Lakshmana, wife Sita and the many other characters who helped Rama find his wife after her abduction by the demon Ravana.

Shi'a/Shi'ism: Movement associated with the early years of Islam; Shi'ites reject the authority of the first three caliphs, but believe that religious authority passed from the Prophet to the husband of his daughter Fatima.

Shiloh: The first non-nomadic Jewish sanctuary site in Canaan, after the flight from Egypt.

Stupa: Hemispherical burial mound. Characteristic Buddhist monument of any size, often made of stone and/or brick.

Sufism: Form of Islam that emphasises mystic religious experience through ascetic practices and spiritual contemplation.

Sunnah: Writings that record Muhammad's religious practices (see also *hadith*).

Sunni: Sunni Muslims believe that Muhammad died without appointing a successor to lead the Muslim community, and they recognize Abu Bakr, Muhammad's father-in-law, as the first Caliph. This succession of religious leadership was (and is) not accepted by Sh'ite Muslims.

Tirtha: 'Ford, crossing place'; sacred site of Hindu pilgrimage.

Tirthayatra: 'Journey to a *tirtha*'; pilgrimage.

Tirthankara: 'Ford-crosser'; one of the 24 Jain spiritual leaders. Also called *Jinas* or 'conquerors'.

Torah: The Hebrew Bible's first Five Books of Moses (Pentateuch); the term is also used in a general sense, to include both written and oral law, encompassing the entire spectrum of authoritative Jewish religious teachings throughout history.

Varanasi: Sacred Hindu city in northern India on the river Ganges; also known as Kashi, Benares or Banaras.

Wailing Wall: Only part remaining of the Jewish temple in Jerusalem, focus of Jewish pilgrimage.

Zam Zam, Garden of: Stage of the *hajj*, where a miraculous well is said to have sprung up to give water to Abraham's first wife Hagar and her son, Ishmael.

Ziyara: Secondary pilgrimage, common among Shi'a Muslims and Sufi, who travel to the tombs of saints and Imam.